—DETOUR—
NEW MEXICO

HISTORIC DESTINATIONS & NATURAL WONDERS

ARTHUR PIKE & DAVID PIKE

THE
History
PRESS

Published by The History Press
Charleston, SC
www.historypress.net

Copyright © 2017 by Arthur Pike and David Pike
All rights reserved

Cover images courtesy of the New Mexico Tourism Department.

First published 2017

ISBN 9781540214119

Library of Congress Control Number: 2016947530

CONTENTS

CONTENTS

INTRODUCTION

If you're just passing through, traveling in New Mexico is easy. Thousands of travelers do it every day. Take Interstate 25, which bisects the state north/south, and it will get you from Las Cruces to Raton efficiently, if not exactly quickly. (It's a big state after all.) Interstate 40 will take you across the state east to west or vice versa with equal convenience. Since large chunks of the state are flat, you won't need to slow down for much, and you'll be rewarded with great views.

But there's a certain breed of traveler more focused on experience than expediency. They'd prefer to wander than make time, to dwell on those views, to seek out the complex and varied history of this state and absorb the lessons it has to offer. They're into detours. This book is for them—for you.

Fans of the detour are drawn to New Mexico for the vibrant history here, layers of it nearly everywhere you turn. That's in keeping with a land where modern roads were laid on top of wagon ruts that were, in turn, laid on top of footpaths, well trod by the state's native sons and daughters. But the benefits of detouring run even deeper than simple history lessons. By leaving the beaten path behind, you'll get closer to the real New Mexico, the one lived day to day in all its diversity. And that experience invariably results in small discoveries that offer big insights into the state, its people and their circumstances.

To help you have the most compelling adventures as you travel, we've divided the state into six geographic regions: northwestern, north-central,

northeastern, central, southwestern and southeastern. These are divisions of convenience only; in fact, you'll find that some of the detours intersect. Where it makes sense, we've offered guidance on the hidden connections between detours, which we call "Detour Déjà Vu."

A few cautions before you begin:

- Road conditions can change from day to day and season to season in New Mexico. Be prepared to take alternate routes on occasion when weather (or road construction) interferes with your best-laid plans.
- Schedules can change as well. We've done our best to provide accurate information about detour attractions, but your results might vary. It's best to call ahead.
- Keep your equipment in good working order. Make sure your vehicle is maintained, keep your tank full (it can occasionally be a long way between gas stations) and replenish your snack and water supplies often.

You'll also be visiting a number of ancient and modern cultural sites, all of which have been carefully preserved. Please respect local customs to ensure these sites are available for future detour enthusiasts. We've included a guide on Pueblo Etiquette from the New Mexico Department of Tourism after this introduction. Please note that this book capitalizes the word "Pueblo" when used in the formal name, like the Pueblo of Pojoaque, or when referring to the residents and Native people and does not when referring to the structure itself.

We've had a lot of help along the way assembling this collection of detours, and we'd like to recognize the following contributors: Robert Julyan, whose knowledge of the state is unbounded; Travis Suazo of the Indian Pueblo Cultural Center, whose helpful guidance made vital parts of the book possible; Vickie Ashcraft, Frank Norris and Kaisa Barthuli, to whom we turned often for insights into Route 66 history; and Dixie Boyle, who is working diligently to preserve the history of Highway 60. We are also indebted to those many people who shared their stories with us, including Jacob Viarrial of Pojoaque Pueblo, Grace Roybal of the Fort Sumner Historic Site, Lee Ann Sandoval and Robert Garnett in Dexter, Randy Dunson, Greg Reiche, George Tomsco, Steve Owen and many, many others. We also thank Chris Pike and Emily Lewis for their illustrations.

As any New Mexico traveler will tell you, there's a detour around every corner in the state. We've barely scratched the surface of potential detour fun in this book. Our hope is that you'll use it as a starter guide to help you get out and discover your own detours. New Mexico rewards exploration. So take that next turn, the one that seems to be beckoning you, and be open to what it offers.

Happy detouring!

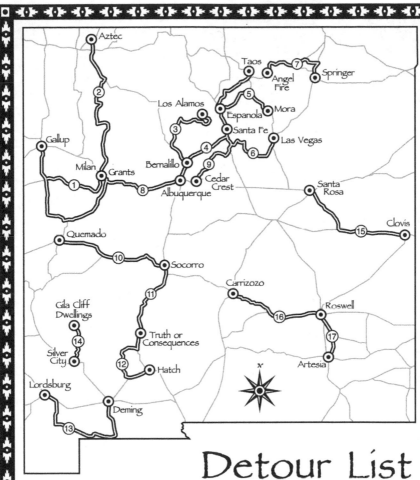

Detour List

PUEBLO VISITOR ETIQUETTE

Attractions on tribal lands, especially those located along major highways, are usually intended for tourists, but tribal communities are home to living Native American cultures and people. When visiting a tribal community, show respect as if you are a guest in someone's home and abide by the recommended visitor etiquette.

- First, contact tribal offices or visitor centers to determine if the tribal community, its dances and events are open to the public. Please note tribal offices and visitor centers may be closed on Pueblo feast days.
- Obey all posted signs in tribal communities. Inquire about rules on photography, sketching and recording, as these activities may be prohibited. Fees and restrictions vary for each pueblo and tribe.
- Cellphones—it is best to leave them in your vehicle when attending Pueblo events.
- Direct visitor inquiries to visitor centers and tribal offices, not private homes or unmarked buildings. Respect the residents of the tribal community you are visiting.
- Remember that Pueblo feast days, dances and ceremonies are expressions of religious belief, not shows or performances. Applause after dances is not appropriate. Dances do not begin and end at precise times and should be observed with attention and respect. Actions such as pushing to the front of a crowd, talking loudly, pointing for extended periods of time, blocking others' views and

approaching dancers is inappropriate. Enter a pueblo home as you would any other—by invitation only. It is courteous to accept an invitation to eat, but be respectful and do not linger at the table, as your host will be serving many guests throughout the day. Thank your host after eating.

- Drive slowly in tribal communities; watch for pedestrians and animals.
- Obey all posted signs and refrain from entering off-limit areas. Never attempt to climb a ladder to enter a kiva.
- Be mindful of your children at all times.
- Limit your questions about religion and culture, as some subject matter is not for public knowledge.
- Do not disturb or remove plants, rocks, artifacts or animals.
- For your own safety and to preserve the historic structures in tribal communities, please do not climb on any walls or other structures.
- Do not bring pets, alcohol, drugs or firearms into tribal communities.
- Help keep tribal lands clean, and please don't litter. Place refuse in trash cans or take it with you.
- Teepees may be used for religious purposes on Apache reservations. They should not be approached by visitors, unless invited to do so.

Courtesy of the New Mexico Tourism Department

NORTHWESTERN NEW MEXICO
— DETOURS —

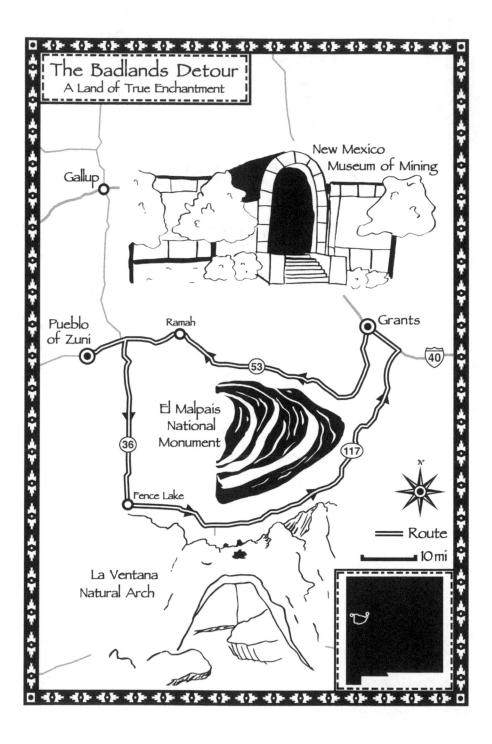

THE BADLANDS DETOUR: A LAND OF TRUE ENCHANTMENT

THE EL MALPAIS LOOP

New Mexico is known as the Land of Enchantment, and this detour will prove those words to be more than just a tourist slogan. When you see ancient petroglyphs carved into sheer cliff walls, walk the rim of a cinder cone volcano and absorb the peace of a historic Spanish pueblo mission church—all in the course of a day—it's hard not to feel enchanted. While the natural world provides the canvas for this detour, the history painted across that canvas (sometimes literally) is very much a human story, both ancient and modern. Here, against an enchanted landscape, Native American populations, followed by Spanish explorers and Anglo homesteaders, all left their mark.

DETOUR LENGTH

Just a few short of two hundred miles

WHAT'S IN IT FOR YOU

- Stroll along the rim of an ancient cinder cone volcano (two, actually)
- Shiver in an underground ice cave
- Read signatures left by travelers on the face of a sheer cliff
- Admire the giant sandstone arch known as La Ventana (the window)

This is a detour of highs and lows—literally. You'll see what we mean when you visit the New Mexico Museum of Mining and learn about the history of mining in the Grants area and the vast uranium deposits that lie north of the town. There are gem specimens, displays on the history of mining and on the founding of Grants itself and even a dinosaur bone unearthed during mining operations. But the real treasure is underneath the museum: the basement has been converted into a replica of an underground mine. When that elevator door opens at the "mine" level, you're going to have a hard time believing you haven't suddenly descended hundreds of feet into the earth. The dirt, the damp feeling, the claustrophobia—it's all here. You'll see mining cars, giant drills used to make holes in the wall for blasting the rock and even a typical miner's lunchroom, with safety posters on the dangers of riding between mine cars and not in them. Savor the underground experience while you can. You're going to be spending a lot of time on top of mountains today.

What exactly qualifies a particular slice of land as *bad*? As you follow NM 53 west, you'll soon find your answer flanking the highway: a seemingly boundless expanse of hardened lava. This 114,000-acre site is known as El Malpais National Monument—a truly enchanted landscape. The word "malpais" combines two Spanish words, *mal*, meaning "bad," and *pais*, meaning "land or country." (It should roll off your tongue in three syllables: mahl-pie-ees.) And while its surface may look menacing, there's a majestic soul hidden under those lava flows, long-dormant volcanoes, magmatic intrusions and cinder cones. It's a truly otherworldly sight, a glimpse back across thousands of years to a younger, more violent version of New Mexico. The area enchants both professional and amateur geologists, presenting a spectacular hardened rock vista to be explored, studied and appreciated for its stark beauty.

If you want to experience it firsthand, the Zuni-Acoma Trailhead is a great way to get up close to this rugged wilderness. Allow yourself six or seven hours to complete the seven-and-a-half-mile trail. It doesn't loop, so you'll either need to plan a return hike or have someone meet you at the other end. Even if you decide not to take the trail, its history is worth understanding. The trail is part of a much larger trade route between the people of Acoma Pueblo to the east and Zuni Pueblo to the west. Like many Native American populations, the two Pueblos traded with each other: jewelry, foods, pottery. The giant lava flows of El Malpais lay between the two pueblos, but these early travelers created a footpath over the course of the hardened rock to allow navigation through, rather than around, the mass of scarred earth. The Native Americans wore moccasins made from the stalks of the yucca

plant to protect their feet against the sharp lava rock; they were known to carry an extra pair, as the broken rock ground the yucca leaves to pulp. Today, a section of this trade route comprises the Zuni-Acoma Trail and is available for hiking, but be advised that the rock presents severe challenges, and critters like mountain lions are known to prowl the area.

El Calderon offers another approach to this unique landscape. The El Calderon Trailhead leads to a 3.8-mile loop trail that will take you past sinkholes and caves and up the side of the cinder cone volcano from which this place takes its name. From the top, you'll look out across miles of New Mexico beauty, dark green fir trees in the foreground and layers of mountain ranges in the far distance.

Bandera Volcano and Ice Caves is privately owned, and admission is charged, but the sights ahead are worth the expense. Here you can walk on a trail of dirt and cinder up the side of another cinder cone volcano to a lookout point with a spectacular view into the mouth of the dormant Bandera Volcano. There's some more beauty underneath the ground here, too. A well-maintained wooden staircase takes you down to a chilly cave and observation platform where you can view the blue-green, algae-tinged sheet of ice lodged in a collapsed lava tube. The depth of the water and the insulating properties of the lava ensure that the temperature remains a steady thirty-one degrees year round.

It's easy to see why the imposing form of El Morro became a landmark for travelers. Not only can it be seen for miles, but the small pond at its base was also a dependable source of water for travelers. Something about this place inspired those travelers to check in here. Along the cliff walls are hundreds of inscriptions from early detourists scratched or chiseled into the stone face. One of the most significant Spanish inscriptions (indeed, the first Spanish-language inscription on the rock) comes from Juan de Oñate, who led the Spanish colonization of New Mexico in 1598 and became New Mexico's first governor. After setting up a capital in what is now Ohkay Owingeh Pueblo (formerly known as San Juan Pueblo), Oñate went exploring. *Paso por aqui*, "I passed by here," he wrote on his way back from the Gulf of California.

Another pathfinder to visit was Lieutenant Edward "Ned" Beale in 1857 (members of his expedition signed the rock in 1859). Beale had been appointed to lead an expedition of the U.S. Army to open a migrant and trade route from Fort Smith, Arkansas, to the Colorado River. (The army in those years was very much in the business of road building.) This would have been a noteworthy expedition anyway, but it was made even more so by some rather extraordinary expedition members: the army was testing the

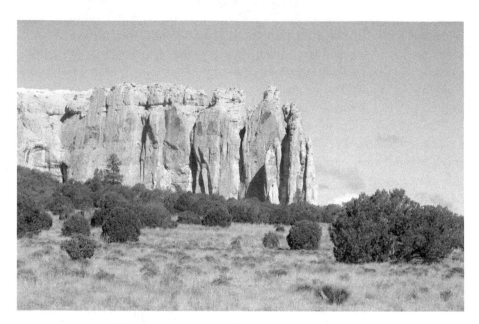

The many signatures on Inscription Rock have been called history's guest book. *Photo by David Pike.*

use of camels to cross the desert Southwest, believing them more suitable to the climate and landscape than horses. Beale's "Camel Corps" fared well, but alas, the experiment never moved forward. The route Beale opened became known as Beale's Wagon Road.

DETOUR DÉJÀ VU

In later years, other roads roughly followed the course of Beale's Wagon Road through New Mexico, including Route 66 from Albuquerque to the Arizona Border (and, later, Interstate 40). You can follow Route 66 westward in the Kicks Detour (Detour 8).

Just a year after Beale's visit, the rock would see a signature by someone whose story would be entwined with his forever, though the two likely never met. Sally Fox was just twelve years old when she passed by with her family in July 1858 and carved her name into the stone. They were part of the first migrant train to travel west on Beale's Wagon Road. A short time after they left El Morro, the caravan was set upon by Mohave Indians along the Colorado River. Sadly, Sally's father was killed, along with seven other

members of the caravan. Sally, though wounded when an arrow pierced her side, survived. In more recent years, Sally's descendants visited El Morro to see her signature. That happens often: descendants of signatories visit to see their ancestors' names. Indeed, rangers keep a notebook in the visitor center with each name and as much as is known about that person, and they are delighted when a descendant visits.

If you're sure of your footing and don't mind a moderately stressful hike, continue up the Headland Trail to the top of the bluff. There you'll follow a winding path around the edge of the mesa, down narrow stairs carved in the sandstone and past stone walls excavated from a larger pueblo known as Atsinna. Atsinna was the home of Ancestral Puebloan Indians, who erected this vast structure of more than eight hundred rooms and two ceremonial chambers known as *kivas*, sometime in the late thirteenth century. Like those early people, you'll have a commanding view of the landscape in every direction and draw the attention of hawks soaring above.

As you continue west on NM 53, you'll soon pass into Cibola County. The name has great historic importance, referencing the fabled "Seven Cities of Cibola"—also known as the Seven Cities of Gold—that inspired sixteenth-century Spain to fund an expedition into this unexplored land. At its head was Francisco Vásquez de Coronado, who came to New Mexico in 1540 lured by legends that seven cities made of gold and filled with treasure existed somewhere in what is now the southwestern United States.

The village of Ramah lies on the far northwestern edge of the Ramah Navajo Indian Reservation. The Navajo are one of the most populous tribes in the United States; almost a third of them live in New Mexico. The Ramah Navajo chapter is geographically separated from the much larger Navajo reservation, most of which makes up the upper northwestern portion of the state. The village of Ramah itself began as a Mormon settlement in 1874. The Ramah Museum has displays on area history.

Farther west on NM 53, you'll reach the Pueblo of Zuni. When Coronado came on his treasure hunt, he spotted the golden rays of sunlight hitting the walls of one of the pueblo structures here (known as Hawikuh) and felt sure he'd discovered the golden cities at last. He happened to interrupt a sacred ceremony, and things got worse from there, with the conquistadors assuming control of the pueblo by force. Not finding Zuni to be made of gold, Coronado decided instead to make it his base of operations, determinedly sending a side expedition to what is now the Pacific coast and leading another into the interior of Kansas. The magical golden cities remained elusive, and after two years, Coronado and his men returned home.

Stop first at the Zuni Visitor Center, where you can browse displays about Zuni history and purchase a photography permit, which you'll need before taking any photographs here. You can also learn more about the proper protocols and regulations that govern your visit. The best way to see the village is to sign up for one of the tours, offered every day but Sunday and days of special religious or cultural significance. Both walking and driving tours are available and will take you around the village and to the mission church of Our Lady of Guadalupe, established in 1629. The pueblo is closed during religious cultural observations, so call ahead to be sure you'll be able to visit.

Heading south on NM 36, the landscape broadens, and the sky opens up above you. You're moving into ranch land now, so expect to see cattle on either side of the road.

After these wide-open spaces, Fence Lake might seem like a metropolis. The pleasant name is descriptively prosaic: there was a small lake here in the 1920s, on the property of rancher Sylvester Mirabel. A prudent man, Mirabel knew that cows will wander; he kept them away from the lake's muddy shores by surrounding that temptation with a fence. Look for the monument near the Fence Lake Community Center that pays tribute to the "mysterious force that drives people to new lands and new frontiers"—an appropriate theme for this detour.

As you return north on NM 117, you'll cross a landscape unlike any other. Giant sandstone bluffs rise like battleships plowing through the blue sea of the sky. If you happen to see any hikers along the roadway, especially in the spring, they're probably making a trek over the Continental Divide Scenic Trail, which runs some three thousand miles through the western United States. A thumbs-up and encouraging word are always welcomed.

While the walking path to La Ventana Natural Arch is short, some of the best views are on the approach, so take your time. *Ventana* is Spanish for "window." Look through that window into another world, one defined by the ageless grandeur of sheer sandstone vaults that catch the gold of the sun.

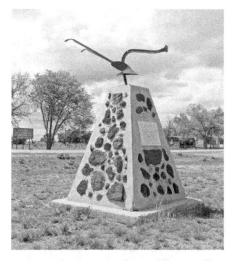

The lovely memorial in Fence Lake is a testament to those who have come this way before. *Photo by David Pike.*

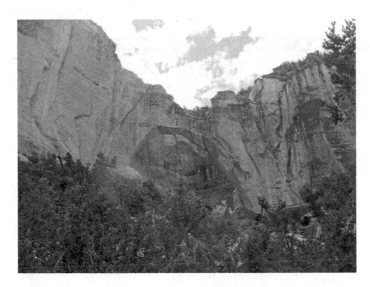

La Ventana, or "the window," offers a view into the beauty of this part of New Mexico. *Photo by David Pike.*

You'll get a truly dramatic view of El Malpais's lava flows, volcanoes and bluffs from Sandstone Bluffs Overlook. On the western horizon is the Chain of Craters, a north–south trending string of cinder cones that forms a geological chorus line. This is a land of stark contrast, scorched by a fiery past but teeming with life in the here and now, including elk and deer and abundant piñon and juniper trees. A desolate place, yet one that provided a home to the ancestors of today's Pueblo Indians, was marveled at by Spanish explorers and, later, stood silently by as a procession of Dust Bowl homesteaders tried to make a go.

For some insight on the latter, look for the stone ruins of the Depression-era Garrett Homestead to your left as you descend the gravel road back to the highway. A few stone walls, neatly laid, testify to the Garrett family's attempt to put down roots in these badlands. Built in the mid-1930s, the ruins speak eloquently to modern travelers, telling the story of the earliest homesteaders' drive to escape the harsh realities of the Depression.

Swing by the Bureau of Land Management Visitors Center for more details on the formation and history of El Malpais, as well as the human story that has played out across it. A short one-mile-loop tour starting at the parking lot will introduce you to the local life that scratches out a living on the lava. Even here, in the baddest of the badlands, life abounds. You'll see squirrels and lizards and butterflies among the ponderosa pines that have adapted to this hardened landscape. You might even catch sight of the state bird, the roadrunner, scampering across the black rocks.

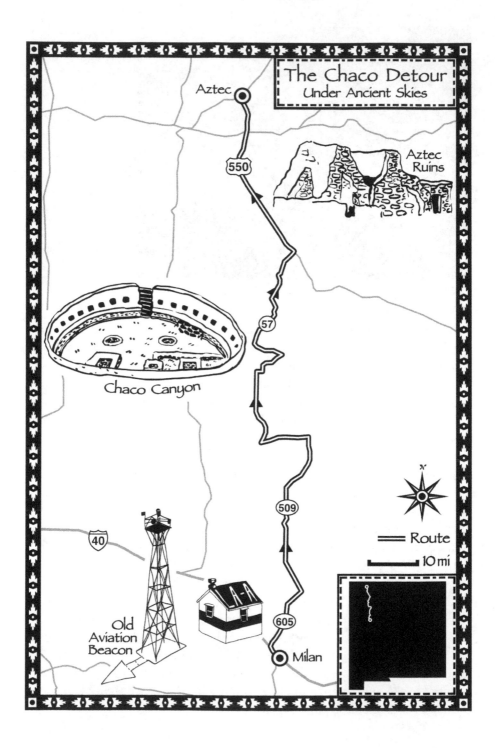

The Chaco Detour
Under Ancient Skies

Aztec

550

Aztec Ruins

57

Chaco Canyon

509

Old Aviation Beacon

40

605

Milan

Route

10 mi

THE CHACO DETOUR: UNDER ANCIENT SKIES

FROM MILAN TO AZTEC

L iving today means soaring across the country in a matter of hours, connecting with people around the world at the click of a button and having access to enormous volumes of information immediately. These things feel uniquely modern, but at base they're not particularly revolutionary. On this tour, you'll learn about a people who preceded us, created their own engineering, developed unique ways of engaging with and appreciating the world and their place in it and advanced their own ways of bridging distances between themselves and other people.

DETOUR LENGTH

Roughly 160 miles

WHAT'S IN IT FOR YOU

- Visit a restored airway beacon site and learn about early aviation in New Mexico
- Walk among pueblos where people of the Chaco Culture lived more than eight hundred years ago
- Explore two of the Chacoan outlier pueblos
- Stroll through a historic downtown commercial district

In Milan, on the western edge of Grants, you'll find the fascinating Western New Mexico Aviation History Museum, built and operated by the Cibola County Historical Society. The museum re-creates and preserves the buildings and equipment of a typical 1920s airway beacon site, a critical part of pilots' navigation systems in the early days of aviation.

In 1929, the Transcontinental Air Transport company, commonly known as TAT, announced a service that would transport passengers from New York to Los Angeles in just forty-eight hours. Its route made strategic use of both air and railroad travel, carrying passengers alternately through the air in a Ford Tri-Motor plane or overland on partner railroad lines. The portion of the route running through New Mexico was mostly done by air— westbound passengers boarded a TAT plane in Clovis, near the Texas border, stopped briefly in Albuquerque, then continued to Arizona and onward to Los Angeles. It was a luxurious ride. The prestigious Fred Harvey Company, which ran the famed Harvey Houses along the railroads, also provided the meals for passengers while in the air. The airline even gave passengers a bound "Certificate of Flight" booklet that included a log of the cities they would visit, with space for them to write notes about their journey.

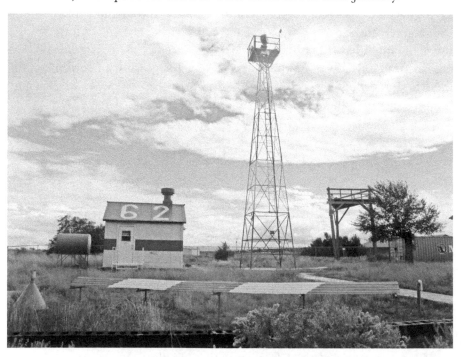

The restored air beacon site in Milan re-creates part of aviation history. *Photo by David Pike.*

Pilots at the time navigated mostly by sight. TAT erected a series of ground beacons about every ten miles across the airway portions of its route, along with landing fields every forty to fifty miles so pilots could land in an emergency. New Mexico had twenty-nine of these beacon sites. The rotating or flashing beacon lights, high atop towers and painted bright colors for visibility, were powered from an adjacent, unmanned power shed. The sites typically also had a giant concrete arrow on the ground pointing the way to the next beacon.

Using buildings and original pieces assembled locally and from other locations, the Aviation History Museum re-creates one of those TAT beacon sites. The power shed is original to the line; it saw duty in Bonita Canyon in the Zuni Mountains west of Grants. Though it had been moved into town and was being used as a storage shed by the fire department, its official identification, LA-A 62, was still visibly painted on the roof, allowing historians to determine its original location on the line. The museum also includes a beacon tower from a site in Arizona and a re-creation of a concrete directional arrow. Also on the property is an original flight service station that served as an air traffic control building for the airport from 1953 to 1973.

Leaving the museum and winding your way north, take some time to appreciate the vast beauty of this land: scenic canyon country ringed with colorful mesas and low ridges like fortress walls, wildflowers along the roadway, the ribbon of highway snaking away into the distance. You're passing through the eastern portion of the Navajo Indian Reservation. About a third of the reservation is in New Mexico, with the remainder in Arizona and Utah. The Navajo, the largest Native American tribe in the United States, call themselves Diné and know this area as their ancestral homeland.

During World War II, the government recruited Navajo men to develop a code based on their native language for secret wartime communications. The Navajo language uses a complex grammar, making it ideal for passing secret information. These marines became known as the Navajo Code Talkers. Twenty-nine men formed the original corps of code talkers in 1942. They developed a core set of about two hundred terms that could be used individually or combined to form new meanings. The code for submarine, for example, combined the words "iron" and "fish." Additionally, the first letter of Navajo words translated into English could be pieced together to spell other words.

In 2001, Congress recognized the contribution of these men to winning the war by awarding the Congressional Gold Medal to the original twenty-nine men and the Silver Medal to the men who followed thereafter. Sadly, the last of the original twenty-nine code talkers, Chester Nez, died in 2014.

Detour Déjà Vu

The High Lonesome Detour (Detour 15) includes a visit to Fort Sumner and the Bosque Redondo Reservation. Thousands of Navajo Indians were forcibly marched there starting in the fall of 1862 in what became known among the Navajo as the "Long Walk."

Chaco Canyon: the name elicits a reverential awe from people around the world. They may have heard of the large-scale, preplanned ancient buildings known as great houses in this beautiful desert canyon or of the Ancestral Puebloan people who lived in this part of New Mexico, started building these elaborate structures here as early as AD 850 and remained for three centuries. They may also know about the "sun dagger" on nearby Fajada Butte, a spiral petroglyph carved into the rock through which a beam of light transverses on the summer solstice and also records the winter solstice and the autumnal equinox. The sun dagger is a beautiful example of the understanding the people of Chaco had of the seasons and the heavens. In fact, archaeologists now feel the structures in Chaco Canyon were built in part as interpretations of that reverence, manifest in stone.

Though by modern standards Chaco seems remote, the people who lived here probably never felt that way. Chaco was a cultural, commercial and ceremonial center made up of several villages among larger pueblo structures, known as great houses, which probably served as public buildings. It was at the heart of an array of more than 150 sites connected by a vast road network. (Sites associated with Chaco outside the canyon are known as outliers—we'll visit a couple later in the detour.) That network ran through the San Juan Basin in New Mexico and into Arizona, Colorado and Utah and was part of an even larger trade network that extended into present-day Mexico.

Several of the Pueblo Indians of the Rio Grande trace their ancestry here, as do the Zuni, Acoma, Laguna and Zia tribes. The Navajo and Hopi have their own connections as well. Archaeologists believe that different cultural groups stayed here at the same time, and the structures were used and reused, built and remodeled through several construction phases over time, possibly influenced by architectural styles from places like Mesa Verde to the north. According to Pueblo traditions, the people who came here did so as part of a larger migration through the Southwest. To many Pueblo people, this is a sacred place, still very much alive.

From a vantage point along the interpretive trail through Pueblo Bonito, you can see across the pueblo structure itself, over the two open plazas and

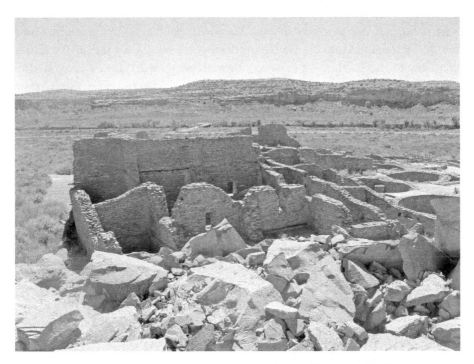

The sheer size of the structures at Chaco Canyon impresses. *Photo by David Pike.*

the kivas and across the canyon. The perspective gives you a greater sense for the scale of the structure. For another perspective, follow the trail inside the pueblo itself, where you can move through the interior rooms, feeling the stone all around you, sensing the depth of the spaces and wondering at the lives of the inhabitants.

The architecture of Chaco, with its buildings often aligned to cardinal points, reflects the engineering skills of the people who lived here, as well as their knowledge of the sky and the seasons. One room at Pueblo Bonito contains a window through which sunlight passes into the adjoining room on the day of the winter solstice. The most common masonry style found in the great houses is known as core-and-veneer. Sandstone blocks were used to create two parallel walls (the veneer) with the stones mortared together with mud. The space between the walls (the core) was filled with rubble to create a thick, sturdy wall. Keep an eye out for T-shaped doors. Because of their placement in the structures and their relative rarity among door types, archaeologists believe these doors may have served a ceremonial purpose.

The road network that connected Chaco with outlier pueblos was another marvel of engineering, but unlike modern roadways, Chacoan roads didn't conform to the earth—the earth conformed to them. When a canyon wall blocked a direct path, the people of Chaco simply kept building; they carved staircases into the cliff walls, some at extremely steep angles. One of these staircases is visible at Hungo Pavi. You'll see a second at a pullout on the road as you return to the visitor center. It's staggering to consider them in use.

The great kiva at Casa Rinconada will inspire awe as well as a sense of scale. Design at Chaco was purposeful. Archaeologists believe this was a community kiva, built to accommodate a large number of people and likely used for ceremonial purposes. Several smaller Chacoan villages were built near it, some of which have not been fully excavated.

You can see Fajada Butte from almost everywhere in the park, but the best place to take it in is at a small viewing area just west of the visitor center. Through the telescope, you can view a close-up of sun dagger rock. During the summer solstice, a ray of light passes through this rock and pierces the middle of a spiral petroglyph on an adjacent rock wall. During the winter solstice, two rays of light bound the outside edges of the spiral.

In 1987, the United Nations Educational, Scientific and Cultural Organization (UNESCO) named Chaco a "World Heritage Site"—a list that also includes the Great Pyramids in Egypt and the Acropolis in Greece—for its importance to the history of the world. You'll understand why when you visit. Contemplate that as you leave the site. But stay focused; the road out of Chaco isn't any better than the road in. Take it slowly.

We have Manifest Destiny to thank for the creation of Bloomfield. In March 1874, the U.S. government set aside land in this part of the Four Corners as a reservation for the Jicarilla Apache tribe. The appropriation didn't last. Anglo settlers clamored for the land themselves, eager to build homesteads and farms along the San Juan River. In 1876, the set aside was taken back from the Jicarilla Apache Indians and opened again to settlement, while a new reservation was established about fifty miles east, centered in Dulce, New Mexico, where the Jicarilla Apache Reservation remains today.

Bloomfield took shape soon after, with early settlers making good on the name by planting fields of vegetables and fruit orchards. One of those settlers was George Salmon. He and his family set up a homestead near the San Juan River, added a bunkhouse and corral and planted a small fruit orchard. It would have been a typical homestead were it not for one distinguishing feature: it included a large masonry pueblo, once home to a

community of Ancestral Puebloan people, now unoccupied and partially collapsed. The Salmon family protected the structure from pot hunters and other vandals, and today the site bears their name: Salmon Ruin.

Salmon Ruin was an outlier in the Chaco system, and you'll see similarities between it and the great houses at Chaco, including the core-and-veneer mortar work. The people at Salmon began construction on the structure sometime in the eleventh century, erecting a two-story building with more than 170 rooms. Salmon has its own great kiva as well, along with other, smaller kivas in the structure itself. A road ran between the pueblo and Chaco, about ninety miles to the south.

Salmon saw two occupations: the first lasting until about AD 1130, the second beginning around AD 1185. During the second occupation, the new residents—who may have arrived from Mesa Verde or other villages to the north—modified rooms to serve new purposes and abandoned other rooms outright.

Salmon Ruin also includes "Heritage Park," where replicas of traditional structures used by native people throughout the Four Corners and surrounding areas are displayed. You can see a *wikiup* used by the Jicarilla Apache Indians, a *hogan* used by the Navajo and a *ramada*, or shade structure, very likely similar to ones that would have been in use at Salmon to provide shade to people sitting or working on the plaza.

A short distance north is the second outlier on this detour, preserved at the Aztec Ruins National Monument in Aztec. One of the outstanding features that you won't see anywhere else is a fully reconstructed grand kiva in the plaza of the west ruin. Light falls softly through the doorway onto the dirt floor below, the chamber is cool and tranquil and a sense of beauty and spiritual significance prevails.

The pueblos at Aztec contained multistory structures, masonry walls, kivas and plazas. Construction began in the late eleventh century, and, like the structures at Chaco and Salmon, the pueblo was modified over time. The great house known as the West Ruin is the most fully excavated; it is the part of the site open to the public today. Standing three stories tall and containing five hundred rooms, it rivaled the great houses at Chaco.

The name Aztec came from early settlers in the area who incorrectly ascribed the structure to the ancient Aztecs of Mexico. The name stuck and, in fact, was transferred to the modern city that developed here as well. That city began around 1879; at the time, the boundary of the Jicarilla Apache Indian Reservation was redefined and the land opened to settlement. Today, Aztec is the county seat of San Juan County. You can learn more about the

early history of the town and visit replicas of a frontier church, a blacksmith shop and an old school, among other structures, at the Aztec Museum and Pioneer Village in the former city hall building.

While there, pick up a copy of the historic Aztec self-guided walking tour and learn the histories of the buildings that make up the downtown commercial district. Although repurposed over the years by new occupants (sound familiar?), the vintage buildings along downtown Main Street remain true to their historic selves. The tour includes the old American Hotel built in 1906 to coincide with the arrival the previous year of a branch line of the Denver and Rio Grande Railroad known as the "Red Apple Flyer" from Durango, Colorado. The railroad opened Aztec to the outside world, and many of those who came to visit stayed at this hotel. Today, though the branch line is gone, the American Hotel survives as an apartment building.

Look also for the block of buildings from 105 to 109 South Main Street. The building on the right (looking from across the street) is the Neoclassical-style Citizens Bank Building, the first bank in Aztec, opened in 1910. Next to that is the Odd Fellows Hall, built in the Italianate style and still in use. In listing it in the National Register of Historic Places, the National Park Service said this building "reflected the optimism which pervaded Aztec just before the arrival of the railroad" and called it one of the best examples of Italianate style in the state. And beside that is the Townsend Building, built by butcher Fred Townsend in 1910. You might even take in a movie at the historic Aztec Theater, built in 1927. The builder, J. Oscar Manning, had a sense of humor. His original name for the place? The Mayan Theater.

NORTH-CENTRAL NEW MEXICO
— DETOURS —

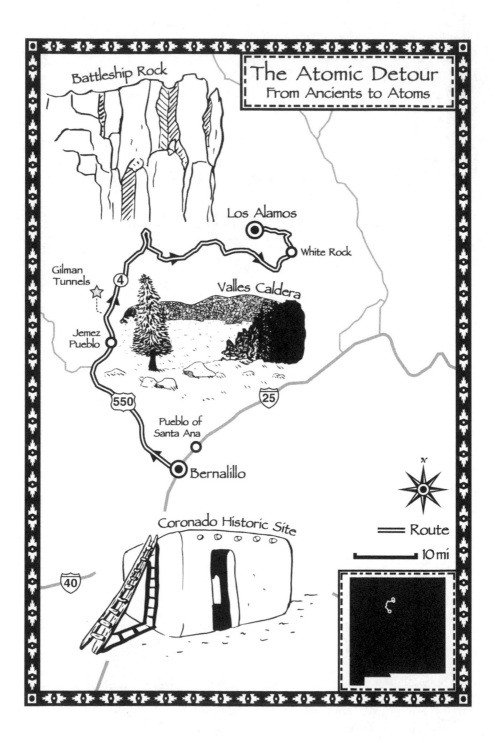

Battleship Rock

The Atomic Detour
From Ancients to Atoms

Los Alamos

White Rock

Gilman
Tunnels

4

Valles Caldera

Jemez
Pueblo

550

25

Pueblo of
Santa Ana

Bernalillo

N

Coronado Historic Site

Route

10 mi

40

DETOUR 3

THE ATOMIC DETOUR: FROM ANCIENTS TO ATOMS

FROM BERNALILLO TO LOS ALAMOS

If you find a corner in New Mexico, chances are there's history just around it. Given that crowded space, it's inevitable that juxtapositions occur. Take this detour, for example. One minute you're climbing ladders high into ancient cliff dwellings used by ancestors of today's Puebloan people; the next you're investigating developments that ushered in the atomic age. This part of New Mexico was a vast crossroads, a place where civilizations met and merged. Sometimes, the places where those cultures interacted are preserved, as you'll see at Coronado National Historic Site and Jemez Historic Site. At other times, it's more a feeling that lingers in the air, the sense of an impending corner with a fresh batch of history waiting to be discovered around it.

Detour Length

106 history-packed miles

What's in It for You

- Visit the ruins of a pueblo associated with conquistador Francisco Vásquez de Coronado
- Stand in the caldera of an ancient super volcano

- Climb ladders high into ancient cliff dwellings
- Walk the streets of a top-secret city where scientists ushered in the atomic era

More than four hundred years ago, two separate and very distinct cultures met near modern Bernalillo, making it a great place to start this detour. For centuries, Native Americans had subsisted in this area, making their homes along the Rio Grande, farming corn and squash, crafting fine pottery and jewelry, practicing their beliefs through ceremonies that carried deep spiritual meaning. The Spanish, meanwhile, set out to explore this new land from their stronghold in what is now Mexico, then part of Spain. At first, they were intent on finding fortune, chasing a legend of golden cities deep into these interior lands. Later, they built settlements, started missions and gained new converts to their faith—extending the Spanish empire in a new land. The confluence of these two divergent cultures forever altered the course of New Mexico history.

The story has multiple beginnings, but we'll start with Spanish conquistador Francisco Vásquez de Coronado. His mission into New Mexico in 1540 began with a bit of hearsay: he was leading an expedition of four hundred soldiers, priests, slaves and livestock from Compostela, Mexico (then part of Spain), northward, intent on investigating rumors of remarkable cities of gold. These rumors came from reports brought back by an earlier expedition, that of Álvar Núñez Cabeza de Vaca, who had shipwrecked off the coast of Texas but had nonetheless returned with fanciful tales from native people he encountered of seven remarkable cities made entirely of gold—the Seven Cities of Cibola. He hadn't actually seen those cities, but he'd been assured they existed in the unexplored regions of what is now the southwestern United States.

Coronado and his men made good time. They reached New Mexico later in 1540, first encountering native inhabitants at what is now Zuni Pueblo in the northwestern part of the state. Later, they came to the Rio Grande Valley, where they found a dozen Tiwa-speaking Indian villages stretching from Bernalillo to just south of Albuquerque. They called the region the Tiguex Province, a name that likely came from their pronunciation of the Indian name. Coronado set up a provisional headquarters in one of the pueblos of the Tiguex Province and spent the winter there. We don't know the specific pueblo for certain, but what we do know is that neither side of the cultural divide would ever be the same afterward.

The northernmost of the pueblo villages Coronado encountered was known as Kuaua. Its partially restored structures are preserved today as the Coronado Historic Site. Although the site is named for Coronado, its chief attractions are associated with Kuaua Pueblo, originally constructed around 1300. Today, new adobe walls have been built to show the size and scope of the original pueblo—an imposing, multistoried structure that once held more than 1,200 rooms and featured 2 plazas. (As is standard archeological practice, the original pueblo has been backfilled for preservation.) You can climb a ladder into one of the reconstructed kivas, or ceremonial rooms. Known as Painted Kiva, this square room contains beautiful murals on its walls, reconstructed in 1938 from the originals. Additional layers of murals once existed beneath these—a set of them has been preserved and is on display in the visitor center.

The nearby Santa Ana Star Casino and the Hyatt Regency Tamaya Resort and Spa are both owned and operated by the Pueblo of Santa Ana. Through a number of unique and creative experiences, the resort offers a venue to learn about and experience the history and culture of Santa Ana Pueblo and its people. You'll find dances on the weekends, demonstrations of traditional bread-making techniques, storytelling, beautiful art made by contemporary Pueblo artists in the public areas of the hotel and even trail rides through parts of the Santa Ana Reservation. The cultural learning center at the resort offers exhibits on the history of the Pueblo, traditional dress and Pueblo culture. The Stables at Tamaya also operates the nonprofit Tamaya Horse Rehabilitation Program, nurturing abused, abandoned and other rescue horses. You can visit the stables where the horses are kept at the resort, or if you take one of the trail rides, you'll probably be riding one. While the original pueblo of Santa Ana itself is used chiefly as a ceremonial site, it is open to the public on the Santa Ana Feast Day, July 26.

During their 1540 expedition, the Spanish noted seven individual but related pueblos near the southern base of what are now the Jemez Mountains, which they called the *Provincia de los Hemes*. That name survives today as Jemez (pronounced HAY-mez), although the people of the Pueblo of Jemez call their home Walatowa. The Jemez people have been living at the present location of their pueblo since the sixteenth century. Linguistically, Jemez is unique among the pueblos of New Mexico; it's the only one in the state whose residents speak the Towa language. Before 1838, the Pueblo of Pecos, southeast of Santa Fe, was another Towa-speaking pueblo, but as the population there dwindled, the residents joined Jemez Pueblo.

DETOUR DÉJÀ VU

Pecos National Historic Park, visited in the Rut Nut Detour (Detour 6), preserves the site of the pueblo of Pecos, whose residents also spoke the Towa language before leaving to join Jemez Pueblo.

You can learn more about Jemez Pueblo at the Walatowa Visitor Center and Museum, which includes displays on the beautiful pottery created by the artists and craftsmen who live here. You'll find a replica of a prehistoric Jemez field house—a small structure used during planting and harvest time—outside the museum. If you'd like to hike within the Jemez Reservation, you can do so only with a Jemez guide. Inquire at the museum for more information. In addition, a few of the feast day dances held by the pueblo are open to the public. They include the San Diego Feast Day on November 12 and the Guadalupe Feast Day on December 12.

Before hitting the road, we recommend you indulge in the delicacies offered by the vendors across from the visitor center. The sellers are usually residents of Jemez, and their food includes traditional meals served at the pueblo. Where else can you eat green chile stew and fry bread surrounded by beautiful red rock bluffs?

A quick side trip along Highway 485, which winds along the side of Guadalupe Canyon and the Guadalupe River, will bring you to two tunnels cut into the side of the mountain. The Gilman Tunnels are all that remain to testify to the presence of the now defunct Santa Fe Northwestern Railway. The line, built in 1922, served the logging camps in the Jemez, delivering raw lumber through Guadalupe Canyon east to the company-owned sawmill operations at Bernalillo. The line was named to honor one of its founders, William H. Gilman, who served as vice president of the line. At the outbreak of World War II, operations on the line ceased.

The village of Jemez Springs wants to be friends right away, with upscale galleries, inns, gift shops and coffee shops lining the road. As the name suggests, this is a hotspot for natural springs, and you can find spas in the area if you want to indulge a bit before moving forward. It's a great way to unwind the tensions of hard detouring.

The Jemez Historic Site preserves a portion of one of the original pueblos of Jemez, known as Giusewa. The ancient pueblo is no longer inhabited, but it remains a place of great historic and spiritual significance to the people of Jemez. Towering over the low walls of the original pueblo are the sandstone and adobe walls of the mission church of San Diego de Jemez, erected in

1621 under the direction of Spanish priest Geronimo Zarate Salmerón. The church saw service for only two decades. By 1640, the mission had been abandoned, as the priest's duties were diverted elsewhere. Over time, as attacks by Navajo Indians took a toll on the village, the pueblos of Jemez concentrated and took shape in their present location at Walatowa. A walking trail leads through the site today and includes stops at the earthen mounds that cover the original pueblo structure, the *camposanto* (cemetery) and one of the pueblo's kivas.

Soon you'll push deeper into the beautiful Jemez Mountains and the Jemez National Recreation Area, which share their name with the pueblo itself. The mountains were formed from a chain of violent volcanic eruptions that started about eleven million years ago. Among the many wonders to be found here is Soda Dam, a natural rock dam on the Jemez River formed from the accumulation of calcium carbonate (the soda) from geothermal springs here. Check out Battleship Rock, an aptly named precipice that dominates the view like the prow of a battleship sailing through a sea of trees. These are only two of the wonders tucked away in these mountains.

One wonder isn't so much tucked as sprawled—the beautiful Valles Caldera National Preserve. (Enjoy the view first at the pullout at mile marker 39, then proceed to the visitor center.) Even if you're not a geology whiz, it's easy to see what this place is all about. It's a collapsed vent, known as a caldera, from an ancient volcano. Within the thirteen-mile-wide caldera are a number of large meadows forested with ponderosa pine, spruce and fir trees. The largest of these is the Valle Grande, or Big Valley. The first modern settlers in the valley were the Baca family, drawn to settle here thanks to an 1841 land grant. The Bacas raised sheep, and you'll still find some of their ranch structures standing. In 2000, the U.S. government acquired the land, bringing it into public ownership.

Just as the Valles Caldera preserves the entwined history of human occupation and natural beauty, so does Bandelier National Monument. This was home for the Ancestral Pueblo people, who may have lived here as early as AD 1100. As smaller groups merged in this area, they began to build more permanent dwelling structures, starting around the mid-1300s. They flourished for about two hundred years, reaching a peak population of five hundred people, subsisting chiefly on farming and participating in a vast trade network that reached into present-day Mexico. Preserved and interpreted at the monument today are structures in and along the steep walls of Frijoles Canyon, as well as the low walls of an ancient pueblo known today as Tyuonyi at the base of the canyon.

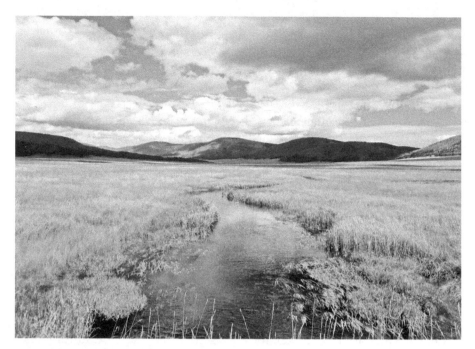

One of the many beautiful views to be found at the Valles Caldera National Preserve. *Photo by David Pike.*

A 1.2-mile trail leads from the visitor center to the pueblo and along the sheer cliff walls. The carved steps and narrow passages of the trail will give you a good sense of how it must have felt for the people of Bandelier to live a life so closely connected with the canyon itself. Petroglyphs are visible along the canyon walls, including images of animals and geometric shapes, the true meaning of which remain the secret of the canyon itself. The trail will take you up along the face of the cliff wall through staircases carved in the rock and very tight passages. You can climb ladders into holes dug into the volcanic tuff of the cliff wall—known as *cavates*—that often had stone rooms fronting them on the canyon walls. More adventurous detourers will want to visit Alcove House, where four ladders and a managed fear of heights are all that stand between you on the ground and you high up on the cliff face inside a large cave, looking at other visitors down below trying to talk themselves into making the climb. Those sturdy wooden ladders are steep, long and hot to the touch in the summer, but the view from the top is stunning. This cave may have served as a home to up to twenty-five people. Inside is a small kiva, partially reconstructed. Even on busy days, there won't be many people in the cave at one time, so go if you can.

A lesser-known area of Bandelier lies up the road at Tsankawi, where you'll find the Ancestral Puebloan village by the same name, trails carved into the rock and glorious views. Tsankawi offers a different experience than that at Frijoles Canyon. At times, the one-and-a-half-mile trail almost disappears into the surface of the rock, leaving you as pathfinder. You may find yourself out of view of any other person here, alone among the ancient pathways worn into the rock.

As you ascend the Pajarito Plateau toward Los Alamos, look to the right for a small pulloff and memorial just before reaching the top of the hill. This is the Clinton P. Anderson Overlook (east side of the highway just before ascending the top of the hill). Anderson was born in South Dakota in 1895 but came to New Mexico as a young man seeking relief from tuberculosis in the dry climate. He served in the U.S. House of Representatives starting in 1941, then did a stint as secretary of agriculture from 1945 to 1948, then returned to Congress as a senator for New Mexico from 1949 until 1973. The outlook is a fitting tribute to Anderson, who was an advocate for strong environmental policies and a major force in the passage of the Wilderness

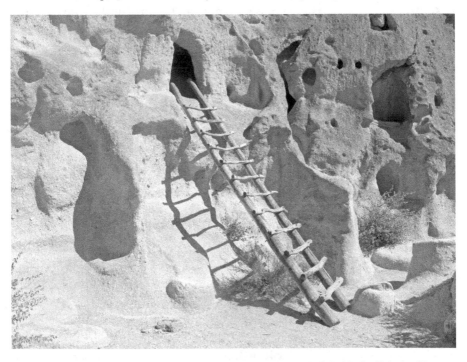

Bandelier offers a glimpse into the lives of the earliest people to inhabit the Pajarito Plateau. *Photo by David Pike.*

Act in 1964, which established "a National Wilderness Preservation System for the permanent good of the whole people." Anderson passed away in Albuquerque in November 1975.

As you reach the top of the hill and enter the eastern limits of Los Alamos, keep a sharp eye out for the Kiwanis Entrance Park. The small park with picnic tables re-creates the front security gate you would have encountered if you worked in the secret city here in 1942. And across the street is the historic East Guard Tower from which soldiers controlled access to that city, a place critical to the outcome of World War II and the country's scientific development ever since.

Los Alamos is best known today as the home of Los Alamos National Labs and the site of the development of the first atomic bomb. The remoteness of the Pajarito Plateau made this possible. In 1917, a businessman from Detroit named Ashley Pond founded what became known as the Los Alamos Ranch School here. Pond came to New Mexico around 1900 hoping the dry air would help him recover from typhoid fever. It did, and he subsequently wanted to pass along the values of healthy living and education to future generations. His school was an exclusive private boarding school for boys, with a curriculum that included a strong emphasis on naturalism.

That same remoteness attracted the attention of the U.S. government during World War II. Officials reasoned it would provide a secure, isolated spot for work on a top-secret project. The U.S. Army built a military post and laboratory on the former ranch and homestead properties, placed the site under the direction of General Leslie Groves and assembled a team of top scientists—names like Enrico Fermi and Robert Oppenheimer—to carry out the work of what was codenamed Project Y, part of a larger effort known as the Manhattan Project. We know the results of that project today: the first atomic bomb in the world, dropped on Hiroshima and Nagasaki, Japan, in August 1945, bringing about the end of the war. But at the time, the world could scarcely imagine such a thing. The project was so secret that scientists and staff members came to New Mexico with little or no knowledge of the work they would undertake.

At the Los Alamos Visitor Center, pick up a guide to the historic walking tour of downtown and see the sites of modern Los Alamos. The tour begins at the Los Alamos Historical Museum, where you can see exhibits on the history of the Ranch School and the Manhattan Project, including a song book, photos and other Ranch memorabilia, as well as a re-creation of one of the apartments used by lab workers. Look also for the typewriter of Peggy Pond Church, daughter of Ashley Pond, who wrote poetry about

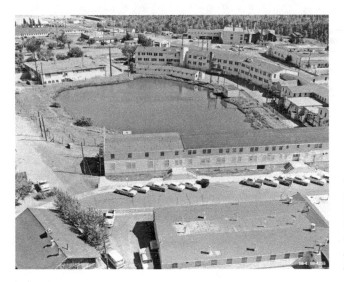

This historic view of LANL around Ashley Pond is quite different from the view you'll see today. *Courtesy of Los Alamos National Laboratories.*

the Pajario Plateau and was the author of the classic New Mexico book *The House at Otowi Bridge.*

The tour also includes sites such as Fuller Lodge, built in 1928 and designed by architect John Gaw Meem, which served as the dining hall for the Ranch School and, later, the Manhattan Project; Bathtub Row, the street along which Oppenheimer and other leading scientists had their homes (the only ones at the time that had bathtubs); the Memorial Rose Garden, where members of the wartime Los Alamos community were remembered by the planting of a rose since the community didn't have its own cemetery; and the location of the Ranch School icehouse, where the first test bomb—nicknamed the "gadget"—was assembled in 1945.

Los Alamos National Labs itself isn't open to visitors, but the lab operates the Bradbury Science Museum downtown to give visitors an idea of what goes on behind its closed doors. With its high-tech displays and modern layouts, you'll certainly feel like you're in an advanced research laboratory. The museum is packed with displays that help explain some of the science behind the development of the bomb, as well as more current experiments. A short film takes you inside the lab, which may be the closest you'll get if you don't work there, and helps make the case for nuclear deterrence. Of particular interest are the replicas of "Fat Man" and "Little Boy," early designs for the nuclear bomb. If you're opposed to nuclear weapon use or development, the museum has you covered, too. There's a display area with dissenting opinions and a logbook in which you can write your opinions and comments for others to see.

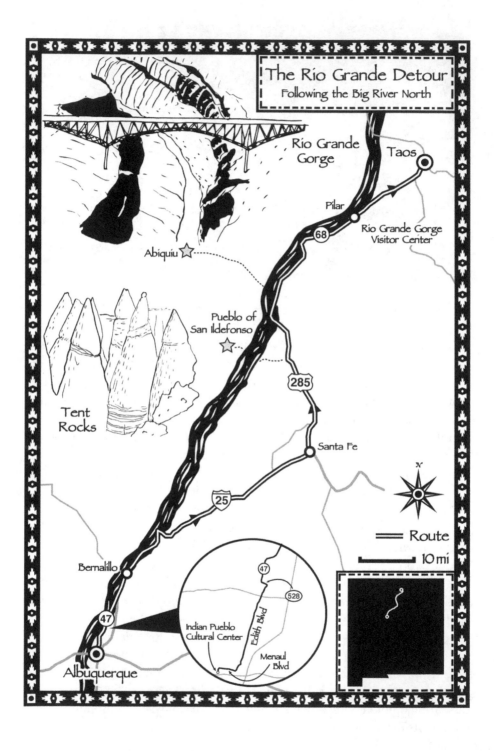

The Rio Grande Detour
Following the Big River North

Rio Grande
Gorge

Taos

Pilar

Rio Grande Gorge
Visitor Center

68

Abiquiu

Pueblo of
San Ildefonso

285

Tent
Rocks

Santa Fe

25

N

Bernalillo

47

Route

10 mi

47

Indian Pueblo
Cultural Center

528

Edith Blvd

Menaul
Blvd

Albuquerque

THE RIO GRANDE DETOUR: FOLLOWING THE BIG RIVER NORTH

FROM ALBUQUERQUE TO TAOS

Water is the ultimate pathfinder. Patient and persistent, it can apply itself to the task at hand for millennia, steadily carving a natural course across the land. And then, in turn, it offers itself as a pathway for colonists and adventurers on the move. We live by rivers, subsist through them, find adventure on them, build our history and our homes around them. That's certainly true in New Mexico, where rivers—the Canadian, the Pecos, the Gila—are at the heart of our heritage. But our most celebrated river is grand in both import and name. Simply put: without it, there would be no New Mexico. It's the big river. The Rio Grande.

DETOUR LENGTH

About 165 miles along the big river

WHAT'S IN IT FOR YOU

- Visit villages and pueblos that have subsisted along the big river's course for centuries
- Stroll through the historic, eclectic Santa Fe Plaza
- Check out the state's premier flea market
- Get an eyeful at the Rio Grande Gorge

Special Note

On this detour, you'll have the privilege of visiting some of New Mexico's Indian Pueblos. Not only are the Pueblos living and active communities, they're also self-governing and sovereign nations. Pueblo people have a strong desire to preserve their cultural heritage and have been doing so successfully for hundreds of years. For that reason, they don't share everything about their beliefs or culture publicly, and not every part of the pueblo or village is necessarily open to visitors. Today, several Pueblos are encouraging visitors to learn more about their culture and history through welcome centers, museums, walking tours and even resorts—leaving the more historic parts of the pueblo for those who live there. In this detour, we've highlighted areas that are best for visitors. We strongly advise calling ahead to determine if the pueblo is open to visitors on the day of your visit, as religious and community activities are not always scheduled in advance, and the pueblo may close to the public without prior notice. Several Native American artists sell from their homes; you can inquire at the tribal offices if they're aware of anyone selling that day. You can also ask about the Pueblo's photography rules. If possible, visit on a feast day, when each Pueblo celebrates its patron saint. You'll observe centuries-old dances and perhaps have an opportunity for a meal. We've noted those dates in this essay. Finally, please review the guide at the beginning of the book for advice on etiquette during your visit. To that advice, we add the suggestion that you approach your pueblo visit with the same spirit you approach any detour stop: participate in the experience with your heart in the lead, showing sensitivity and respect.

Start your detour at the Indian Pueblo Cultural Center in Albuquerque. Jointly owned and operated by the nineteen Pueblos of New Mexico, it serves as a welcome center and museum to introduce visitors to the heritage of the Pueblo people. Exhibits document the general history of the Pueblos, their sovereignty and culture and traditions. A film on continuous loop describes the life and art of two prominent women: Pablita Velarde of Santa Clara Pueblo, known for her beautiful paintings of Indian life, and Maria Martinez of San Ildefonso Pueblo, whose striking black-on-black pottery is instantly recognizable and regarded worldwide. The center has several murals painted by artists from New Mexico Pueblos, including one by Pablita Velarde—look for the artist herself painted among the people in the scene—and another by her daughter, Helen Hardin. Native dances are held here every weekend, and this is a good opportunity to see some fine dancers if you're not able to attend a Pueblo feast day.

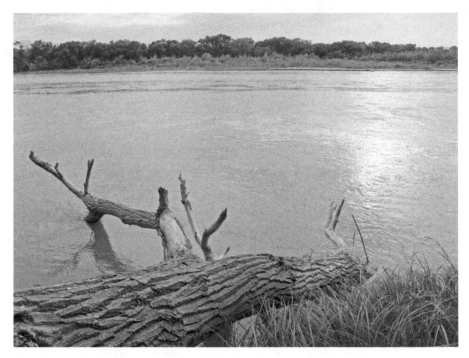

The Rio Grande, flowing strong and sure near Albuquerque. *Photo by David Pike.*

Before you hit the road, a word about a seminal event in New Mexico history: the Pueblo Revolt. In 1680, after almost one hundred years of Spanish rule—including attempts by Franciscan priests to suppress Native American religious practices—most of the Pueblos in New Mexico rose in united revolt against the Spanish. The leader of the revolt was a man named Popé of the Pueblo of Ohkay Owingeh. Popé gave the fastest runners a knotted rope to carry to each pueblo. Each knot on the rope indicated the number of days until the revolt took place. Each night, one more knot was undone, and after the last one was unwound, the revolt would begin. The revolt—the first successful orchestrated uprising against the Europeans—drove the Spanish from the province for twelve years. When they returned in 1692, several practices, including the use of forced Indian labor, were outlawed, and relations between the two groups improved.

From the Indian Pueblo Cultural Center, it's an easy few blocks to historic Edith Boulevard, which will lead you north. This is no normal street. In fact, it follows nearly the exact route of the main branch of the historic, colonial-era Camino Real. The Camino Real, or "Royal Highway," was the principal trade and colonization route between New Mexico and

the controlling authorities in what is now Mexico. From its inception with the colonization effort of Don Juan de Oñate in 1598 to the late nineteenth century and the arrival of the railroad, thousands of wagons traveled its course hauling goods, food, missives and settlers.

DETOUR DÉJÀ VU

To learn more about the Camino Real, and even parallel its course through part of the state, check out the Forgotten Highway Detour (Detour 11).

The Pueblo of Sandia, just north of Albuquerque, shares its name with the nearby Sandia Mountains. Both come from the Spanish word for "watermelon," a name that probably originated when early Spanish conquistadors saw gourds planted near the base of the mountains. The Tiwa-speaking residents of the pueblo first settled along the Rio Grande in the 1300s. The Pueblo participated in the Pueblo Revolt, burning the mission church Spanish priests had established there; the residents returned and reestablished their pueblo around 1748. The Pueblo today operates Sandia Lakes—three separate lakes, actually—each stocked with trout in the spring and winter and catfish in the summer and fall. Today, the Pueblo is known by its pre-Spanish name of Na-Fiat. The Pueblo celebrates its feast day on June 13.

It's possible that the Spanish explorer Vásquez de Coronado visited the Keres-speaking Pueblo of San Felipe as far back as 1540, but the first documented European contact was made in 1581 by Spanish explorer Francisco Sanchez Chamuscado. He called this region the Province of San Felipe—the name by which the Pueblo is known today. San Felipe Pueblo participated in the Pueblo Revolt, and sometime afterward, the people established a new home atop a nearby mesa. By 1706, they were living in their present location. Today, the Pueblo operates the large Casino Hollywood just off the interstate, where you can call Lady Luck and see if she'll answer. Don't overlook the San Felipe Travel Center as just another roadside stop-and-go. Many days, artists from the Pueblo set up booths outside the travel center to sell jewelry and other handcrafted items. The pueblo itself sits along the banks of the Rio Grande to the west; call the tribal offices to inquire if any artists are selling that day. San Felipe celebrates its feast day on May 1.

You've probably seen the beautiful *heishi* (HEE-shee) necklaces that have become closely associated with the Pueblo of Santo Domingo. These

beautiful necklaces are strung with decorative shells, turquoise or other materials, often cut into small tubular shapes. Artists from the Pueblo operate booths in the lot next to the gas station; look for heishi necklaces, jewelry and pottery. The pueblo itself has moved several times over its history due to repeated flooding of the Rio Grande but has remained strong and resilient for many generations. You might also find the Santo Domingo Trading Post interesting. It was first built in 1922 and served as a place where Santo Domingo artists could sell their wares to travelers visiting on the nearby railroad or by car. A fire gutted the structure in 2001, but it has since been restored, and it's a beautiful building to see. The Pueblo celebrates its feast day on August 4.

As the Rio Grande flows through the state, a number of dams and man-made lakes along its course manage the flow of the waters for irrigation and flood control. One of them is Cochiti Lake and Dam at the Keres-speaking Pueblo of Cochiti. The U.S. Army Corps of Engineers completed the earthen dam in 1973 and still maintains and operates it today. In the visitor center you can learn more about the geology of the Rio Grande Valley and admire a stunning view of the dam and surrounding mountains. That view includes the nearby Kasha-Katuwe Tent Rocks National Monument, a region of slot canyons and fantastically shaped rocks formed from volcanic rock and ash expelled from eruptions that also created the Jemez Mountains to the west. Two trails pass through the monument. The first leads to a small cavate and stays on level ground. The second winds through the narrow passages of a slot canyon to an overlook atop one of the cliffs. Hiking the full length of this trail involves pulling yourself up over rocky blockades in the canyon and on the cliff wall, but if you're not up for that much effort, the first part of the trail is on level ground and offers plenty of stunning views as it meanders through the canyon.

Along with beautiful vessels and jewelry, artists at Cochiti Pueblo are known for their "storyteller" figures, depicting a man or woman (and sometimes an animal) surrounded by children listening raptly to a tale. Cochiti celebrates its feast day on July 14.

The towering basalt cliff you'll ascend next on this detour is known as La Bajada, a Spanish word meaning "the descent," and clearly named by people traveling south, not north. Caravans on the Camino Real faced the cliff with trepidation. During the Spanish colonial era in New Mexico, this formidable obstacle offered a geographic demarcation line between the upper Rio Grande river (or Rio Arriba) and lower river (or Rio Abajo) districts of the state. Today, that division no longer has political value, and cars speed up

and down the hill with little effort. But La Bajada still impresses; it's not hard to imagine the challenge it presented early wagon masters.

Speaking of earlier times, for a glimpse of the past, a visit to El Rancho de las Golondrinas is essential. The name is Spanish for "Ranch of the Swallows." This historic property re-creates an authentic ranchero from the Spanish colonial era in New Mexico. It's a living history museum, and you'll meet and talk with people dressed in traditional Spanish colonial attire as you wander the site, which includes a nineteenth-century ranch house, a mill, a blacksmith shop and a *morada*, used by members of the religious group known as the Penitentes for worship. The ranch site was originally a part of a village known as La Cienega. The village was a stopping place, a *paraje*, along the Camino Real—one of the last before northbound caravans reached Santa Fe—and a reliable place to eat and water the livestock before journey's end.

The capital city of Santa Fe, founded between 1607 and 1610, is the oldest capital city in the United States. Today, it's an eclectic amalgam of old and new. It's a place where you can rub shoulders in galleries and museums with people from around the world, then step onto a side street to find yourself utterly alone. A place where old pickup trucks share the streets with the latest sports cars, where chile *ristras* hang from porches, where you can admire centuries-old architecture one moment and listen to a jazz ensemble performing on the historic Santa Fe Plaza the next. It's a city of moments. Expect to be enchanted by the smell of the air, by the crystal moon at night, by the toll of cathedral bells sounding over the town.

DETOUR DÉJÀ VU

If you want to explore the city of Santa Fe further, refer to the Rut Nut Detour (Detour 6).

The Santa Fe Opera is known internationally for the beauty of both its venue and its performances. The opera house perches on a hill on the northern boundary of Santa Fe, offering a commanding view of the surrounding mountains. The Santa Fe Opera is the legacy of musician John Crosby, who came to New Mexico from New York as a youth in the 1940s, attending the Los Alamos Ranch School for Boys. He returned in 1957, intent on founding an opera company here, which he did—the opening night performance of *Madame Butterfly* happened that same year. Since then, the company has built

a reputation as the starting point for both new operas, premiering many new shows, often written by American composers, and new singers.

Your life will be incomplete without a visit to the Tesuque Pueblo Flea Market. We're not exaggerating. Table after table after table of vendors—both from Tesuque Pueblo (which you can visit a short distance down the road) and from other local communities—gather here to sell their art, beads, crafts, food and you-name-its. As markets go, this is one of the most vibrant in the state. When you finish at "The Flea," visit nearby Camel Rock, still within the boundaries of Tesuque Pueblo. This distinctively shaped rock formation clearly resembles the neck and head of the humped desert dweller. And while camels are not native to the American Southwest (with the clear exception of the one in front of you), it's worth noting that the U.S. Army in the mid-nineteenth century did experiment with the idea of using camels to transport troops and supplies across the arid Southwest, leading to the short-lived U.S. Camel Corps. In fact, Lieutenant Edward Beale led a caravan of camels from El Paso to Los Angeles, passing by Inscription Rock in northwestern New Mexico, where members of his expedition later carved their names. The Pueblo of Tesuque celebrates its Feast Day on November 12.

DETOUR DÉJÀ VU

You can visit Inscription Rock and see Lieutenant Beale's signature, as well as those of many other intrepid travelers, on the Badlands Detour (Detour 1).

The Pueblo of Pojoaque might look very different today were it not for the actions of a few brave individuals in the early 1930s. At that time, the pueblo was mostly empty due to drought; its residents had moved to Kearns, Colorado, and other places for employment and to be with family members. But in 1932, word reached the people, including the Pueblo governor, that the Bureau of Indian Affairs was calling for Pojoaque residents to return to claim their land or it would be released to other claimants. A small number of residents—some say no more than eleven—returned, reestablished and revitalized the Pueblo. That included rebuilding some of the cultural traditions, an effort in which the Pueblo received assistance from other Tewa-speaking Pueblos nearby. The hard work has been successful: today the Pueblo has some five hundred residents living in a strong and vibrant community.

Pojoaque offers several attractions. Stop first at the Buffalo Thunder Resort and Casino. Throughout the lobby, you'll find contemporary art collected

from each of the New Mexico pueblos. It's an eclectic and fascinating mix of paintings, sculptures, pottery and other forms of art expressing the visions of a range of talented artists. The Poeh Cultural Center and Museum, founded in 1991 to help preserve the art and culture of the Puebloans, includes an immersive, three-dimensional timeline of the history of the Pueblo, featuring figures sculpted by artist Roxanne Swentzell of Santa Clara Pueblo and murals by Marcellus Medina of Zia Pueblo. The exhibit is called *Nah Poeh Meng*, which is Tewa for "Along the Continuous Path." It leads you from a darkened space representing the emergence the Pueblo people underwent to come into this world and on through a panorama of history, ending in the living room of a modern home, complete with a young boy watching TV. Add this to your must-see list. The Pueblo celebrates its feast day on December 12.

The Pueblo of Nambé is one of the six Pueblos in New Mexico belonging to the Tewa language group. The people of Nambé lived in this beautiful place for centuries before the arrival of the Spanish. The Nambé Falls Recreation Area is on Pueblo land. A long, narrow cascade of water falls from the edge of a recessed canyon ledge and stair-steps downward over three tiers to a creek below. Trails lead through the rugged setting, one to an overlook of the falls. You'll probably see some galleries and artist shops open on your drive out. The Pueblo also operates the Nambé Falls Casino on U.S. 84/285, next to its existing Nambé Falls Travel Center. The Pueblo celebrates its feast day on October 4.

The Tewa-speaking Pueblo of San Ildefonso may be best known as the home of famous potter Maria Martinez. The tradition of black-on-black pottery is carried on by many fine potters and other artists at the Pueblo today. Check in at the Tewa Visitor Center and admire some of the pottery on display there, then take a quarter-mile walking tour down one of the main roads of the pueblo, which will lead you past the plaza (access to the plaza itself is restricted), beyond an enormous broadleaf cottonwood tree, to the San Ildefonso Church. Residents often sell their own art from their homes, so look for OPEN signs as you go. In the complex that holds the Pueblo governor's office is the Maria Poveka Martinez Museum, featuring pottery made at the pueblo, including that of Maria Martinez and her husband, Julian Martinez. Members of the Pueblo also own and operate the Than Povi Gallery. In this former trading post building is an array of fabric, paintings, sculpture, pottery, jewelry and other art from all twenty-two tribes in New Mexico, with more than one hundred artists—established and up-and-coming—represented. The Pueblo celebrates its feast day on January 23.

This photo of Maria Martinez polishing pottery was taken at San Ildefonso Pueblo in 1938. *Photo by Wyatt Davis; courtesy of the Palace of the Governors Photo Archives (NMHM/DCA), Neg. No. 044192.*

Just within the southern border of Rio Arriba County is the city of Española. The name may have come from a nearby pueblo in the late sixteenth century, known to the Spanish as San Gabriel de los Españoles, or Saint Gabriel of the Spaniards.

DETOUR DÉJÀ VU

If you want to explore Espanola further, it's the starting point for the Traditions Detour (Detour 5). Take that tour to learn more about the Plaza de Española, the Misión y Convento and the historic Bond House.

A quick side trip on U.S. 84 will bring you to the small settlement of Abiquiú, well known as the home of painter Georgia O'Keeffe, who had a house both in Abiquiú proper and another at the nearby Ghost Ranch

Education and Retreat Center. Her house in Abiquiú is open for tours. While her house at Ghost Ranch is not, you can take the "O'Keeffe Landscape Tour" offered at Ghost Ranch to visit by shuttle bus the land she called "the faraway" and see some of the specific landscapes she captured in her beautiful paintings. But long before O'Keeffe arrived, Abiquiú had its own history. In the fifteenth century, Tewa-speaking Indians made a home here, and Spanish settlement began in the 1730s, with the village of Santa Rosa de Lima—the old chapel ruins are still visible along the roadway. In 1754, Governor Tomás Vélez Cachupin ordered the village, which had been abandoned due to harassment by nomadic Indian tribes, resettled. The new settlers were largely *genizaros*, Native Americans who had been captured or traded and raised in Spanish households. Visit the Pueblo de Abiquiú Library and Cultural Center to learn more.

South of Española are the Puye Cliff Dwellings. Two thousand years ago, ancestors of the people of Santa Clara Pueblo came to this picturesque cliff and surrounding area from the Four Corners region and built dwellings in the cliff wall and atop the mesa. They farmed corns, beans, squash and pumpkins in the valley floor, fired pottery, wove blankets and sharpened obsidian and other stones into spear points. A few rock outcroppings on the cliff face served as lookout towers, where the people of Puye could scan the countryside for enemies. Eventually, they left the cliff dwellings and settled into their current home, the Pueblo of Santa Clara, along the river. Santa Clara was the home of Pueblo artist Pablita Veldarde, whose mural you saw earlier in the tour. Santa Clara is also strongly associated with the traditional "wedding vase," a vase with two drinking spouts, one for the bride and one for the groom. You may find artists selling from their homes. Again, call ahead to the tribal offices to ensure that the pueblo is open on the day you plan to visit. Santa Clara celebrates its feast day on August 12.

Many of the pueblos in New Mexico have names given to them by Spanish explorers in the sixteenth century, most often from a patron saint or from the Spanish pronunciation of the Indian name. In recent years, some Pueblos have chosen to return to their pre-Spanish names. One of these is Ohkay Owingeh, formerly known as the Pueblo of San Juan. Ohkay Owingeh had existed along the banks of the river for centuries before Juan de Oñate and his colonizing expedition arrived in 1598 and gave the pueblo its former name of San Juan. At San Juan, the Spanish established the first European capital of what is now New Mexico, and the capital remained here until 1610, after which it was moved to Santa Fe. Popé, the man who organized the Pueblo Revolt, was from Ohkay Owingeh. Ohkay Owingeh celebrates its feast day on June 24.

The road begins to narrow when you reach Velarde, as it enters a canyon and follows the course of the Rio Grande north. From this point north to Pilar, the road and the river are constant and close companions. Numerous turnouts beckon, offering a break from the traffic (this is a well-traveled road). Look for the one on the west side of the highway just before Embudo—the one with the unusual concrete slab. This may seem like an unassuming roadside pullout, but a major scientific endeavor occurred along the river near here in 1888. To gather information about the strength of river flows around the country—information useful for, among other things, irrigation—the U.S. Geological Survey established gauging stations in the late nineteenth century. And the first one in the country was in Embudo, near this very spot: the Embudo Stream Gaging Station. Follow cement steps down toward the river and then a narrow dirt path to the edge of the water, where you can see the station itself on the opposite bank. The USGS operates more than seven thousand stream gauging stations in the country today, and Embudo Station, the oldest of them all, is still going strong.

Also in Embudo you'll find the Classical Gas Museum. Owner Johnnie Meier's philosophical slogan, "In Rust We Trust," gives you a clue to what's featured inside: vintage roadside memorabilia, and lots of it. Gas pumps, service station–branded road maps, even dioramas of old service stations

An 1888 photo of Camp Embudo, noted in the original photo caption as "the birthplace of systematic stream gauging." *Courtesy of the U.S. Geological Survey.*

evoke memories of another era. Some items have been restored, while others have been sculpted by entropy—but all are beautiful. Among the rare treasures here is a MALCO gas sign. MALCO was a true homegrown company, with its headquarters in Roswell, New Mexico; its refinery in Artesia, New Mexico; and its stations around the state.

If there was ever a place to admire the awesome beauty of nature, the Rio Grande Gorge Visitor Center is it. Operated by the Bureau of Land Management, it has information and displays on the Rio Grande and the gorge itself, but even if you arrive after hours, be sure to view the outdoor exhibits. And, of course, admire the Rio Grande itself—best seen from the outdoor patio, where your elevated position will give you a prime view of the true majesty of those waters as they race down the canyon. The visitor center is on the southernmost reach of the Rio Grande del Norte National Monument, a tract of land following the Rio Grande from this point north to the Colorado border, and encompassing large sections of land north and west of Taos. Officially establishing the monument on March 25, 2013, President Barack Obama nailed it when he called this land "a landscape of extreme beauty and daunting harshness."

Nearby is the small village of Pilar, where you can find artist galleries and, if your adventurous soul longs to be set free, river rafting guides to help you conquer the Class 4 and 5 rapids on the big river. The community was founded in 1795 as Cieneguilla, or "Little Marsh."

On March 30, 1854, this area was the site of a fierce battle between Jicarilla Apache and Ute Indians against the U.S. Army. That morning, First Lieutenant John Wynn Davidson led troops with the First Cavalry Regiment on patrol from nearby Cantonment Burgwin (now part of Southern Methodist University near Taos). In a canyon near here, they encountered as many as two hundred Jicarilla and Ute Indians. The official account submitted by Davidson stated that troops were ambushed by the Indians; other accounts dispute that claim and say the soldiers were the aggressors. The Battle of Cieneguilla lasted at least two hours, ending only when the soldiers retreated. Twenty-two soldiers were killed and thirty-six were wounded. The number of Indians killed or wounded isn't known for certain.

Spanish settlement in the region south of Taos in the late 1770s—a region formerly made up of lands farmed by the Taos Indians—gave rise to the community of Ranchos de Taos. Here you'll find the famous San Francisco de Asís Church, which may be the only church in the country better known for its back view than its front. It's a favorite subject of painters and photographers and has been for decades. Georgia O'Keeffe made those

rounded and buttressed adobe walls of the apse the subject of a series of paintings, the best known probably being her *Ranchos Church, No. 2, New Mexico*, painted in 1929. Ansel Adams captured it through his lens the same year. The walls have been so well maintained over the years that they look almost the same as they appeared to those artists decades ago. Quite a feat for a church built around 1815!

The village of Taos has some of that renegade spirit you often feel in mountain communities. But Taos adds to that a vibrant art scene and a deep history. That history began in the early nineteenth century as the community grew alongside nearby Taos Pueblo. It's location at the base of the Sangre de Cristo mountains made the settlement of Don Fernando de Taos, as Taos was known at the time, a mountain man's paradise. The annual Taos Trade Fair hosted beaver trappers, Spanish and Anglo settlers and Pueblo and Plains Indians, all eager to trade pelts and hides, jewelry, supplies and other wares. Taos developed in a style typical of villages of the time, with a central plaza surrounded by houses and other buildings. These structures were usually built so that all doors and windows opened into the secure plaza, providing a defense against outsiders. Historic Taos Plaza today is ringed with an eclectic assortment of shops and historic structures, including the former Taos County Courthouse.

With the outbreak of the U.S.-Mexico War in 1846, American troops occupied New Mexico and the Southwest. That year, Taos merchant Charles Bent, a former mountain man himself, was appointed the first American governor of New Mexico. But all was not peaceful in Taos; the town became the backdrop for a key rebellion against the new government. In January 1847, Spanish-speaking settlers and allies from Taos Pueblo banded together in protest—fearing, in part, a loss of their lands to the new government—and laid siege to Bent's house. Before his terrified family, the governor was killed and scalped by the insurgents, though his wife and children were spared. Other American officials were similarly killed. When American troops from Santa Fe arrived to quell the hostilities, the rebels retreated to Taos Pueblo and holed up inside the mission church. But the army broke through a wall in the church and fired on and killed the men inside. To learn more about this historic battle, visit the Governor Bent House and Museum.

Famous frontier army scout Christopher "Kit" Carson also called Taos home. Carson first came to Taos in the late 1820s and made a living as a trapper in the surrounding mountains. In 1843, he purchased a house just off the plaza, open today as the Kit Carson House Museum. Carson's treatment of the Native American population—particularly his work for the

U.S. Army forcibly resettling the Navajo onto a reservation at Fort Sumner, New Mexico—has made him a controversial figure today. He's buried in what had previously been known as Kit Carson Memorial Park, but plans are underway to rename the space Red Willow Park. Buried with Carson at the park are art patron Mabel Dodge Luhan, Governor Bent and other historical figures.

A rock on a mountain wagon path precipitated the next layer of history to emerge in Taos. The rock fractured the wheel of a passing wagon in 1898, forcing the owners, Bert Geer Phillips and Ernest L. Blumenschein, to pause on their tour of the West. Both men were artists, and the mountains, landscapes and culture they found here fired their imaginations—so they decided to stay. Joined by other artists, most from the East Coast, the group founded the famous Taos Society of Artists. Benefactress Mabel Dodge Luhan helped the art scene flourish—she invited Georgia O'Keeffe, Ansel Adams and writer D.H. Lawrence to experience Taos firsthand, invitations that enriched the artistic legacy of New Mexico. You can visit the studios of Taos Arts Colony cofounders Eanger Irving Couse and Joseph Henry Sharp at the Couse-Sharp Historic Site. The two men and their families lived on adjoining properties not far from the Taos Plaza, where they produced art featuring local residents of Taos Pueblo and beautiful southwestern scenes.

In its history, its scale and its heritage, Taos Pueblo impresses. The multistoried pueblo, resting at the foot of the Taos Mountains, is a moving sight, the brown earthen walls, protruding *vigas* and painted doorways immediately recognizable. Little wonder that the United Nations declared Taos Pueblo a UNESCO Heritage Site in 1992.

The Taos people have been living in the Taos Valley for centuries; construction of the present pueblo began sometime around 1400. Because of its geographic location as the northernmost Rio Grande pueblo, Taos became an important center of trade between the Pueblos and the Comanche, Ute and other Indians of the plains to the east. The first European contact with Taos Pueblo came in 1541, when officers of the expedition of Coronado visited on their quest for gold. After the Spanish began colonizing the state in the late sixteenth century, mission priests directed the construction of a church, San Gabriel de los Taos, in the pueblo. Residents of Taos Pueblo resisted the new religion, and when the Pueblo Revolt broke out in 1680, they killed the mission priest and destroyed the chapel. The church was reconstructed when the Spanish returned, but that church in turn was destroyed in 1847 by American troops during the

aforementioned Taos Revolt. The structure was rebuilt a few years later and remains in use today.

Tours of Taos Pueblo are given several times a day, usually led by a resident of the pueblo. You'll see the pueblo structure itself, the plaza and the mission church of San Gabriel de los Taos as you learn about the history and traditions of Taos. You can usually buy jewelry, pottery, art, moccasins, drums and other items directly from the person who made them. And if residents have opened their homes for meals, be sure to partake—you'll enjoy the food, the company and the experience in equal measure. The Pueblo celebrates its feast day on September 30.

We end this detour at the Rio Grande Gorge, a spectacular canyon cut into the land by the mighty river itself. If you're sensitive to heights, you'll want to skip the pedestrian walkway that crosses the gorge along with the highway. But if you can brave it, your reward will be an unparalleled view of the big river, silent and strong, as it flows southward, forever.

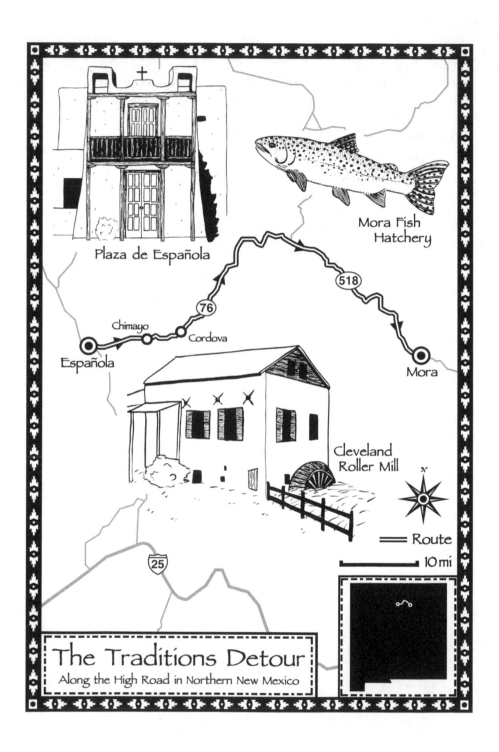

Plaza de Española

Mora Fish Hatchery

518

76

Chimayo

Cordova

Española

Mora

Cleveland Roller Mill

Route

10 mi

25

The Traditions Detour
Along the High Road in Northern New Mexico

THE TRADITIONS DETOUR: ALONG THE HIGH ROAD IN NORTHERN NEW MEXICO

FROM ESPANOLA TO MORA

New Mexico, as a state and as a state of mind, is a composite. Cultures mix and mingle here. Diversity is the backbone of the state. Yet for all the meshing of cultures that occurs, each group in the state maintains its own unique, resilient identity, proudly preserves its traditions and generously shares them with others. This detour passes through a slice of the state's cultural diversity, connecting you with historic communities scattered across the rugged face of Sangre de Cristo Mountains. Like the state itself, they present a unique blend of old and new, offer a glimpse into the traditions of colonial New Mexico and ultimately reassure us that the best of the past can endure into the present.

DETOUR LENGTH

Sixty-six tradition-filled miles

WHAT'S IN IT FOR YOU

- Explore centuries-old villages along the High Road to Taos
- Experience the moving miracle of healing dirt
- Learn about the artistic traditions of northern New Mexico, including weaving and woodcraft
- Learn the history of mill working at the Cleveland Roller Mill

If you'd been in New Mexico in the spring and summer of 1598, you would have witnessed an incredible sight: a column of soldiers, settlers, wagons and livestock traveling north from Zacatecas in what is now Mexico into the wide-open land of New Mexico. Leading the column was Juan de Oñate, who had earned the honorific title of "Don"—akin to "Lord." Sixteenth-century Spain was at the height of its power, driven to expand its empire. Oñate was leading the country's first colonizing mission in that quest.

After miles of difficult travel, Oñate and the colonists camped just north of present-day Española at the pueblo of Ohkay Owingeh. There they established the first European capital in what is now the United States. Within a year, they had moved across the river and into a pueblo known as Yunque-Ouinge. They modified the pueblo for their needs and even built a new mission church—dedicated to Saint Gabriel—where they could worship. Oñate renamed the pueblo in honor of the saint: San Gabriel de los Españoles (Saint Gabriel of the Spaniards).

Fast forward to the mid-nineteenth century, when the town of Española emerged from a collection of smaller farming villages in the valley along the Rio Grande. Much had happened in the intervening years: the capital had moved to Santa Fe, the Pueblo Revolt had exiled the Spanish from the state for twelve years, settlement had progressed along the Rio Grande and across the state, the Territory of New Mexico had become part of the United States. And the little village known as Plaza Española was on its way to becoming one of the largest and most politically important cities north of Santa Fe.

This heritage is reflected in downtown Española today at the Plaza de Española. The plaza is a collection of historic sites important in the history of the city. Chief among them is the Misión y Convento, a full-scale replica of the original adobe church built at San Gabriel de los Españoles at the end of the sixteenth century. The original church no longer stands; indeed, the Pueblo of Yunque-Ouinge no longer exists. The church was re-created from information gathered through an archaeological study performed at the former site by the University of New Mexico in the 1960s. The replica mission church tells its story clearly. With its enormous scale, straight lines and earth-tone walls, it gives you a sense of the pride the colonists had in their mission and the strength they found in their faith. Inside, you can admire painted altar screens—*reredos*—that document the history of the Española Valley, from the earliest Native American villages in the area to the present community. There's also a panel depicting some of the adobe churches found in northern New Mexico villages. Look closely, we'll be visiting a few on this detour.

The nearby Bond House Museum documents another period of Española history. This was the home of Canadian-born Frank Bond, who came to New Mexico in 1883 and established a mercantile store in Española with his brother, George. Frank began work on a house here in 1887, the same year he married May Anna Caffall. From an original two-room adobe, the structure grew into the splendid home you see today. Looking much the same as it did when completed in 1911, the house was as grand inside as out, with a kitchen, parlor, ten other rooms and a staircase leading to the second floor, all surrounded on the outside by a small park. The Bond family became prominent in Española, operating the local G.W. Bond and Brother Mercantile and other stores in northern New Mexico, raising sheep and engaging in civic affairs.

Today, as in the past, travelers have two ways to get from Santa Fe to Taos. This part of the detour follows portions of a route known as the High Road to Taos. There aren't any moral implications to the name; the route simply travels through the higher elevations of the scenic Sangre de Cristo Mountains. (The name of the mountains, translated from Spanish to mean "Blood of Christ," likely comes from the ruby glow of the morning and evening sun as it strikes the slopes.) If you're interested in the corresponding low road—again, no judgment—see the Rio Grande Detour (Detour 4).

You may already be familiar with Chimayo. The reputation of the small village extends worldwide based on its tradition of fine weavings and history of miraculous cures. The weavings you'll find in the many stores and galleries here are locally crafted by hand, often by families who have been weaving for generations. They feature motifs common to traditional southwestern fabrics, including geometric designs, repeated linear patterns of alternating colors and thunderbird figures, all represented in striking reds, oranges, blues—or, sometimes, in more muted and tranquil hues. Rightly so, blankets, shawls and other weavings from the Chimayo area appear in museums and galleries around the world. What might have been intended as a blanket, an item of warmth and shelter, is often displayed on a wall as pure art, offering a different sort of comfort.

The weaving trade alone would make Chimayo an important place to visit, but tradition here extends also to the belief that the village is the site of miraculous cures, attributed to holy dirt found in an unassuming back room of the Santuario de Chimayo. Dirt taken from a small hole in this room is said to contain healing properties when rubbed on an afflicted body part. It's a humbling thought, made all the stronger by the fact that you need to bend down to enter the low doorway into the room that holds the dirt. The adjoining sacristy is enhanced by photographs and letters on

the walls from those who claim miraculous cures. The assorted crutches, walkers and other discarded medical equipment lining the walls also offer mute, but moving, testimony.

In the Rincón de Don Bernardo Abeyta Welcome Center next to the church, you can learn more about the fascinating history of this place. The welcome center is named for Bernardo Abeyta, one of the original settlers of Chimayo in the late seventeenth century. According to legend, Abeya came upon a glowing cross near his home one day in 1810, hovering above the spot from which the holy dirt is now taken. It's also believed that a small statue of Santo Niño de Atocha wandered through the village at night so regularly that the slippers adorning his feet grew tattered. Around Good Friday, the faithful from around New Mexico make a pilgrimage to Chimayo, sometimes walking one hundred miles or more, in an expression of their abiding faith and reverence for this special place.

Just as Chimayo is known for its weaving, the village of Córdova is known for its tradition of woodworking. Fine craftsmen here have found international recognition as *santeros*—artists who create religious figures, often from wood, known as *santos*. (The word *santero* translates in English to "saint maker," and *santo* to "saint.") Woodwork from Córdova is characterized by

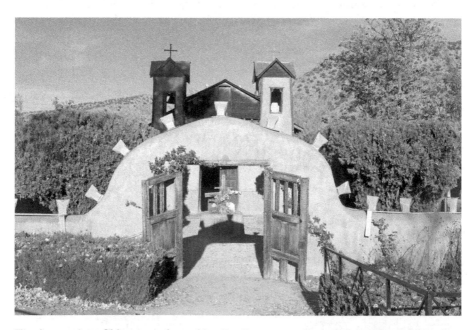

The Santuario at Chimayo, a place of healing for many, a place of beauty for all. *Photo by David Pike.*

its unadorned purity, a style that allows the essence of the wood itself to dominate. You can find woodworking shops open today, and a gallery or two as well. (Be forewarned: the roads become narrow and winding once you leave the highway!) This is an old village, founded here before 1750 and named for one of the early settlers.

At Las Trampas, you'll find the town laid out as a traditional colonial Spanish village: a plaza, often fronted by a church, with houses (usually one story, with windows facing into the plaza) along its side. The design offered protection—the walls of the buildings provided a bulwark against attacks by hostile Indians, often the Comanche or Apache. The design is found throughout New Mexico in older communities settled in the eighteenth and nineteenth centuries by Spanish colonists and also in Native American pueblos. In Las Trampas (the name is Spanish for "traps" and likely references early beaver traps in the nearby river), the magnificent Church of San José de Gracia dominates, with its towering belfries, wooden doors, balcony and protruding vigas. Construction began in 1760, less than ten years after the village itself was settled, one of a string of outlying settlements established in hopes of protecting the capital in Santa Fe. Sixteen years later, in 1776, the church was completed—the same year that the Continental Congress in Philadelphia drafted and signed the Declaration of Independence.

On the highway running past the Pueblo of Picuris you'll find some of the more interesting road signs in the state, advising motorists of bison in the area. The residents maintain a herd of buffalo on their reservation, and you're about to see them. But first, some history. The Picuris people have lived in this location since around 1300. The first meeting between the Picuris and Europeans came in 1591, when Spanish explorer Gasper Castaño de Sosa visited and left a record of the Pueblo at the time as reaching eight stories high. You can learn more about the history of the Pueblo at the visitor center, which contains a museum and a restaurant. A small fee gives you access to a walking tour, which winds up around the hill past the tribal offices where you can see, among other things, a four-centuries-old tower kiva situated on a grassy hill, as well as the beautiful church. As you leave the pueblo, drive down Buffalo Trail, and there, near where the road curves to the south to return to the highway, you'll find the buffalo herd, often grazing in the field. If you ask us, any day that includes seeing a buffalo is a good day. The Pueblo celebrates its feast day on August 10.

Cleveland was named to honor President Grover Cleveland, who was in office when the town opened a post office in 1892. The village had been settled earlier than that, though, around 1835. The Cleveland Roller Mill is

The historic roller mill in Cleveland. *Photo by David Pike.*

the thing to see here. Built in the nineteenth century, this massive mill with its water-powered wheel no longer grinds wheat into flour; rather, it serves as a museum. The Mora Valley was home to many wheat fields in the late 1800s and early 1900s, and the mill was one of several that once served this area.

Given the strength of the weaving tradition in this part of New Mexico, you won't be surprised that there's also a functioning mill operating in Mora: the Mora Valley Spinning Mill and the Tapetas de Lana Weaving Center. You can tour the mill and see the giant machines that scour, pick, blend and spin unprocessed wool into yarn on a bobbin ready to become the next blanket, shawl, rug or piece of art. Much of the equipment in the mill has been in use in one place or another for decades; in fact, some machines were salvaged from other defunct New Mexico mills. The Mora Valley Spinning Mill has operated as a nonprofit weaving center in Mora since 1998, giving local weavers low-cost access to high-quality fibers and offering a showcase for their creations.

The Mora Fish Hatchery is an overlooked Mora treasure. The grounds alone are worth a visit, with a tree-lined drive leading toward small hills dotted with piñon and juniper trees, like something out of a grand estate. There's a small visitor center with informational displays about trout rescue efforts in the Gila Wilderness after the 2012 Whitewater-Baldy fire. The museum isn't ostentatious, and you'll likely have it to yourself. A couple of fish tanks provide a steady hum and offer the ever-changing melody of flowing water—a great opportunity to experience some rare peace and calm.

If you're up for it, a short hiking trail just north of the hatchery building leads to the top of the hill behind the facility. It's a one-mile hike up and back, and the latter half of the "up" portion gets a bit steep, but from the bench at the summit you'll get a grand view of the Mora Valley that you won't see anywhere else. Be prepared to wonder at the fact that you're enjoying this view, this place of history and tradition, as if it were yours alone to discover.

NORTHEASTERN NEW MEXICO
— DETOURS —

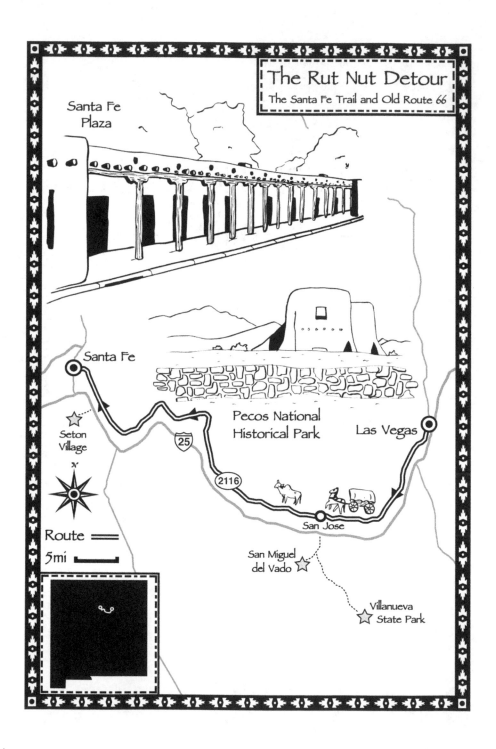

THE RUT NUT DETOUR:
THE SANTA FE TRAIL AND OLD ROUTE 66

FROM LAS VEGAS TO SANTA FE

If you've ever seen a stretch of dirt or grass worn down from human foot traffic, you've seen what planners call a "desire path." We humans make our way across the land, and when there isn't a convenient pathway to get to where we want to go, our desire leads us to stomp one out. That's essentially what happened in 1821, when traders from Missouri blazed a trail to Santa Fe so they could sell to the newly independent government of New Mexico. So the famed Santa Fe Trail was, in effect, a dusty, eight-hundred-mile-long desire path. And over it, in both directions, traveled settlers and traders, the Army of the West and, later, tourists on Route 66. Even today, it inspires wonder among those who call themselves "Rut Nuts." It's quite possibly the quintessential New Mexico detour.

DETOUR LENGTH

Sixty-nine rutted miles

WHAT'S IN IT FOR YOU

- Stand where General Stephen Watts Kearny and the Army of the West declared the Southwest officially part of the United States in 1846
- Retrace the Santa Fe Trail and immerse yourself in its history

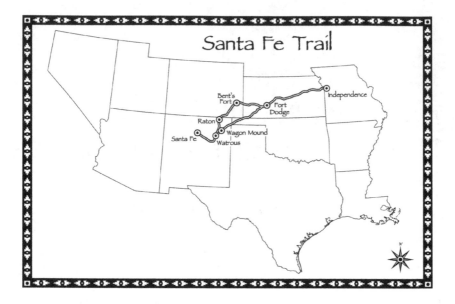

- Learn about the Civil War's Battle of Glorieta and walk the battlefield where the major engagements took place
- Explore the historic Santa Fe Plaza, western terminus of the Santa Fe Trail

One day in 1835, twenty-nine families arrived in this area to settle a grant of land awarded by the Mexican government. They gave their new home the name *Nuestra Señora de los Dolores de las Vegas*, "Our Lady of the Sorrows of the Meadows." Today we know it simply as Las Vegas.

Before the end of the century, the Atchison, Topeka and Santa Fe Railway had arrived, selecting Las Vegas as a division headquarters in 1879 and constructing a roundhouse here. The arrival of passengers and building materials by rail from the East Coast greatly influenced the growth of Las Vegas, including the very layout of the town itself. Development around the railroad east of the downtown plaza created a separate community—New Town—while the older section became Old Town. Later renamed East Las Vegas and West Las Vegas, respectively, the communities developed as separate municipalities, with their own schools and services, separated by Gallinas Creek. More recently, services have merged, and those divisions are not as relevant.

Today, the renovated train station serves as the visitor center and chamber of commerce. You'll need a map and guide if you hope to see all the historic sites in this city, and you can pick one up here. Next door is the Castenada

Hotel, a magnificent example of the Mission Revival–style elegance of a bygone era. Built in 1899 by architect Frederic Louis Roehrig of Denver, Colorado, this grand, two-story structure was a Harvey House restaurant and hotel, one of several founded by entrepreneur Fred Harvey along the route of the Santa Fe Railroad in the late nineteenth century. Harvey Houses were known for their tasty meals and high-class service and their Harvey Girl waitresses. A short walk down the platform north of the depot will give you a view of the elegant courtyard at the front of the hotel, which was under renovation in 2015, soon to reopen.

West of the depot, you'll find an interesting landmark in the small triangular park bounded by Grand and West Lincoln Streets. This is a Woman's Christian Temperance Union fountain. Founded in 1874 to promote abstinence from alcohol, the WCTU included among its awareness efforts the building of water fountains in communities throughout the country, often near saloons or drinking houses, to exalt the benefits of drinking water over alcohol. Known as "temperance fountains," they were both functional as well as decorative, containing actual working drinking fountains and sometimes even a water trough for animals. More than sixty fountains were built throughout the United States, Canada and Australia. The fountain here was built in 1896 by local artist Angelo de Tullio; it was placed near the location of several downtown saloons. The lion that crowns it might look a bit beleaguered, but he did give the park its name: Lion Park. In recent years, the citizens of Las Vegas have come together to preserve their fountain, and plans are underway for a full restoration. By the way, the Woman's Christian Temperance Union is still active; with offices in Evanston, Illinois, the organization advocates for social justice and clean living.

As you make your way downtown, stop at the resplendent Neoclassical Carnegie Library. This is one of the 1,689 libraries built in the United States in the late nineteenth and early twentieth centuries with money donated in part by steel tycoon Andrew Carnegie. Carnegie was born in Scotland in 1835 but moved as a child with his family to Pennsylvania, where he went on to found the Carnegie Steel Company and become one of the wealthiest men in America. Carnegie believed strongly in self-determination, and he saw libraries as a way that society could help individuals develop and become responsible, contributing members of society. Carnegie began his library project near home, creating one in Dunfermline, Scotland, where he was born, and later, one in Braddock, Pennsylvania, near his boyhood home of Philadelphia. Then the project expanded to local communities throughout the country. The library in Las Vegas, opened in 1904, was the first of three

in New Mexico. A second opened in Roswell in 1906 and a third in Raton in 1912. The Carnegie Library in Las Vegas is the only one of the three still functioning as a library.

The historic downtown Las Vegas Plaza is typical of Spanish colonial villages, with a central open space surrounded by buildings. It was here, on August 15, 1846, that Brigadier General Stephen Watts Kearny, leading the U.S. Army of the West to claim the Southwest—then under the control of Mexico—for the United States, changed the course of New Mexico history. Kearny ascended a rooftop on a building fronting the plaza and stated to those who had assembled below:

> *I have come amongst you by the orders of my government, to take possession of your country, and extend over it the law of the United States. We consider it, and have done so for some time, a part of the territory of the United States. We come amongst you as friends, not as enemies, as protectors, not as conquerors. We come among you for your benefit, not for your injury.*

The speech went on from there, but that was the gist of it; you can read the full text of Kearny's speech on a metal plaque at the northeast corner of the plaza. From Las Vegas, Kearny continued west, claiming the whole of the Southwest for the United States. An almost two-year battle with Mexico ensued, at the end of which Mexico ceded the land that is now New Mexico to the United States, along with that of other southwestern states.

As you leave Las Vegas and travel south, find the turnoff to NM 283 and drive to the New Mexico Historic Marker for Puertocito de la Piedra Lumbre (north side of the highway between mile markers 0 and 1). The field here looks unassuming, but if it weren't for what took place here on November 13, 1821, the Santa Fe Trail might never have happened.

A few months before that date, in September 1821, an enterprising trader named William Becknell loaded his wagons full of goods in Franklin, Missouri, and headed west. His was not a random undertaking. The Mexican Revolution was drawing to a close, and Becknell suspected that the Mexican government (which then controlled the Southwest, including what is now New Mexico) would be more open to trade with the United States (which, at the time, was the land east of New Mexico) than the Spanish government had been before it. So Becknell led a group of traders west to test his theory. Also, he needed the money; he was deep in debt at the time.

On November 13, Mexican soldiers under the command of Captain Pedro Ignacio Gallego met Becknell and company in this location. There

were some communication difficulties—Becknell spoke no Spanish—but he nonetheless managed to explain his mission. The soldiers escorted Becknell and his entourage to the nearby community of San Miguel del Vado and from there to Santa Fe. Franklin met with the Mexican governor and was no doubt overjoyed when his theory proved correct. The governor allowed the traders to sell their wares, and plans were quickly made for a return trip.

And so the famous Santa Fe Trail was born. But in reality, it wasn't particularly new. Becknell had simply followed trails already well traveled by explorers and Native Americans. Nonetheless, Becknell became known as the "Father of the Santa Fe Trail," and we're not going to begrudge anyone a good title.

Over the next six decades, two major routes developed on the trail as it divided in Dodge City, Kansas. A northern route, known as the Mountain Branch, ran northwest from Kansas into Colorado, then turned south and entered New Mexico near present-day Raton; the trip over mountainous Raton Pass gave this route its name. The second branch of the trail bore southwest, entering New Mexico in the upper northeastern corner of the state. This route became known as the Cimarron Cutoff. The two branches of the trail met near Fort Union and Watrous, north of Las Vegas.

As you continue south on the "Las Vegas Highway" frontage road, you'll closely parallel the route of the Santa Fe Trail between Las Vegas and Santa Fe. Thousands passed this way, right up until the arrival of the railroad into New Mexico in 1880. Steel rails effectively ended the need for the Santa Fe Trail.

And if that wasn't enough, you're also paralleling a portion of another historic route, that of old Route 66, aka the Mother Road, aka the best place to get your kicks. This stretch has a peculiar history: it was abandoned as an official part of the road in 1938, long before Route 66 itself was decommissioned in 1985. Originally, Route 66 in New Mexico traveled north from Santa Rosa to Romeroville (just south of Las Vegas), then went west to Santa Fe (closely paralleling the road you're now following), south through Albuquerque to Los Lunas, then west again to Laguna Pueblo. This northern twist brought the road (and travelers and their money) through Santa Fe, the state capital. But in 1938, as one of his last official acts as New Mexico governor, Arthur Hannett changed the alignment of the route to run straight west from Santa Rosa to Albuquerque and from Albuquerque to Laguna Pueblo.

DETOUR DÉJÀ VU

See the Kicks Detour (Detour 8) for more of the fascinating history of Route 66 in New Mexico and to follow another portion of the road westward from Albuquerque to Grants.

Farther down the road, near where the highway takes a turn to the west, you'll see a distinctive butte to the south. Oddly shaped landforms tend to inspire their own legends, and this one is no exception. Known as Starvation Peak, this 7,042-foot-high butte may have figured in an incident in which travelers (or early settlers, depending on who's doing the telling) along the Santa Fe Trail fled to its flat top from a hostile Indian attack. The peak's name gives away the grisly ending of this sad story. It's probably just a legend, and we'd rather focus on the butte's rugged beauty than its tragic reputation.

To this point, we've focused mostly on nineteenth- and twentieth-century history, but the story of this part of New Mexico stretches much further back in time. Native Americans lived in this region for centuries before the arrival of the Spanish in the sixteenth century. On a ridge overlooking the Pecos River Valley around the fifteenth century, Towa-speaking Indians constructed grand structures, reaching five stories high and supporting a community of two thousand people. They cultivated corns, beans and squash in the rich soil of the valley, hunted for meat, crafted fine and decorative pottery and jewelry and gathered to worship in ceremonial spaces known as kivas. You can visit some of them today at Pecos National Historical Park.

Located between the nomadic Plains Indian tribes to the east and the Rio Grande Valley Pueblo Indians to the west, the residents of Pecos were an important link in an extensive trade network that carried pottery, turquoise, buffalo skins and food across the miles. When the Spanish arrived in New Mexico in the sixteenth century, they gave the pueblo the name Pecos, likely from their pronunciation of the name by which the Indians knew their home. (When you pay your entrance fee to Pecos National Historical Park, also pay the fee for access to Glorieta battlefield; we'll be traveling there shortly.)

The lives of the Pecos residents were irrevocably changed with the arrival of the Spanish in New Mexico after 1598. As they did at other pueblos in New Mexico, Spanish priests established a mission at Pecos Pueblo to administer their faith to the Indians. Under the direction of Franciscan priest Fray Andres Juárez in 1621, Indians at the pueblo built the mission church of *Nuestra Señora de los Angeles de Porciuncula*, or "Our Lady of the Angels of Porcinuncula." Its towering, cruciform shape and twenty-foot-

thick adobe walls were intended to inspire faith. An adjoining *convento* served as the priest's living quarters and administrative offices.

The north and south complexes of Pecos Pueblo and the remains of the mission church are accessible via an interpretive trail through the park. The trail leads past the mounds of the north pueblo, the partially restored south pueblo and into a reconstructed kiva. You'll also walk through the remains of the mission church and convento. Even in decline, their beauty inspires a sense of wonder.

At the far end of the convento, along the trail leading back to the visitor center, look for the ruts of the Santa Fe Trail, which passed near Pecos; the pueblo must have been a marvelous sight to travelers. Over time, raids by nomadic Indian tribes and a decline in population weakened Pecos Pueblo. In 1838, the last residents left to join their linguistic cousins at Jemez Pueblo.

DETOUR DÉJÀ VU

You can visit Jemez Pueblo and learn more about its history in the Atomic Detour (Detour 3).

The quiet beauty of this part of New Mexico belies an action-packed history. It was here where a nearly forgotten battle of the American Civil War played out. The location of that engagement lies within the boundaries of Pecos National Historical Park and is available to visit at the Glorieta Battlefield Trail. However, the trail is not within walking distance of the main Pecos Park and requires a separate entrance fee and an access code to unlock the gate; you can get both at the Pecos National Historical Park Visitor Center. With code in hand, follow the directions the rangers will give you to reach the gate—you'll need to backtrack a bit on NM 63 and travel down a well-maintained dirt road to a parking area, where the code will get you past the gate.

From the parking area, you can follow two different trails. One is a .3-mile accessible trail that leads to a rise with an interpretive area detailing the main phase of the battle on March 28, 1862. The main trail runs 2.25 miles over Artillery Hill to Windmill Hill and back, with fourteen interpretive stops along the way that lead you in roughly chronological order through the three days of battle and the sites where Union and Confederate troops engaged each other. If you take the longer trail, look for the sign with information on Pigeon's Ranch and a photo of the site in its heyday. We'll be traveling past it later in the detour.

The battle that took place here, known as the Battle of Glorieta Pass, is often called the "Gettysburg of the West." It began when the Confederate army set out to overthrow Union forts in New Mexico, claim the territory and secure the gold from mines in Colorado. Under the command of Brigadier General Henry Hopkins Sibley, Confederate troops marched through New Mexico from Texas. They commandeered Fort Fillmore near present-day Las Cruces in southern New Mexico in early 1862 and, in February of that year, engaged troops at Fort Craig near what is now Socorro. The Union held the fort, but the Confederates managed to get past it and continue their march north. They claimed Albuquerque next, then Santa Fe, forcing Governor Henry Connelly to move the territorial capital briefly to Las Vegas.

An advance column of Fifth Texas Regiment soldiers under the command of Major Charles Pyron began to move up the Santa Fe Trail toward Colorado. Meanwhile, soldiers of the Colorado Volunteers, New Mexico Volunteers and U.S. Regulars under the command of Major John M. Chivington were moving toward them from the north, intent on stopping their advance. The two sides camped just miles apart on the night of March 25, 1862, each unaware of the other.

What followed was a battle that spanned three days, in and around the area known as Glorieta Pass. During the fighting, Union ranks were reinforced by the arrival of the main body of Colorado Volunteers under the command of Colonel John P. Slough. And on the Confederate side, essential supply wagons, some eighty in all, arrived from the south, along with an additional roster of troops led by Lieutenant Colonel William R. Scurry, who took command of the Confederates. On the third day, March 28, Confederate troops twice outflanked the Union line, forcing Slough to withdraw. Come nightfall, Scurry similarly withdrew his troops, likely sensing that he was on the verge of victory.

Scurry might have won the day's battle, but he'd lost the war—thanks to a daring move by Major Chivington and Lieutenant Colonel Manuel Chavez of the New Mexico Volunteers. While the battle raged near the Santa Fe Trail hostelry known as Pigeon's Ranch, Chivington, Chavez and troops under their command ascended Glorieta Mesa near the Confederate camp at Canoncito, intending to attack from the rear. That plan changed when they spied the Confederate supply wagons, horses and mules below them. Union soldiers raided the camp, set fire to the wagons, destroyed the supplies and freed the horses.

It was a turning point in the battle and, indeed, for the prospect of a Confederate takeover of the Southwest. Left without supplies, the Rebels couldn't continue their assault, much less their advance through the state.

Sibley withdrew his troops southward through New Mexico, dogged by Union troops along the way, engaging in only small skirmishes on his retreat to Texas. The Confederate army had been defeated, and the Southwest remained part of the Union.

As in any battle, lives were lost or changed forever. The Union army lost fifty-one men, with seventy-eight wounded. The Confederates lost forty-eight men, with eighty wounded. If you've ever visited a battlefield, whether from the Civil War or some other engagement, you know that the ground itself holds a special significance, as if the fierce energy and resulting anguish of the engagement has seeped into the dirt. Though you're in a secluded spot in the middle of New Mexico far from those parts of the country generally linked to the Civil War, and though you can hear birds singing and the passing of traffic in the distance, you can still sense the fear, the anger and the pain here. This is a solemn place.

Continue north to the town of Pecos, which takes its name from the nearby pueblo. (So does the Pecos River—and yes, it's that Pecos, as in the "Law West of the Pecos," the famous nickname adopted by western justice of the peace Judge Roy Bean.) The village was founded around 1700, a century before the last residents left Pecos Pueblo and well before the Santa Fe Trail came through.

The stone walls and stained-glass windows of Saint Anthony's Catholic Church in Pecos have a distinctive gothic appearance, a style influenced by the first archbishop of New Mexico, Jean-Baptiste Lamy. Born in France, Lamy became vicar apostolic of the New Mexico Territory in 1851. The French influence on the Catholic Church in New Mexico continued long after Lamy's death in 1878, and this beautiful church is evidence of that. Construction began around 1904 under the direction of Father Maxime Mayeux and was completed two years later, when Father Edward Paulhan was the parish priest. It replaced an earlier church built at this spot in the 1860s.

DETOUR DÉJÀ VU

The town of Lamy, south of Santa Fe, was named for Archbishop Lamy. You can visit it in the Turquoise Skies Detour (Detour 9)

Continuing west on NM 50 from Pecos, you'll soon skirt the northern edge of the Glorieta battlefield, the area you just hiked. Keep a sharp eye out for the memorials to Glorieta soldiers (between mile markers 1 and 2 on the north side of the highway). Two memorials have been placed in this small

roadside grotto; one honors the Colorado Volunteers, and the other honors the Texas Mounted Volunteers.

A short distance down the road, look for the brown adobe building with a pitched wooden roof perilously close to the highway—there's a pullout on the south side of the road where you can stop safely. This is all that remains of Alexandre Vallé's Pigeon's Ranch, the site of fierce fighting during the Battle of Glorieta on the morning of March 28 and a field hospital at the end of the battle. (If you're not sure you're there, look for the "Pigeon's Ranch Road" road sign nearby.) Born in France, Vallé grew up in St. Louis. Sometime in his history he learned about the Santa Fe Trail and came here around 1850 to establish his hostelry. It was said that his nickname, "Pigeon," came from his peculiar style of dancing. This structure on NM 50 is abandoned and you can't enter it, but it's well maintained by the Park Service. In its heyday, it was one of a handful of buildings on the property that supported more than twenty rooms in all, making Pigeon's Ranch one of the more prominent hostelries on the trail—the Harvey House of its day.

You'll have to return to the interstate briefly at Glorieta, but look for the exit to Cañoncito a short distance later and exit again onto the Old Las Vegas Highway.

The name Cañoncito should sound familiar. It was near here that the Confederates camped and Major Chivington and his men attacked and burned the supply wagons. But that's not all. Remember Brigadier General Stephen Watts Kearny and his Army of the West marching through the Southwest in 1846? To stop them, New Mexico governor Manuel Armijo ordered an assembly of citizen militiamen into this canyon to defend the territory against the invasion. But when Kearny and his men arrived on August 15, they found that the men had disbanded and Armijo had fled for safety to Mexico. Kearny passed through to Santa Fe, where, just to be on the safe side, he again declared the territory to be part of the United States and set up a new government.

A short trip west on the frontage road will bring you to the outskirts of Santa Fe, the capital of New Mexico and the namesake and endpoint of the Santa Fe Trail. You'll pass Museum Hill, named for the fine museums that can be found here, including the famous Wheelwright Museum of the American Indian, the Museum of Indian Arts and Culture, the Museum of International Folk Art and the Museum of Spanish Colonial Art. The latter features a re-creation of the interior of a Spanish colonial home with authentic furniture and art in situ. The Old Santa Fe Trail Building (across from the intersection of Old Santa Fe Trail and Camino del Monte Sol) hosts the offices of the National

One of the remaining buildings at historic Pigeon's Ranch. *Photo by David Pike.*

Park Service's Intermountain Region. The Old Santa Fe Trail Building is one of the earliest designs of National Park Service architect Cecil Doty, completed in 1937 when Doty was the regional architect for the NPS. (Doty went on to design other prominent Park Service buildings in New Mexico, including the visitors' centers at Carlsbad Caverns National Park and White Sands National Monument.) The building is done in the Spanish Pueblo Revival style, very popular in Santa Fe. Workers with the Depression-era Civilian Conservation Corps built it, including a wonderful portal-lined interior courtyard complete with fountain. Inquire at the reception desk about a staff-led tour of the building and its striking courtyard.

Just as it did for travelers on the trail itself a century ago, your trip down the Old Santa Fe Trail (through ever-narrowing and winding streets) will end at the Santa Fe Plaza. There is perhaps no more quintessential New Mexico site than this small square filled with immense history. The large pyramidal monument in the center of the plaza memorializes a number of people, including the Union soldiers of the Battle of Valverde. Another small stone memorial, placed by the Daughters of the American Revolution, recognizes the plaza as the western terminus of the Santa Fe Trail.

Still, for all its history, the plaza is a living place, filled with an assortment of people, that speaks to the vibrancy of this historic city, the oldest capital city in the United States, founded in 1607. Across the street, under the portal of the Palace of the Governors and the Museum of New Mexico, Native Americans spread their handmade jewelry and pottery on blankets for sale, while on the plaza itself, at any time of day, you'll find tourists, locals out for a break from work, street performers, law enforcement officers, city maintenance workers and others, all surrounded by the shops, restaurants, museums and galleries that make this city so distinctive. No wonder everyone was in such a hurry to get here.

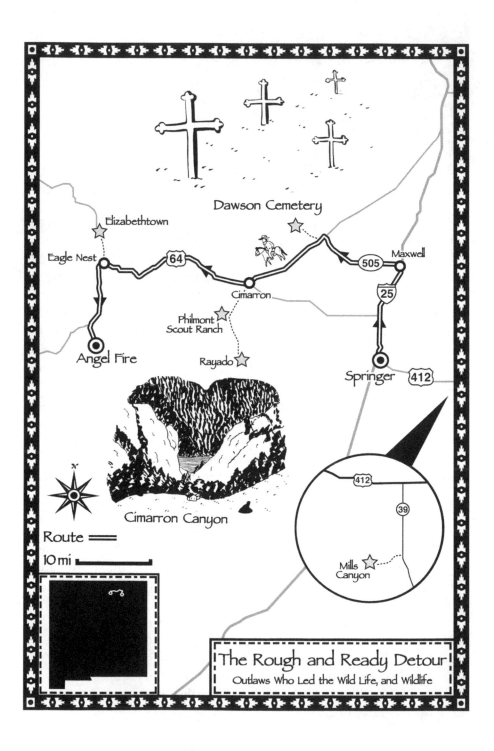

Dawson Cemetery

Elizabethtown

Eagle Nest

64

Maxwell

505

Cimarron

25

Philmont
Scout Ranch

Angel Fire

Rayado

Springer

412

Cimarron Canyon

412

39

Mills
Canyon

N

Route ═══

10 mi ▬▬▬▬▬

The Rough and Ready Detour
Outlaws Who Led the Wild Life, and Wildlife

THE ROUGH AND READY DETOUR: OUTLAWS WHO LED THE WILD LIFE AND WILDLIFE

FROM SPRINGER TO ANGEL FIRE

New Mexico is justifiably famous for towering landscapes. But it's the towering personalities of its people that have shaped the human history of the state: personalities like Lucien Bonaparte Maxwell, once the owner of more than one million acres of northeastern New Mexico, or Melvin Mills and Frank Springer, attorneys who brought the law to what was still an untamed frontier at great personal risk. It was a wild life these men lived, populated by outsized personalities on the wrong side of the law as well, like gunslinger Clay Allison. But then nobody ever said building the frontier was easy.

DETOUR LENGTH

Seventy-three rough-and-ready miles

WHAT'S IN IT FOR YOU

- See the swales and ruts of the Santa Fe Trail
- Meet the famous figures who dominate the history of northeastern New Mexico: Lucien Maxwell, the Springer brothers, Kit Carson, Melvin Mills and others
- Learn about the Colfax County War and visit the sites where hostilities played out
- Reflect on the sacrifice of America's veterans at the Vietnam Veterans Memorial State Park

The town of Springer takes its name from two of the most enterprising individuals ever to set foot in New Mexico: brothers Frank and Charles Springer. Frank came here from Iowa around 1873. A lawyer, he accepted a position as an attorney with the Maxwell Land Grant Company—more about that later, though note for the moment that the main street of Springer is Maxwell Avenue. Charles joined him a few years later, working for the same company but also finding time to launch a cattle-ranching operation, the CS Cattle Company in nearby Cimarron, which remains in operation today.

The two-story, Second Empire–style building that today holds the Santa Fe Trail Interpretive Site and Museum was the original courthouse, back when Springer was the county seat. (It won that distinction from Cimarron in 1882 but lost it to Raton in 1887.) Through its life, the building has served as the Springer Public Library and even a reform school for boys (though not at the same time) before finally being put into service in its current capacity. The museum features exhibits on the history of the Santa Fe Trail, which passed through Springer and was a major part of the history of northeastern New Mexico, serving as the chief trade route between New Mexico and points east in the nineteenth century. You can also see the old jail cell at the back of the building and the judge's chambers upstairs.

And, if you're not too queasy, there's also—believe it or not—an electric chair. We don't know if it was used in the New Mexico State Penitentiary, but yes, it presumably has been used. New Mexico abolished the death penalty in 2009.

An important incident in the history of this part of New Mexico played out on the lawn of the museum when it was the courthouse in March 1885. To understand it, we need to introduce you to Lucien Bonaparte Maxwell.

Maxwell, born on September 14, 1818, in Kaskaskia, Illinois, came to New Mexico sometime in the 1830s to trap and scout in the mountains around Taos. He didn't remain a mountain man for long. In Taos, Maxwell met a

Lucien B. Maxwell, an imposing historic figure in northeastern New Mexico. *William A. Keleher Collection (PICT-000-742-0089), Center for Southwest Research, University Libraries, University of New Mexico.*

woman named Luz Beaubien, and the two were married in 1844. Luz was the daughter of Carlos Beaubien, who was awarded a land grant in northeastern New Mexico by the Mexican governor. Actually, that grant wasn't just *in* northeastern New Mexico, it practically *was* northeastern New Mexico—and part of north-central New Mexico and southern Colorado as well. It included, in fact, a stunning 1,714,763 acres. Through inheritance, and after buying out the other heirs, Maxwell came to own the entire grant himself. He formed the Maxwell Land Grant Company to oversee activates on his land, including several ranches, mining interests and the Indian Agency in nearby Cimarron.

Maxwell was friends with frontiersman and army officer Kit Carson, and together the two adventured out with the expedition of military officer John C. Frémont in the 1840s to help open what is now the American West. Mission accomplished, both Carson and Maxwell returned to New Mexico in 1848, settling in the small village of Rayado, south of Cimarron (we'll visit there later in the tour). A short time later, Maxwell moved his mansion and land headquarters to Cimarron. In 1870, Maxwell sold his grant to a foreign investment company and moved to Fort Sumner, New Mexico.

DETOUR DÉJÀ VU

You can pick up Maxwell's story in the High Lonesome Detour (Detour 15), which includes a trip to Fort Sumner, New Mexico, where Maxwell and his family lived after they left northeastern New Mexico.

When he was president of the land company, Maxwell overlooked the squatters who had moved onto his land. The new owners, though, did not. Their attempts to remove squatters from grant lands resulted in a conflict known as the Colfax County War, with both sides contending that they were the rightful owners of the land. For their part, grant officials were in league with a group of powerful officials based in Santa Fe known as the "Santa Fe Ring."

Which brings us back to the courthouse lawn and the date of March 16, 1885. A few days earlier, area cowboys John Dodds and Sam Littrell had come to Springer and raised hell, leading to Dodds's arrest. Dodds managed to get word to his friends in Raton, who rode to Springer upon hearing the news. A shootout occurred on the lawn between sheriff deputies and the men, with two killed in the gunfire and a third, John Curry, wounded. When

Curry's brother, George, heard of the incident, he rode to Springer as well, just in time to see his brother die in the old Springer Hotel. George had earlier been involved in an incident with a militia organized by the Maxwell Grant Company; in Springer, he was arrested and jailed in the courthouse. He was set free a few weeks later after paying a small fine. Curry, by the way, overcame this somewhat sordid episode and went on to great things. He served as governor of New Mexico from 1907 to 1910, after which he was elected to the U.S. House of Representatives for one term.

One more towering personality deserves mention in the history of Springer: Melvin Whitson Mills. Born in Sparta, Ontario, Canada, on October 11, 1845, Mills moved to New Mexico as a young man to practice law. A lawyer working for truth and justice in an era of rowdy, lawless mining camps created the type of dramatic conflicts that followed Mills through his life. One of his most notorious cases was his defense of Charles Kennedy. Kennedy owned a cabin along Nine Mile Creek at the base of the Taos Mountains, not far from Elizabethtown, which we'll visit here shortly, and often hosted travelers for the evening. Oddly, travelers seldom seemed to leave the cabin. When a posse investigated, they found human skeletal remains under the floorboards, and New Mexico had one of its first serial killers. When Mills managed to get a hung jury at Kennedy's trial, a mob led by local cattleman and gunslinger Clay Allison took the reprobate (Kennedy, not Mills) and hanged him from a tree.

One more story: In 1875, Mills was accused of being an accomplice to the murder of Reverend Franklin J. Tolby, a Methodist minister from Cimarron and an outspoken critic of the Santa Fe Ring and the Maxwell Land Grant Company. The discovery of Tolby's bullet-ridden body in Cimarron Canyon on September 14 of that year—his personal belongings untouched—was the spark that ignited the Colfax County War. Mills was accused of the murder and quickly taken prisoner by a mob. He survived being lynched by ducking behind the horses of the U.S. Cavalry from Fort Union, who rode in at the last minute to quiet the dispute. A rough life for a man raised as a Quaker who didn't believe in violence.

Once circumstances settled down, Mills moved to Springer from Cimarron, and he began to sense that this community would be the new center of economic clout in the region. He built a splendid mansion here in 1877 and farther south, in what is now known as Mills Canyon, planted a stunning orchard known as the Orchard Ranch Resort, the grounds holding apple, plum, cherry and other fruit trees, along with extensive vineyards—all irrigated with waters from the Canadian River. Sadly, a four-day rainfall in

early September 1904 flooded the river and destroyed the ranch. Mills lost his mansion and was forced to live in a much smaller property next door. Approaching death, Mills asked the bank president—a friend—to let him spend his final days in his former mansion. That's where he was when he passed away on August 19, 1925.

As you've probably guessed, the small community of Maxwell is the namesake of land baron Lucien Maxwell. Founded along the course of the Atchison, Topeka and Santa Fe Railway in 1879, the original name of the community was Maxwell City, and some of the first settlers were Dutch Calvinist immigrants who built a church and sanatorium in the small community. The beautiful two-story bank building on Maxwell Avenue, which still stands, was completed in 1910 and once held the offices of the Maxwell Irrigated Land Company, a land grant subsidiary created to oversee irrigation projects on grant land. Drought forced farmers from the area, and Springer and Raton took over as the economic hubs of Colfax County, but Maxwell survives today as a small, peaceful community alongside the interstate.

Maxwell is also remembered in the name of the Maxwell National Wildlife Refuge, a 3,699-acre area of wetlands, playa lakes and shortgrass prairie. Administered by the U.S. Fish and Wildlife Service, the refuge hosts geese, American avocets, sandhill cranes and other migratory birds, as well as land-bound wildlife like turkey and deer. Dirt roads lead through the refuge with spots for parking and admiring the view. Fishing is available, and primitive campsites can be found on the west side of Lake 13.

Your trip west on NM 505 will probably be a solitary one; this is not a well-traveled road at any time of year. Watch for cattle or horses on the roadway. You'll probably also see antelope, elk and deer—even buffalo—out on the grasslands and a bit closer to Cimarron. This is the wide-open and sparse view that greeted travelers along the Santa Fe Trail as they crossed this region going south. Look for remnants of the trail between mile markers 3 and 4—most visible looking south. Don't expect to see an actual trail, though. What you're seeing here is known as a *swale*, a depression in the land made, in this case, by the heavy foot, hoof and wagon traffic over the years the trail was in operation. Later in this detour, we'll see something that more closely resembles an actual trail.

By following CR A38 five miles down a dirt road, you'll arrive at the Dawson Cemetery. While the ghost town of Dawson is on private property and you can't get to it, you don't really need to. You can actually get a much better sense of life in Dawson by visiting the cemetery, which is open

to the public. It is one of the most haunting cemeteries in New Mexico, filled with row upon row of white metal crosses, bearing surnames from around Europe, the United States and Mexico, reflecting the cosmopolitan makeup of this coal-mining town. Dawson was a company town, built by the Phelps-Dodge Corporation in 1906 on land owned by John Dawson, who had purchased the property from the Maxwell Land Grant. This was no ramshackle mining town. Dawson was magnificent, complete with a two-story mercantile store and bowling alley—even a movie theater. But it was also the site of two terrible mining tragedies, among the worst in New Mexico history. The first occurred on October 22, 1903, when coal dust ignited in Mine Number 2. That disaster claimed the lives of 263 men. The second tragedy happened on February 8, 1923, when 124 men lost their lives in an explosion in Mine Number 1. Today, miners who worked side by side in the mines now lie side by side for eternity after those same mines took their lives.

Back on the road to Cimarron, look again for signs of the Santa Fe Trail just before mile marker 312 (traveling west). You should see a more visible depression to the left, south of the highway.

The translation of the name Cimarron is *wild* or *unruly*, but there's no reason to cast aspersions on this delightful village. It was, in fact, one of the more important settlements along the Mountain Branch of the Santa Fe Trail. Travelers on the trail might camp here overnight, water their livestock (and themselves) at the town well and spend the night in the St. James Hotel.

Originally, Lucien Maxwell built his home in the settlement of Rayado, about ten miles to the south. But as Cimarron developed, he decided instead to build a home and ranch here and make Cimarron the headquarters of the Maxwell Land Grant offices. The village had been established on land that was once the homeland of the Ute and Jicarilla Apache Indians, and for a time after 1851, the U.S. government created a reservation in the area and operated an Indian Agency in Cimarron to supply the Indians with blankets and food. The village was prominent enough to be made the first county seat of Colfax County in 1872. In 1876, a few years after Maxwell had sold his grant and left northeastern New Mexico, Melvin Mills bought the grant at auction for a little over $16,000. He later sold it to Thomas Catron, another political baron in nineteenth-century New Mexico, a member of the Santa Fe Ring and also one of the state's first two senators after statehood in 1912. After that, the land fell to private hands or became public.

Cimarron is divided into Old Town Cimarron and New Town Cimarron. Let's start in New Town, at the Cimarron Visitor Center (corner

of U.S. 64 and Lincoln Avenue). Pick up a fact sheet on Cimarron history and also a guide to the walking tour, which we highly recommend. And while you're at it, walk a few steps toward the northern end of the park surrounding the visitor center and pay your respects to the man of the hour, in the form of a folk art–style sculpture of Lucien Bonaparte Maxwell. Depicted as he appeared in his mountain man days, Maxwell sits holding a rifle across his lap, ready to defend his community from all ne'er-do-wells. So e'er-do-well.

Moving on to Old Town, be sure to visit the glorious and historic St. James Hotel. This charming place was the creation of French-born Henri Lambert, who first came to New Mexico in 1863 to hunt for gold. "Like everyone else," he later said, "I wanted to become a millionaire." When that didn't pan out, he moved to Cimarron, where in 1872 he built the hotel and saloon to cater to weary travelers along the Santa Fe Trail. By then he'd also changed the spelling of his first name to a more Americanized "Henry."

Lambert was a chef who once served as a cook in the Union army for General Ulysses S. Grant and later, by his own account, for President Abraham Lincoln in the White House. Lambert could scarcely have known how his hotel and history would intersect—the result of being one of the finest hotels and dining houses along the trail. Many famous historical figures stopped at the St. James. These old rooms have given respite to the likes of southwestern lawmen and brothers Wyatt and Morgan Earp, noted for their participation in the famous Gunfight at the O.K. Corral in Tombstone, Arizona; outlaw Jesse James (under the alias R.H. Howard); and William "Buffalo Bill" Cody and Annie Oakley, both traveling with the famous Wild West Show. Not everyone who visited left; at least twenty-six deaths were recorded in the hotel, many of them either in the saloon or as a result of what happened in the saloon. For evidence, look up at the bullet holes in the roof! The St. James has a reputation for being haunted, and there's no question that it is. You need only step inside to feel strongly the wild spirits of the past that still linger here.

Other highlights on the walking tour, which takes place in the blocks around the hotel, are the former site of Lucien Maxwell's mansion; the old Barlow, Sanderson and Company Stage office; the livery stable; and the plaza and well where travelers along the trail watered their livestock and camped overnight. You'll also see the beautiful Aztec Grist Mill, built in 1864, which once served as the Indian Agency. In 1876, not long after the discovery of gold in the surrounding mountains, the Ute and Jicarilla were moved to their

present reservations in Colorado and north-central New Mexico, and the agency here was disbanded.

Next to the mill is an oblong building that once served as the Colfax County Courthouse back when Springer was the county seat. The old jail one block away remains mostly intact, the result of its sturdy construction. If it's not open, you can peer inside through the front door. Look for the stone foundation of a ten-foot-high, four-foot-wide wall that once surrounded the jail. How's that for a defense system? It's like an Old West palisade. (This joke will make sense later in the tour.)

Before leaving Cimarron, take a short drive up the hill south of the town to the Mountain View Cemetery. Here you'll find the graves of Reverend Tolby and Henri Lambert (his name is spelled "Henry" on the tombstone) and his family, not far from one another.

A short side trip will bring you to Philmont Scout Ranch. The largest Boy Scout property in the United States, Philmont hosts thousands of Scouts and Scout leaders every season. In addition to hikes, camping and other outdoor and skill-building activities, the camp also offers a training center for Scout leaders. All this was made possible by a generous gift of land to the Scouts from oilman Waite Phillips (of Phillips Petroleum and Phillips 66 fame) in 1938. The land was part of a ranch that Phillips had established here in 1926 and called the Villa Philmonte. Phillips originally called the Boy Scout camp the "Philturn Rocky Mountain Scout Camp"—Philturn being an amalgam of his surname and the Boy Scout motto, "Do a good turn daily." Later, he augmented his original 35,857-acre donation with an additional tract of land, and the Boy Scouts have added on since then, making Philmont an incredible 214-square-mile property.

Visitors will enjoy the Philmonte Museum, which offers displays on the history of the camp and on the founding of the Boy Scouts of America. The journals and much of the artwork of conservationist Ernest Thompson Seton are also kept here. He was one of the founders of the Boy Scouts, who lived in a village of his own design near Santa Fe. Beside the museum is an impressive collection of historic wagons used on the property over the years. You can also tour Villa Philmonte, inside and out, often led by a Scout. The interior is decorated with ornate wooden furniture, beautiful fireplaces and magnificent art. In several places, you'll see Phillip's ranch brand incorporated into the fixtures and art. You'll even get to see (and hear) the beautiful 1927 player piano that plays Gershwin tunes. The exterior is equally beautiful, with a courtyard and large, grassy lawn.

Just a bit farther down NM 21 is Rayado, the picturesque site where Lucien Maxwell first built a house back in 1848 before moving his family and his land grant offices to Cimarron. It's also the place where Maxwell's friend, army officer and frontier scout Kit Carson built his home. Today, a reconstruction of his home and a stage stop form the Kit Carson Museum. The museum is open during the summer and features staff dressed in period attire. Across the street is the historic adobe Holy Child Chapel. The site is on the Philmont Scout Ranch and owned by the Boy Scouts of America.

Back on the main route again, you'll soon reach Cimarron Canyon State Park, which parallels the Cimarron River on its journey through the Cimarron Range of the Sangre de Cristo Mountains. You'll soon come to the area known as the Palisades, named for the sheer cliff walls—geologically a Tertiary-period sill. The formation resembles the fence-like spikes that form a defensive palisade around a castle or perhaps a Wild West jail. (Get it now?) Look also for the trailhead for Clear Creek Trail (mile marker 292); this is the spot where Reverend Tolby's body was discovered after he was murdered back in 1875. Tolby Creek and Tolby Campground also bear his name. Cimarron Canyon State Park, which was created in 1979, also offers hiking trails, camping and trout fishing in the Cimarron River.

As you descend the western slopes of the Cimarron Range, you'll be entering the fifteen-mile-long, three-mile-wide Moreno Valley, which separates the Cimarron Range from the Sangre de Cristo Mountains. The name means "brown" in Spanish. The valley takes its name from the Moreno River flowing through it. The giant, and likely snow-crested, peak to the west is Wheeler Peak, the highest peak in New Mexico at 13,161 feet. It's named for U.S. army lieutenant George Montague Wheeler, leader of one of the four "Great Surveys" conducted by the U.S. government to map the West after the Civil War.

For shimmering Eagle Nest Lake, we can again thank the Springer brothers, who purchased land from the Maxwell Land Company and built a dam along the Cimarron River to create a dependable water source for their ranch and others in the area and to control flooding of the river. The impounded waters are today a prime recreational attraction. The dam itself, four hundred feet long, was added to the National Register of Historic Places in 1978. In the nomination for the register, the National Park Service noted that it's "one of the oldest functioning arched-type dams in New Mexico in a privately financed irrigation project." You can visit the lake and dam at Eagle Nest Lake State Park and get some fishing or boating in while you're

at it. The small village of Eagle Nest, founded in 1919 and named for the lake, offers an eclectic assortment of places to shop and dine, with ski rental stores next to espresso cafés next to tackle shops.

A quick side trip to Elizabethtown is in order if you want to visit the first incorporated city in New Mexico. It was obviously much bigger then, with more political heft—the result of its prominence as a mining town supporting burgeoning gold mining in the surrounding mountains. The man who drafted the articles of incorporation? Attorney Melvin Whitson Mills. Elizabethtown—or E-Town, as it was commonly known at the time—was named for Elizabeth Moore, daughter of Captain William Moore, a sutler at nearby Fort Union and one of the first to recognize ore and gold deposits in the mountains here. Moore became a founder of the town back in 1868. E-Town even served as the first county seat of Colfax County, but a devastating fire in 1903 wiped out a number of the original wooden buildings, and the dwindling of mining brought on a decline. Several people still live in the area, but E-Town is a regular in ghost town books. Today, a small museum recounts the history of the settlement, and the stone ruins of the old Mutz Hotel and a cemetery on the hill provide a picturesque backdrop against the Baldy Mountains. The town's namesake, Elizabeth Moore, is buried in the cemetery under the name Elizabeth Catherine Moore Lowrey.

Like Eagle Nest, Angel Fire, too, has become a resort town. Its beautiful name, according to place name expert Robert Julyan, may have come from an earlier name the Ute Indians used to describe what is now Angel Fire Mountain, perhaps a reference to the glow of sunlight on the mountain. It's the sort of place where the office buildings are all log cabins, and the main road through town is named Mountain View Boulevard. Angel Fire today is a popular ski destination.

You won't be able to miss the Vietnam Veterans Memorial State Park on the hill overlooking town, and you won't be able to forget it after you visit. The graceful, soaring form of the memorial seems more a part of the natural landscape than a man-made structure; it's inspiring from any angle. The park began when Victor "Doc" Westphall and his wife, Jeanne, set out to build a memorial to veterans of the Vietnam War soon after the death of their son, First Lieutenant David Westphall of the U.S. Marines. David Westphall and other men of his company had been killed in an ambush at Con Thien on May 22, 1968. When completed in 1971, the memorial was one of the first in the country to honor veterans of the Vietnam War. In 2005, the memorial became an official state park of New Mexico, the

The soaring chapel of the Vietnam Veterans Memorial State Park on a hillside in Angel Fire. *Photo by David Pike.*

first state park in the country dedicated to Vietnam veterans. The memorial includes a moving chapel, known as the Peace and Brotherhood Chapel, a museum, a gift shop, a UH-1D (Huey) helicopter donated by the New Mexico National Guard and the burial plots of Doc and Jeanne Westphall. Recently, the open field just south of the memorial was selected as the site of a new veterans' cemetery.

And that makes a fitting end to this detour, high on a hill, near curves of a memorial that echo the soaring mountains and overlook a land that still holds the memory of the towering personalities that shaped it.

CENTRAL NEW MEXICO
— DETOURS —

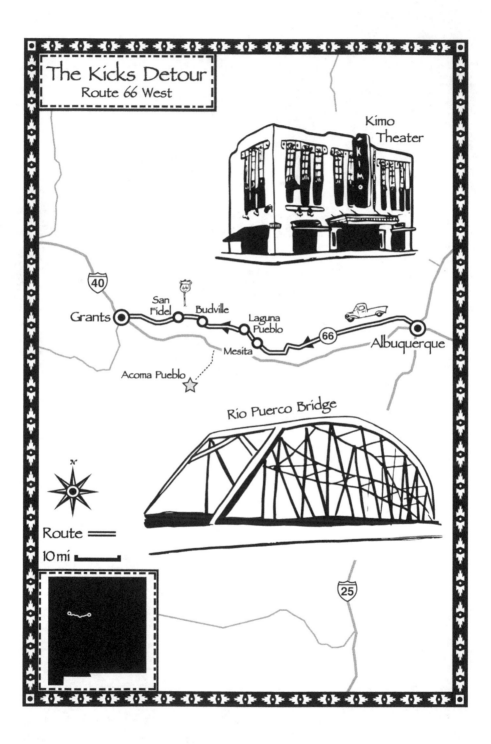

The Kicks Detour
Route 66 West

Kimo Theater

40 Grants San Fidel Budville Laguna Pueblo Mesita 66 Albuquerque

Acoma Pueblo

Rio Puerco Bridge

N

Route
10 mi

25

THE KICKS DETOUR: ROUTE 66 WEST

FROM ALBUQUERQUE TO GRANTS ALONG OLD ROUTE 66

Before there was an interstate or an Internet, there was Route 66. And like those more modern forms of connection, Route 66 connected towns and townspeople from Chicago to Santa Monica. Established in 1926, Route 66 was designed to ease east–west travel across the country by uniting existing routes into one planned "Main Street of America." It did so beautifully, keeping Americans moving for the next several decades— migrants, Depression-era refugees from the Dust Bowl, adventure seekers. In the process, it inspired its own mythology and even its own theme song, which we bet you're humming right now.

Detour Length

Round about eighty miles

What's in It for You

- Travel Central Avenue in Albuquerque, home of the Madonna of the Trail
- Relax in a park dedicated to a local Albuquerque hero
- Enjoy the neon signs, roadside architecture and landscape along one section of old Route 66
- Visit beautiful Laguna and Acoma Pueblos

All of Central Avenue in Albuquerque was once Route 66, so this tour could technically start anywhere. But we prefer to embark on detours with full bellies, so we suggest kicking off from the impressively retro Route 66 Diner. This diner, complete with neon lights, rounded corner architecture and tons of memorabilia, will give you a sample of what dining along Route 66 looked (and tasted) like. Route 66 inspired lots of roadside architecture, with service stations, diners and motels (along with some great neon signs acting as clarion calls to the weary traveler) lining the road, many flaunting their southwestern look to entice travelers.

At the Corner of Central and Forth Streets downtown, you'll get to experience a real rarity: the spot where Route 66 crossed itself. Yes, you read that right. That bit of historical engineering is the result of the actions of New Mexico governor Arthur Thomas Hannett.

When Route 66 was first designated in 1926, it ran along the existing roadways of the National Old Trails Highway and the Ozark Trail through the states. In New Mexico, that meant 66 ran from Santa Rosa, about 115 miles east of Albuquerque, north to Romeroville (just south of Las Vegas, New Mexico), then to Santa Fe, the capital city. From there, it continued south through Albuquerque and down to Los Lunas, where it turned northwest and continued west to Laguna Pueblo. If that seems like a roundabout way to run a road, it is. But the legislators in Santa Fe wanted the road, and the tourist traffic it brought, to pass through the capital city.

Then came the election of Democratic governor Arthur Thomas Hannett, who took office in 1927, a term that coincided with early plans in the country for a new road to cross the United States. Hannett served only a single two-year term, being defeated in the next election by Republican Richard C. Dillon. But in the short time between the election and the beginning of the new term, Governor Hannett made a decision that would forever alter the history of Route 66 in the state. Here's how he describes that decision in his autobiographical book *Sagebrush Lawyer*:

> *When I became Governor, I called in the highway engineers for consultation regarding a new east-west trans-continental route. A map was placed on the table and various routes were marked. I picked up a ruler and laid it on the map—the ruler pointed out a straight line from Santa Rosa to Albuquerque and on to Gallup. "Gentlemen," I said, "This will be our new highway!"*

Crews with the highway department assembled quickly and worked through the end-of-year holidays to build out sixty-nine miles of new

highway west from the city of Santa Rosa to the small town of Moriarty (about forty miles east of Albuquerque) before the end of Hannett's term. Opponents of the rerouting tried to sabotage the effort by putting sugar in the gas tanks of their caterpillar tractors and sand in their engines, forcing crews to sleep with their equipment to protect it. The new highway opened on January 3 of the following year.

The two road alignments existed simultaneously until Route 66 was paved in 1937. At that time, Hannett's straighter route became the officially designated route. Historians refer to this as the "realignment of 1937" and often speak of the old highway in terms of pre- and post-realignment.

At the intersection of Central and Fourth Streets, Northwest, the pre-alignment route running from Santa Fe through Albuquerque to Los Lunas crossed the post-realignment route running east–west from Moriarty through Albuquerque to Laguna Pueblo. A small memorial marking the site is farther down Fourth Street at Civic Plaza.

While you're headed that way, a few blocks farther down Fourth Street, you can see the Madonna of the Trail statue. Conceived by the Daughters of the American Revolution (DAR), the Madonna of the Trail statue is one of twelve identical statues located along and paying homage to the National Old Trails Road. The road was the network of trails across the country that were the source roads for Route 66. Firmly grounded in this wayside park, our Madonna peers intently forward, waiting (according to August Leimbach, the artist who designed her) for her husband to return to the blockhouse from an earlier foray. Sensing trouble, she's gathered her children and her gun and scouts the horizon.

Just down Central is the KiMo Theater, as fine an example of the Art Deco–Pueblo Revival architectural style as you're likely to see. Built in 1927, the structure is said to be haunted by the restless spirit of a six-year-old boy who died there in a boiler explosion. Inside, you'll find an unrivaled collection of turquoise-studded skulls, big-sky murals and intricately carved roof beams and pillars.

Next, find Robinson Park, a triangular space bounded by Central Avenue, Copper and Eighth Streets, Northwest. This isn't so much a Route 66 landmark, but we wanted to point it out anyway for its history. The fountain in the park is dedicated to John Braden, a man remembered today for one final act of heroism. During the territorial fair parade in October 1896, Braden was driving a wagon filled with fireworks for the celebration, when a spark caught his wagon on fire. Braden kept control of his wagon and drove

his horses away from the crowd, averting what would likely have been a terrible loss of life—but, sadly, losing his own in the process.

Tooling west on Central through downtown and western Albuquerque, the 66 landmarks—and some great neon signs—come one right after the other. Look for motels like Tower Court ("Modern in Every Detail," it once proclaimed) and El Vado Court (closed since 2005 but awaiting redevelopment). As you reach the edge of town and ascend the long, large rise heading west, you're on the matter-of-factly-named Nine Mile Hill, located nine miles from the city center. When you reach the top, cross the interstate and turn right on the frontage road—a remnant of old 66.

The Enchanted Trails RV Park and Trading Post will beckon. It can't help it: this site has been attracting travelers on Route 66 since it was first built back in the late 1940s by the Hill family. Using the coincidence of their name, they called the place the Hilltop Trading Post. When first built, however, the trading post was located on the other side of what is now Interstate 40—Route 66 being at the time a divided highway in this location—and faced north. Mr. Hill didn't like being the last site that motorists on Route 66 would encounter before Albuquerque, correctly figuring they wouldn't bother to stop but just keep driving into the city. So he dismantled the building and moved it to the other side of the road, facing south, and became the first stop motorists would encounter going westward after climbing Nine Mile Hill, when they were sure to need refreshments and gas for the journey. He also installed a petting zoo and that perennial favorite of Route 66 roadside attractions: a snake pit. (The legacy of Route 66 showmanship rests on such enterprising and creative minds.) The RV park today features a number of restored vintage trailers available for rent, including a 1963 Winnebago named "Dot" and a 69 Airstream named "Josephine."

As you reach mile marker 4, you'll encounter the aptly named Rio Puerco. The name means "dirty river" in Spanish. Here you can admire the historic Rio Puerco Bridge. There's a small parking area beside the bridge where you can leave your car and walk out across the structure itself. The bridge was constructed in 1933 using a Parker through truss design. Stretching 250 feet in a single span, you're looking at one of the longest bridges of this type in the state and one of the few remaining of this design.

The modern travel station across the road was once the site of a Route 66 trading post—owned, in fact, by Mr. Hill's brother—but it's been torn

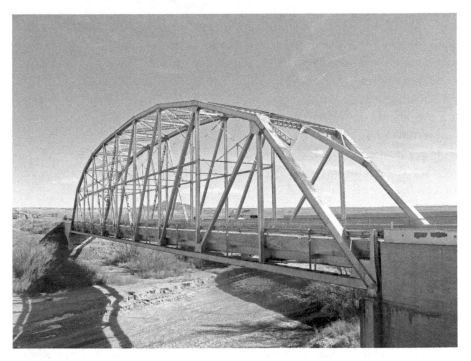

Historic Rio Puerco bridge along old Route 66. *Photo by David Pike.*

down now. The modern station is home to the Laguna Burger, a half-pound of heaven in the form of hamburger, cheese and green chile. In the interest of journalistic integrity, we tried one, and it checks out deliciously. As you savor your meal, you'll be on the eastern edge of the boundaries of Laguna Pueblo. The pueblo is home to more than seven thousand inhabitants, some of whom operate the casino and hotel you'll see on the south side of the interstate.

From here, you need to get back onto the interstate and continue west (the frontage road visible to your right is the old road, but it dead ends). The interstate runs over the route of the original 66, just as that road followed the worn path of the older National Old Trails Road.

Take Exit 126 toward Los Lunas, turn left, cross the interstate and hop on NM 6 until you reach an intersection with a railroad bridge to your right. This is Correo. The name is the Spanish word for "mail" and was selected because the post office here was the only one for miles around. You wouldn't know it today, but this humble spot looms large in Route 66 history. It was in Correo that the pre-1937 alignment road, which ran south

from Albuquerque to Los Lunas and then turned west to Laguna Pueblo, met the post-1937 alignment, which ran from Albuquerque to Laguna Pueblo and was known as the Laguna Cutoff. The pre-1937 alignment route coming northwest roughly thirty miles from Los Lunas is now NM 6. Meanwhile, the remains of the Laguna Cutoff running from the east can still be seen here but are not passable. They testify to the force of politics on detouring history.

Jack D. Rittenhouse, whose *Guide Book to Highway 66*, published in 1946, was the first comprehensive guide to the Mother Road, offered this description of Correo as it looked in that year:

> *Here there are two establishments, one on each side of a railroad, which crosses U.S. 66. Correo (Pop. 10) offers gas, groceries, small café, and a few cabins. As is the case with most roadside establishments along here, these places carry a display of curios, jewelry, and Navajo rugs.*

Return to the interstate and go about fifteen minutes to the Mesita exit. As you continue west on the frontage road from this point, you'll be traveling through what is easily one of the most beautiful sections of old 66. (Though remember you are on the Laguna Reservation; observe all posted signs.) When you round the corner past mile marker 3, Owl Rock swoops into view. The rock formation looks like a somewhat-broad-in-the-beam, giant rock owl perched along the northern edge of the highway. Old postcards of the rock show that wind and rain haven't yet taken a toll on its distinctive shape.

While you're traveling this beautiful stretch, it's a good time to think about the impact that Route 66 had on our cultural history. In recent years, the National Park Service—charged with preserving the architectural and human history of Route 66 through the Route 66 Corridor Preservation Program—has studied the experience of minorities along Route 66, finding that those 2,500 miles from Chicago to Santa Monica meant different things to different people. Before the passage of the Civil Rights Act in 1964, black motorists were likely to experience discrimination as they traveled. So they turned to guides like *The Negro Motorist Green Book*, commonly known as the "Green Book," published by Victor H. Green, which listed businesses across the country that would serve them. Often, other black families would open their homes in lieu of motels for black motorists traveling Route 66 through New Mexico. Route 66 also passed through a number of Native American communities

(both the pre- and post-1937 alignments), like Laguna Pueblo. In 2009, the New Mexico Department of Transportation and the Federal Highway Administration led a study of Native American views of the route. Though the experiences vary by tribe and pueblo, it's safe to say that Route 66 opened Native American communities to the outside world, and vice-versa, in unprecedented ways. Not surprisingly, these relationships between people and road continue to be complex, as you'd expect from a road that changed so many things about our country.

The beautiful Laguna Pueblo is the second-largest pueblo in the state, home to more than eight thousand residents living in the pueblo itself or in six surrounding villages. The shining, white St. Joseph Mission Church overlooks the community. (No photography is allowed inside the chapel.) The peaceful interior, cool and sheltering, features a long, narrow transom and closely spaced vigas—wooden logs—supporting the roof.

Down the road you'll find Budville. The most prominent feature here today, architecturally speaking, is the gas station along the highway. Budville was, as you might guess, named for a man named Bud: H.N. "Bud" Rice, who built a service station in 1927 and operated what appears to have been a vibrant towing service. (He shared a towing boundary with Mr. Hill back there at the Hill Top Trading Post, now Enchanted Trails RV Park.) Rice also served as justice of the peace, earning the title the "Law West of the Rio Puerco." Sadly, in 1967, he was held up at gunpoint while at the station and shot to death. His widow, Flossie, took over the towing company, running it until 1979. Sometimes, it's the small places that tell the most powerful stories of tragedy and perseverance.

Another grand story waits just down the road. A few miles past Budville is the Villa de Cubero Trading Post, built in 1937 by state senator Sidney Gottlieb, with small cottages behind it and the remains of an old café across the highway on the north. Those few small Mediterranean-style cottages were advertised as the "Villa de Cubero De Luxe Tourist Courts" in an old Route 66 postcard from the 1950s. It's possible one of them hosted a very renowned visitor. Legend has it that writer Ernest Hemingway stayed here for a couple of weeks back in 1951, when he wrote portions of his novel *The Old Man and the Sea*. While Hemingway scholars insist their man was in Cuba in 1952 and unlikely to be holed up in a tourist court for two weeks without anybody knowing, the story persists.

Just west of San Fidel, look for the abandoned Whiting Brothers sign—with its giant shield-shaped sign emblazoned with a red W and B on yellow background. These signs and the stations themselves were icons of Route

66. Whiting Brothers gas stations were part of a chain of service stations along the route, some locations also offering motels and grocery stores, but all promising gas for less. Though many of the stations were closed in the 1970s, a few still operate in Arizona.

The road goes through an underpass to cross to the south side of the interstate (RVs shouldn't attempt it), after which you'll reach the town of McCartys. The town also gave its name to the youngest of the lava flows composing El Malpais National Monument just west of here; the flows spread generally northward and reached almost to McCartys. The resplendent Santa Maria de Acoma Church here is a scale replica of the San Estevan del Rey Chapel at the nearby pueblo of Acoma.

A short side trip to Acoma Pueblo is a rewarding experience. Known as Sky City, the pueblo is high atop a mesa, offering a grand view of the surrounding country. A shuttle leaves from the Acoma Visitor Center to the mesa top, where the Acoma people have been living since at least AD 1150. A guide will tell you about the history of the pueblo, which includes a visit from Spanish conquistador Vásquez de Coronado in 1540 and the first European contact with the Acoma people, as well as the later contact with soldiers with the colonizing expedition of Juan de Oñate in 1598, which resulted in a battle between the Acoma people and the soldiers. You'll also visit the original San Estevan del Rey mission church and learn about its construction in 1629. Many Acomans are fine artists, and several may have their pottery and other pieces out for sale in the pueblo. When the tour has ended, you can ride the shuttle back down—or you can follow the old stairs and footpath down the butte. We don't recommend the latter option unless you have nimble footing and no fear of heights!

When the road intersects with NM 117, go right to reach Grants, the final stop on your kicks tour.

DETOUR DÉJÀ VU

To kick around Grants some more—including a visit to an underground museum—visit the Badlands Detour (Detour 1).

In some senses, Route 66 was a victim of its own success. As more travelers took to the road, traffic increased and with it congestion and safety hazards. The solution, a modern and efficient highway system

launched in the 1950s, spelled the end of the Mother Road. But Route 66 hung on in sometimes-crumbling concrete and always vigorous spirit. Decommissioned on June 27, 1985, by the American Association of State Highway and Transportation Officials, Route 66 still haunts our imaginations decades later.

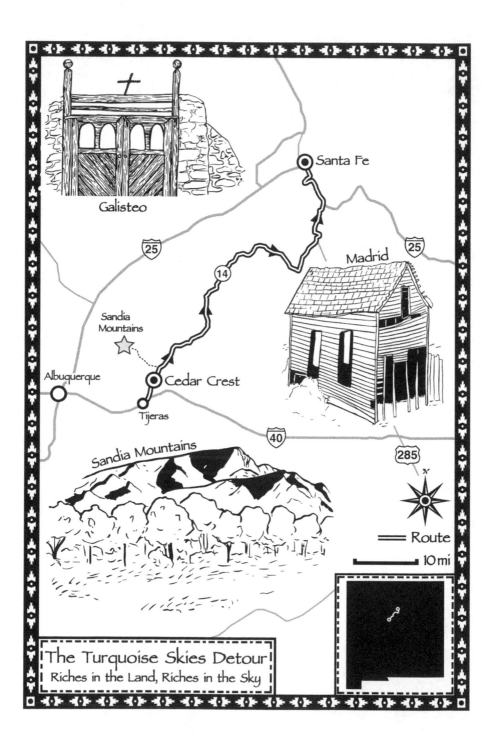

Galisteo

Santa Fe

25

Madrid

25

14

Sandia
Mountains

Albuquerque

Cedar Crest

Tijeras

40

285

Sandia Mountains

Route

10 mi

The Turquoise Skies Detour
Riches in the Land, Riches in the Sky

DETOUR 9

THE TURQUOISE SKIES DETOUR: RICHES IN THE LAND, RICHES IN THE SKY

FROM CEDAR CREST TO SANTA FE

Some states are ideal for people watching, others for bird watching. New Mexico is the perfect state for sky watching. Whether you're detouring during the clear days of the shoulder months, the crisp days of winter or the deep-heated weeks of summer, you'll have plenty of viewing opportunities for the drama overhead. On any given day, the New Mexico sky shades from deep gray to brightest crimson and everything in between, but it's the blues that predominate—sapphire to lapis to cyan to teal. And looking up is not the only way to see those colors. The earth offers them, too, echoed in rare gems uncovered in the dark New Mexico soil. So, fittingly, both earth and sky inspire the history you'll encounter on this, the Turquoise Skies detour.

DETOUR LENGTH

Some eighty miles driving and some two miles hiking, all under blue skies

WHAT'S IN IT FOR YOU

- Explore an old ghost town reborn as a counterculture artist colony
- Pet a llama
- Hike the "little hills" that were mined for turquoise by prehistoric Indians and, later, Spanish and Anglo settlers

Highway 14 was known as the Turquoise Trail long before it became officially designated as the Turquoise Trail National Scenic Byway, a name that honors the history of turquoise found along it.

From Cedar Crest on, the rugged Sandia Mountains rise to the west; you're crossing the foothills of the range's eastern face. The four-lane road narrows to two after the turnoff to Sandia Peak. As you continue north, the prominent mountains on view ahead of you and to the right are the San Pedro Mountains. On their slopes in the late 1830s, miners found placer gold deposits, which led them to establish a small mining camp known as Real de San Francisco. Today that community survives as the aptly named Golden. Golden thrived in its short heyday. Reports from the U.S. Geological Survey estimated that the haul from placer gold mining in the San Pedros was worth around $2 million. But as the mines dwindled, so did the population, and Golden today survives with a character that blends past and present. The stone building on the valley floor (off the road marked 34C) is the old Golden School. The structure is on private property but visible from the road. The stately San Francisco de Asis Catholic Church, with its deep brown adobe walls and brilliant white cross set above the front doors, makes a stirring sight perched atop a hill at the north end of town. Recently closed to visitors, the church is open for Mass on Saturdays.

Now the Ortiz Mountains become your guide as you continue north, with the highest peak, 8,897-foot Placer Mountain, recalling the origins of the communities in this area. Semiprofessional and amateur miners scoured these mountains as far back as the eighteenth century, but it was shepherd José Francisco Ortiz who found gold here in 1828. His discovery opened the San Pedros to gold mining. The mines in their slopes became known as the New Placers District, while mines in the Ortiz Mountains were known as the Old Placers District.

Some mining communities survive today only in memory. Others, though, are reborn in a different form, and it's the latter you're about to experience. Keep your eye out for the unusual sight of old mining shacks on the road ahead, many painted in bright (and sometimes) startling modern colors. And when you turn the corner and enter the small town up ahead, you'll be immediately immersed in what could be described mathematically as two parts history, one part funky. You're in Madrid. (Local pronunciation, by the way, stresses the first syllable of that name. Say MAD-rid when you're visiting or prepare to be corrected.)

Madrid (remember: MAD-rid) is a town with several histories. The first dates from the early 1860s, when a camp sprang up here to meet the needs

of miners working claims in the Ortiz Mountains. Then the Albuquerque and Cerrillos Coal Company established a company town here in 1920, focused on the coal in those same mountains, and Madrid really took off. The town flourished, with up to three thousand residents, a fire station, three boardinghouses, a company store and even a baseball team. Every house was wired for electricity, a rare luxury at the time. Indeed, Madrid became renowned for its Christmas light displays. Homes were adorned with colorful lights, and the ballpark became "Toyland," filled with lighted angels, a merry-go-round and even a giant lighted Ferris wheel.

When the demand for coal waned after World War II, the community struggled, and most of the residents left. In 1954, the townsite, including all the structures, land and mineral rights, was put up for sale for the bargain price of $250,000. There were no takers. Madrid was down but not out. In 1975, lots and houses were sold individually for $1,000 to $2,000 each—the low price and interesting historical structures attracted counterculture residents, and Madrid rose to life again. The new residents refurbished houses and opened studios and other businesses. It worked: the

This early photo of Madrid, taken circa 1898–99, shows the coal-breaking plant, the railroad and several houses for the miners and their families. *Photograph by Theodore P. Wilson; courtesy of R.J. Wilseck, New Mexico Bureau of Geology and Mineral Resources, Historic Photograph Archives, Socorro, NM 87801.*

town today flourishes as a tourist destination and perhaps one of the most interesting communities in the state.

Just as Madrid is a town like no other, the Mineshaft Tavern and the Madrid Old Coal Town Museum here is a museum like no other. It stretches across several buildings that once hosted local railroad and mining operations. The old engine repair shop is now a theater, hosting melodramas every summer weekend. Exhibits in other buildings focus on the history of the town. You can see scrip used in the company store, learn about movies filmed here and get the scoop on Madrid's connection to Thomas Edison, who made this region the backdrop for his experiments in using electricity to separate gold from harder rock. For train buffs, engine 769, a Richmond steam engine locomotive vintage 1900 is on display. This old hauler carried coal and water to and from the nearby railroad community of Waldo. The museum also offers a glimpse of how wonderful those holiday lights must have been: the Ferris wheel used in the Toyland Christmas display survives and is on display here.

Before you leave Madrid, stop at the restored Oscar Huber Memorial Ballpark (to the left just as you turn the corner to leave town). The park, built in 1928, was named for the former superintendent of mines and the man who largely oversaw the town's development. Even the field was special—it's believed to be the first baseball field in the West to have working lights for nighttime games! If you're not claustrophobic, take a seat in one of the cramped dugouts on either side of the field and contemplate the team name: the Madrid Miners.

You'll find the sleeper community of Cerrillos on the same page in the history book as Madrid and Golden. From here, miners scattered out across the hills to extract gold, silver, copper, lead and other valuable ores. But the history of mining in these hills goes much deeper (pun intended). It begins around AD 1000, when native people living and farming in the nearby Galisteo Basin were prying beautiful blue-green rocks from inside the small hill we now call Mount Chalchihuitl. Although they would have known those rocks by a name other than turquoise, it's not hard to understand the appeal of those beautiful gemstones, which even today seem like slices of sky fallen to earth.

Modern Cerrillos took root around 1879, the year prospectors from Colorado discovered silver and lead in the little hills here. The budding town that developed took its name from that landscape—*cerrillos* is the Spanish word for "little hills." Cerrillos reached a population of more than two thousand, with miners seeking turquoise, as well as the silver and lead

that started the boom. Even the luxury jeweler Tiffany's got into the act, financing local turquoise mining at a company-owned mine.

To help you dig into the fascinating history of the village, the Cerrillos Historical Society has installed plaques on nineteen historic properties throughout town. Many are found on First Street. Here is the old Cerrillos Bar, now known as Mary's, on a lot that originally housed a restaurant built around 1893; the DeLallo-Simoni Building, built before 1893, which has housed saloons and stores over its lengthy history; and the Simoni Store, built in 1892, which served as a hotel and dry goods store. The sign over the doorway of the Simoni building, which reads, "Thank you to the citizens of Cerrillos for your time and help," was left by the cast and crew of the 1988 western *Young Guns*, filmed in Cerrillos.

Founded in 2009, Cerrillos Hills State Park is one of the newest parks in the state. The visitor center has displays on the area and hiking trail maps. Hiking the one-mile-long Jane Calvin Sanchez Trail takes you past several small mines, cordoned now for safety, three of which have interpretive signs and short histories. The Village Vista Trail offers a one-of-a-kind view of Cerrillos and is an easy hike. Its trailhead begins at a sundial known as a *noon analemma*. For maximum effect, get to the sundial around noon if you can, when it works best—the science involved is explained on the wall inside the sundial structure.

As you travel to the rustic village of Galisteo, you're leaving the Turquoise Trail, but the beautiful views and open spaces will cushion the blow. Land to the north is part of the Galisteo Basin Preserve, a thirteen-thousand-acre region set aside for conservation, with a significant portion open for protected public use. The preserve is only part of the much larger Galisteo Basin, which stretches from the Sandia Mountains north to the Sangre de Cristo range. Paleo-Indians migrated into this area around 7500 BC. By the twelfth century, the Galisteo Basin was home to Tanoan-speaking people, who lived in large multistoried pueblos and who, as we learned earlier in the tour, mined and traded turquoise and other minerals from the surrounding hills.

Modern Galisteo began life as a small Spanish garrison around 1795, from which soldiers could protect nearby Santa Fe from hostile Indian attacks. A village grew, as settlers arrived soon after and farmed and raised livestock along Galisteo Creek. The village today retains its pastoral heritage; the Nuestra Señora de los Remedios Church is an inspiring sight.

The size of the small community of Lamy is in indirect proportion to the influence of its namesake, French-born Jean Baptiste Lamy. Lamy came to

New Mexico in 1850 as the first vicar apostolic of New Mexico, which was then an extensive new diocese created by the annexation of the Southwest to the United States in the Treaty of Guadalupe Hidalgo. Lamy rankled some New Mexico clergy, who had been loyal to the diocese in Mexico, but he was nonetheless a major influence on religious affairs in New Mexico during the nineteenth century. He's the subject of Willa Cather's beautifully crafted novel *Death Comes for the Archbishop*.

DETOUR DÉJÀ VU

You can visit Saint Anthony's Catholic Church in Pecos and admire its design, influenced by Archbishop Lamy, on the Rut Nut Detour (Detour 6).

The village of Lamy began when the Atchison, Topeka and Santa Fe Railroad reached here in 1880. A spur from Lamy carried passengers to Santa Fe, while the main line continued west. Amtrak still stops in the town today, with one east-bound train and one west-bound train pulling in daily. Passengers disembarking here today tend to hop in their cars and depart, but their historical counterparts had another option: to get coffee, or even book a room, at the comfortably ornate El Ortiz hotel, located where the park east of the depot is today. Modest in scale, with only twelve guest rooms, the Ortiz was nonetheless grand in design. The lobby featured Native American rugs, a fireplace and elegant vigas (wooden beams) supporting the roof. The wraparound counter at the hotel coffee shop saw both passengers and railroad employees, the latter catching a quick lunch before the next departure. The Ortiz was one in the chain of restaurants owned by hotel entrepreneur Fred Harvey, who had a contract with the railroad to establish hotels and restaurants—known as Harvey Houses—along its route. The hotel closed in 1940 and has since been torn down, but a plaque in the park includes photos of it and a layout of the interior.

To learn more about Lamy, visit the Lamy Railroad Museum across from the depot in the former Legal Tender restaurant. The conjoined structures composing the museum initially housed a large general merchandise store, probably built around 1881. By 1889, the store was being run by Louise and William Sayles. After William was killed chasing a robber from the establishment, Louise married John Pflueger, and the store was renamed Pflueger General Merchandise. The saloon was added sometime around 1894 and features an enormous wooden bar from Germany brought by

train in sections. In the 1950s, the property became the Pink Garter Saloon and Restaurant. After being acquired in 1970 by prominent oil industry executive Robert O. Anderson, the Pink Garter became the Legal Tender, the name still on the façade today.

All this history made its mark. Look, for example, at the hole in the poker room left by the bullet that killed an unfortunate onlooker at a table one day (and whose ghost is rumored to still haunt this room). And be sure to admire the scale-replica model railroad of the Lamy station, tracks and surrounding hills, built by the Santa Fe Model Railroad Club.

Continue north under turquoise skies to Santa Fe, where this detour ends.

SOUTHWESTERN NEW MEXICO
— DETOURS —

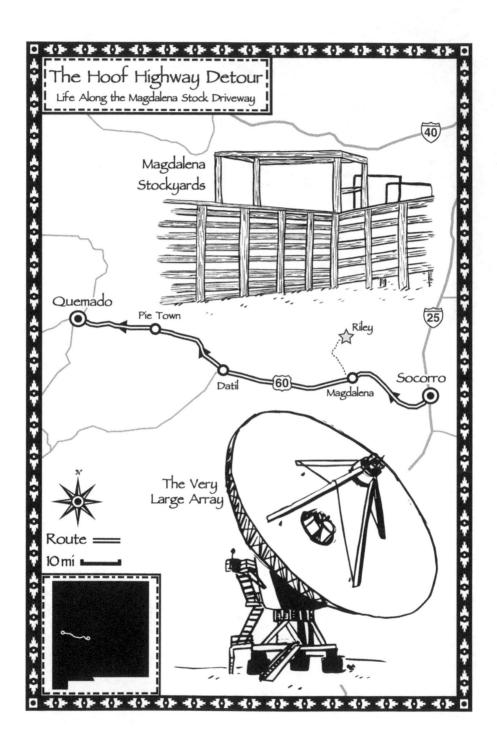

The Hoof Highway Detour
Life Along the Magdalena Stock Driveway

Magdalena
Stockyards

Quemado

Pie Town

Riley

Socorro

Datil

60

Magdalena

The Very
Large Array

Route

10 mi

DETOUR 10

THE HOOF HIGHWAY DETOUR: LIFE ALONG THE MAGDALENA STOCK DRIVEWAY

FROM SOCORRO TO QUEMADO

In many ways, the history of New Mexico is a story of people and things on the move: The early Native Americans who migrated across this land. The Spanish conquistadors who arrived in the sixteenth century looking for gold. The colonists who came after, founding new towns that still exist today. The homesteaders who arrived to make new lives for themselves and their families. Stagecoaches carrying travelers westward. Railroads crisscrossing the state. Scientists and engineers literally launching the space age. You'll be on the move during this detour, too, and you'll cross paths with all these traveling types.

DETOUR LENGTH

Roughly 108 fascinating miles

WHAT'S IN IT FOR YOU

- Explore the mineral heritage of former mining towns
- Follow in the hoof prints of thousands of cattle
- Gaze up at the giant antennas of the Very Large Array
- Eat delicious pie in a town named for the same

Let's look at some rocks. The Mineralogical Museum of the New Mexico Bureau of Geology and Mineral Resources, located on the campus of New Mexico Tech (one of the state's premier universities), houses a dazzling collection of gems and minerals. Specimens have been collected from the nearby mining camps of Kelly, now abandoned, and Magdalena, both of which we'll be visiting later in this detour. In fact, the school largely owes its existence to these valuable ores. The institution was founded in 1889, smack in the middle of the mining boom in those camps and a corresponding boom in the economy of Socorro itself. The name of the university when it was founded—New Mexico School of Mines—reflects its original mission of training engineers and geologists to oversee the mines.

DETOUR DÉJÀ VU

If you want to spend more time exploring Socorro, take the Soak It In Detour (Detour 12), which visits the old plaza and several historic sites around it.

As you approach Magdalena, look to the slopes of the peak south of town for what appears to be a rockslide on the mountain. Using your powers of observation and interpretation (or those of your children, if they're handy), you might see the shape of a woman's head in the rocky arrangement. Some believe she's Mary Magdalene, one of Jesus's followers and namesake of the mountains and the town ahead.

That town, Magdalena, began slowly, in contrast to the mining that took hold in the mountains in the 1860s. The small tent camp that developed here originally took the name Magdalena Mines. When the Atchison, Topeka and Santa Fe Railway laid a branch line from Socorro in 1884, the town took off. Hotels, schools, churches and banks were established—industries needed to support a boomtown. By one account, the population reached a peak of three thousand people. A Depression-era Works Progress Administration guide to the state captured the result of all this activity: "[M]oney was free and easy, liquor was abundant, and the old frontier lived lustily here."

Joining those miners were cowboys driving their beef herds from ranches large and small to the Magdalena railhead. The route they followed, which parallels today's U.S. 60, became known formally as the Magdalena Stock Driveway and informally as the "Hoof Highway" or "Beefsteak Trail." It began around 1885 and was firmly in place by 1916, the year the Department of the Interior set aside a protected swath of land specifically for the purpose of

driving livestock. It was still going strong during the Depression, when young men with the Civilian Conservation Corps drilled wells every fifteen miles to supply water for the cattle. But by 1950, the trail was little used, as cattle were transported mostly by truck, and today it's been abandoned altogether.

Magdalena may have since dropped the word "Mines" from its name, but it has never dropped its character as a western town born and raised on cattle and mining. The historic Magdalena stockades (North Ash Street, about a block north of U.S. 60) are still intact, one of the largest stockades along the Driveway. Other sites to see include the old Atchison, Topeka and Santa Fe Railway Depot (Main Street, one block north of U.S. 60) built in 1915 and in use until the branch line to Magdalena was torn up in 1973. Today the property houses the Magdalena Library and city offices. The former Bank of Magdalena building (corner of First and U.S. 60), erected sometime before 1908, retains much of its historical brick grandeur, a clear throwback to the days when Magdalena was one of the busiest shipping and commerce points in New Mexico.

The railhead at Magdalena also served as a shipping point for ore from the mines at nearby Kelly (inquire locally for access availability). Prospector Colonel J.S. ("Old Hutch") Hutchason may have been the first to uncover lead ore in the foothills of the Magdalena Mountains in the late 1860s. Realizing the potential of his find, Hutchason quickly established the Juanita Mine and the Graphic Mine. The mining camp of Kelly grew up around these and other claims, evolving into a community with banks, hotels, stores and a host of small adobe furnaces for processing the lead and silver being pulled from the mountains. The Little Mission Church of Saint John the Baptist ministered to the miners' spiritual needs and survives today as perhaps the best-preserved structure from that time. Second in line would be the giant headframe and support structures of the old Kelly Mine at the eastern end of what was once Kelly's main street.

This early view of Magdalena shows the original dirt roads. *"Birds Eye View of Magdalena,"* *Thomas K. Todsen Collection, Ms. 02230561, New Mexico State University Library, Archives and Special Collections.*

Socorro resident Gustav Billing acquired the Kelly Mine in 1882, and it's largely him we have to thank for the railroad reaching Magdalena. Originally, ore was hauled to the railroad in Socorro by mule train. Billing helped convince the Atchison, Topeka and Santa Fe Railway to lay the spur line from Socorro to Magdalena so that ore could be transported more easily to a smelter Billing owned in Socorro. The smelter and the prosperity it brought turned Socorro into a thriving and fairly well-to-do community.

In 1893, silver was devalued, as the country adopted a gold standard. Billing's smelter closed the following year, and Kelly likewise faded. But in 1902, Cony T. Brown, a local mining engineer and, later, a regent of the School of Mines, assayed the greenish rocks being discarded in the mining operations at Kelly and found they were smithsonite, a mineral used in the production of paint. Brown then purchased the Graphic Mine, which he sold to the Sherman Williams Paint Company. This new discovery gave Kelly a few more decades of life, up until around the time of the Great Depression, when the mines were largely depleted and the town's brightness had faded.

As they toiled deep in the darkness underground, those miners in Kelly couldn't have imagined that the vast Plains of San Agustin to the west would one day be used to study an even deeper darkness: space. At the National Radio Astronomy Observatory, scientists "look" into space by listening. The highly sensitive radio telescopes at the NRAO collect data from radio waves emitted by objects in the great faraway. Depending on research needs, the twenty-seven antennas can be moved like giant chess pieces on railroad tracks along a three-pronged array, the largest arrangement spanning twenty-two miles across. This collection of telescopes is known as the Karl G. Jansky Very Large Array (or VLA), named for the American scientist who helped found radio astronomy. Often, the astronomers who are using the VLA for research aren't physically on site—they may be collecting data from halfway around the world.

The VLA is monumental, poetic and pure science. Yet for all its grand industrial presence, it looks like it could have emerged from the ground like a collection of giant white flowers, worn to smooth

An antenna with the Very Large Array trained to space. *Courtesy of the New Mexico Tourism Department.*

perfection by the wind. Self-guided tours of this bouquet are available daily, but check the website for the schedule of guided tours (highly recommended), often led by NRAO scientists themselves, who can answer your questions about radio astronomy and their search for worlds beyond our own.

The small community of Datil began around 1884, when Levi Baldwin opened a store here, the same year the U.S. Army established a military installation known as Camp Datil along nearby Datil Creek. Soldiers of the Sixth Cavalry and, later, the Tenth, Thirteenth and Twenty-third Infantry protected early settlers and travelers along the Magdalena Stock Driveway from Apache raids. The camp was abandoned only a couple years later, in 1886, and nothing of it remains. Datil, the town, however, perseveres. Worth seeing is the Baldwin Cabin Public Library, an old forest service cabin, surrounded by gorgeous pines and even prettier views. The cabin takes its name from the Baldwin family, whose ancestor Levi Baldwin you may remember as the man whose store started it all.

The Datil Well Campground preserves one of those historic wells that the Civilian Conservation Corps installed along the Hoof Highway. Cowboys drove their thirsty cattle to the well to drink. Modern travelers can do the same today—the well still supplies the campground with water, and the site is a quiet and secluded spot perfect for peaceful relaxation. It offers twenty-two campsites shaded by piñon and juniper trees and three miles of hiking trails. There's a visitor center in a small A-frame, open seasonally, with maps and area information.

The deliciously named Pie Town does, indeed, owe its origins to the baking of pies. It started in 1922 when Clyde Norman opened a filling station along the Hoof Highway and, being the "crusty" sort, a restaurant as well, featuring pies. Those pies became well known locally and soon caught on with early motorists. In true entrepreneurial fashion, Norman called the small settlement that grew up here Pie Town, a name adopted officially when the post office opened in 1927. Today, the Pie-O-Neer Café carries on the tradition. Stop in for a bite.

The area around Quemado was probably settled about 1800 by José Antonio Padilla, who established one of the first sheep ranches in this area. The town takes its name from the nearby Rito Quemado, or Burned Stream—a name that may have originated from bushes along the creek that were burned to provide access to the stream. Another suggestion for the name is that it recalls an Apache chief whose hand was burned in a fire. Regardless, Quemado today is a medium-sized town, the last along U.S. 60 before the Arizona line. A short trip to Quemado Lake will bring you to one of the clearest blue lakes you'll ever see, in a pristine forested area that offers the perfect environment to reflect on the joys of hoofing it.

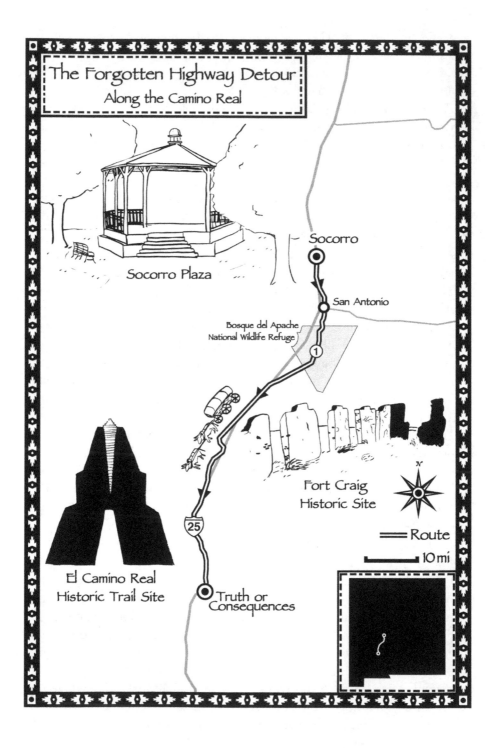

The Forgotten Highway Detour
Along the Camino Real

Socorro Plaza

Socorro

San Antonio

Bosque del Apache
National Wildlife Refuge

1

Fort Craig
Historic Site

El Camino Real
Historic Trail Site

25

Truth or
Consequences

Route

10 mi

THE FORGOTTEN HIGHWAY DETOUR: ALONG THE CAMINO REAL

FROM SOCORRO TO TRUTH OR CONSEQUENCES

We call this the "Forgotten Highway" detour because you might be the only one on the road the whole way. It follows Highway 1, and as they say, one can be a lonely number. But if you've ever wanted to drive for miles through a desert landscape without encountering another person, this is your chance. Take solace in the fact that you're paralleling parts of the Camino Real, or Royal Highway, the chief corridor for settlement of New Mexico for three centuries, which we'll learn about on the way. Also, remember that you did buy a book with the word "detour" in the title.

DETOUR LENGTH

Eighty royal miles, more or less

WHAT'S IN IT FOR YOU

- Travel along the historic Camino Real, the Royal Road, a centuries-old trail that connected New Mexico with the controlling authorities in Mexico
- See the birthplace of famous hotelier Conrad Hilton
- Walk among the ruins of a frontier fort and the site of one of the few battles of the Civil War in New Mexico

Socorro is the launch pad for this detour, and there's plenty to see in town before starting your journey. That's because Socorro is filled with history—even in its name, derived from the Spanish word for "help." When New Mexico colonizer Juan de Oñate led his colonizing expedition from Mexico (then under the control of Spain) into this part of what is now New Mexico in 1598, his beleaguered advance guard came upon a Piro-speaking Indian pueblo known as Teypama near here. The Indians gave Oñate and his hungry men food and drink, leading Oñate to name the village *El Pueblo de Nuestra Señora del Socorro*, or the "Village of Our Lady of Aid."

You might only get to see the inside of the resplendent nineteenth-century Garcia Opera House if there's a performance taking place; otherwise, admire its structure from outside. Completed in 1886 by the widow of prominent Socorro patriarch Juan Nepomuceno Garcia, it has thirty-four-inch-thick walls and features a raked (upward-tilting) stage. Performances here are often given by the Socorro Community Theater. The local troupe doesn't shy away from challenging productions, with a repertoire that includes *A Doll's House* by Henrik Ibsen and *Hamlet* by Shakespeare.

Just a couple blocks away is the historic plaza, with its typical Spanish colonial arrangement of buildings framing the public square. The historic San Miguel Church was built around 1815 atop the ruins of an even earlier church. That earlier church had been abandoned, along with the early settlement of Socorro, during the Pueblo Revolt of 1680, during which the pueblos along the Rio Grande revolted against Spanish rule and drove Spanish settlers from the state for twelve years.

The Capitol Bar, anchoring the east end of the plaza, offers a glimpse inside one of the most historic commercial structures in town. Built in 1896 by Giovanni and Tobaschi Biavaschi, two brothers who immigrated to New Mexico from Italy, the building has been a bar since its inception—although during Prohibition, it did so while masquerading as a simple pool hall. During part of its history, the back room doubled as a jail, where the guilty were jailed by then-owner and justice of the peace Amos Green. In the early 1930s, the next owner, Fred Emilio, honored Judge Green by painting the front of the building green and naming the place the Green Front. The name stuck until 1937, when it became the Capitol Bar, a name it has carried since.

Head toward the south end of town and connect with NM 1 near the car wash. This early stretch of NM 1, the true main character of this detour, will carry you across the interstate, where you'll pass through small settlements that cluster along the roadway, including San Antonio. You'll know it when you

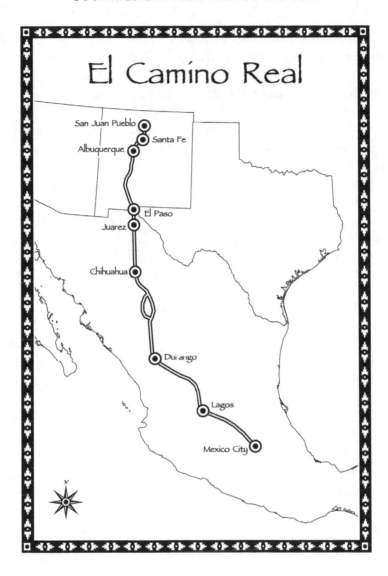

reach the stop sign—the only one until you reach the end of the trip—where NM 1 intersects with U.S. 380.

San Antonio is a small village, but it offers a few unique attractions. Grab lunch at the Owl Bar, located in what was once a grocery store and famous now for its green chile cheeseburgers and dollar-bill-encrusted walls. After, stroll through the small Bosque Gallery across the road where you can sample the visions of local artists. San Antonio was also the childhood home of a boy named Conrad Hilton, whose name you might recognize from hotels across the world. Hilton's father had mining interests in the area

and (as you'd expect) operated a small hotel here, back when the railroad ran passenger service. Young Conrad began his empire humbly, meeting the trains and carrying passengers' luggage back to the family hotel. The bar from the Hilton Mercantile Store, also run by the Hilton family, was salvaged from a fire and is now in place at the Owl Bar.

A few miles south, you'll enter the Bosque del Apache National Wildlife Refuge, a wintering ground for migrating birds of all species. If you're visiting during November through mid-February, you'll see an amazing assortment of birds, including ducks, geese, pelicans and the Rocky Mountain sandhill crane. If you're on the refuge any other time, don't worry; the setting alone is reward enough. A hike on the Canyon National Recreation Trail will take you through beautiful Solitude Canyon, which winds through a landscape that is home to a number of desert dwellers. The entrance fee at the Bosque is small; the return on investment large.

As you continue down NM 1, you're following in the footsteps of thousands of Spanish, Mexican and, later, American soldiers, settlers, merchants and priests and their livestock who traveled this same route for more than three centuries. This was the *Camino Real del Tierra Adentro*, or "Royal Road to the Interior Land." It wasn't really new (it generally followed footpaths already established along the Rio Grande by Native Americans), nor was it just one road. (Over time, branches of the Camino Real developed to avoid rough land or connect to small settlements on both sides of the river, making it more a system of roads than one true road.) But in terms of history, it was indeed royal.

The first Spanish-speaking colonists to use the Camino Real arrived in 1598 under the command of Don Juan de Oñate, traveling north into the vast interior land from Mexico, then under the domain of Spain. Their goal was to colonize the "new" Mexico to the north. Over the years, trade caravans, missionaries and other settlers traveled back and forth on this royal way. The Camino Real remained the main avenue of travel and commerce until well into the nineteenth century, when it was replaced by railroads. The road saw so much traffic during its history that the earth where it passed is still worn, and archaeologists mapping the ancient route can use aerial photos to trace its outlines on the desert floor.

Soon you'll come upon a historic marker for the Mesa del Contadero. This Spanish name translates to "counting place," in this case, a narrow spot along the Camino Real where the Rio Grande flowed close to the base of a mesa, allowing livestock to be herded through individually and inventoried. From the rise at the site of the historic marker, you can clearly see the broad, flat-topped mesa to the southeast.

Despite the attempts of sun and rain to reclaim their own, enough remains of the earthen adobe walls of the Civil War–era fort preserved at Fort Craig Historic Site for you to picture the site in its prime. You'll probably have the place to yourself, except for the long-gone sounds of soldiers drilling on the parade grounds or the blacksmith at work in the smithy.

It's not widely known, but a portion of the Civil War played out in the Southwest, including an important battle not far from here. The battle began in early 1862, when the Confederate army came within view of the fort. Under the command of Brigadier General Henry Hopkins Sibley, the Confederates were taking advantage of a loosely guarded Southwest; Union troops had been reassigned to fight the war from posts in the North. Fort Craig, then under the command of Colonel Edward R.S. Canby, was one of the few defensive barriers between the Rebels and the gold fields in Colorado, which they hoped to raid to fund their cause. The two sides met on February 21, near a small nearby village known as Valverde, in an engagement today known as the Battle of Valverde. (Among the details lost to time and memory is the exact site of the actual battlefield itself.) After the Confederates captured six brass cannons from the Union side, forcing the Federals to retreat to the fort, Sibley marched his men forward, where they would meet Union troops again at the Battle of Glorieta Pass.

An early view of Fort Craig. *William A. Keleher Collection (PICT 000-742-0764), Center for Southwest Research, University Libraries, University of New Mexico.*

DETOUR DÉJÀ VU

The Rut Nut Detour (Detour 6) includes a hike around the sites where the major engagements of the Battle of Glorieta took place.

Just before the highway crosses back over to the east side of the interstate, you'll see a small truck stop with a restaurant and gas pumps. It looks prosaic enough, but there's a secret here, hidden from all but the most discerning eyes. You won't learn the secret from the outside; go inside to see it. (Besides, after making it this far on the forgotten highway, you may be itching to see another human being.) We recommend the "El Camino Real Fries" as both tasty and thematically appropriate. As you sit at your booth, take a look at the wall separating the front part of the building from the back—the green metal one, rounded at the top. Do you see it? Here's a hint: the name of the café is the Santa Fe Diner.

That's right. The diner is partially inside an old Santa Re Railway dining car! The car was converted in the 1970s. Later, walls were built around the railroad car to make the diner larger, concealing the car inside. It's not just the food that makes this place a worthwhile stop, it's the improbability of the place, the fact that you're eating in a roadside grill partially built in an old railroad car in the middle of the desert.

A bit farther south, you'll reach the back portion of an interstate rest area that abuts NM 1. (There's a very small parking area here where you can pull over and access the facilities, if necessary.) Just as rest areas are important to modern travelers, they were similarly critical to those early colonists trekking over the Camino Real. Their rest areas were called *parajes*, or stopping places. There were parajes all along the Camino Real, including one near here called the Paraje de Fra Cristobal—named for Franciscan priest Cristobal de Salazar ("Fra" being an alternate spelling of "Fray," the Spanish word for "friar"). The priest is said to have died near this spot in 1599 on an expedition from Santa Fe to Mexico over the Camino Real. In fact, the isolated mountains to the east are the Fra Cristobal Range. Legend says that with a little imagination, you can see the good friar's head, shoulders and hand in the outline of the mountain.

The impressive sculpture just down the gravel road to the east is titled Camino de Suenos, or Road of Dreams. It was commissioned in 2005 to commemorate the Camino Real. The artist chosen to create the piece, Santa Fe resident Greg E. Reiche, actually camped out on the Camino Real for a couple of nights to appreciate the land and history and create a piece of

art worthy of them. We think he got it just right; the monolith makes an impressive statement against the New Mexico sky, one that surely would have left the road's first travelers awestruck.

The El Camino Real Historic Trail Site is New Mexico's most remote museum, given the long stretch of this part of the Camino Real through the state—but it's also one of our favorites. The building itself is awe-inspiring. The architects, Dekker/Perich/Sabatini of Albuquerque, envisioned the structure as a giant ship crossing the desert. The long walk into the museum feels like a gangplank; the overlook at the east end looks like a mast. The displays wind through an indoor labyrinth that will make you feel like you, too, are on a journey. Ask for a guide to the view off the overlook, where you can get a closer look of the "nose" of Fra Cristobal, the direction of the trail in the distance and the location of the former Piro-speaking pueblo of Senecú. Around you, creosote and desert grasses wave in the wind, while overhead, isolated clouds skate across a pristine sky or build into thunderheads, rising on the afternoon heat. This is the same sky under which early Camino Real travelers passed, though they likely did so at night; caravans often traveled in the evening and nighttime hours to avoid the heat of the day.

As you pass through deep Nogal Canyon, near mile marker 17, take a look at the interstate to the east. Whether you have the soul of an engineer or an artist, you'll appreciate the craftsmanship on display in the steel-deck truss bridges supporting the interstate as it spans the canyon. There's a small area where you can pull over at the bottom of the canyon—the dirt road to the bridges is private, so don't go farther. But from this vantage point, you can admire the characteristic triangular trusses of the Warren truss bridge design, sharp angles standing in relief from the soft curves of the desert landscape that surrounds them. The bridges, one each for southbound and northbound traffic, were built by the highway department in 1968. Spanning 373 feet, they seem to be holding the canyon walls apart. It's another piece of desert art.

Continuing down NM 1, you'll shortly reach the second stop sign of this detour and, unfortunately, the end of this forgotten highway—physically and metaphorically. Take the on ramp here onto the interstate, and take the memory of generations of travelers home with you.

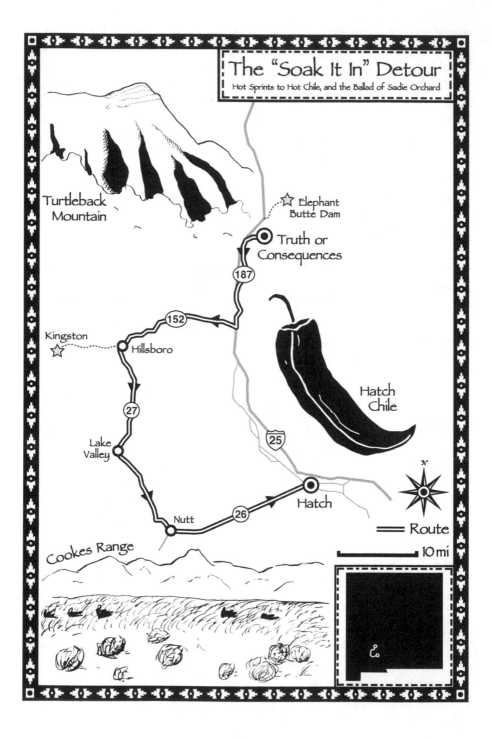

The "Soak It In" Detour
Hot Sprints to Hot Chile, and the Ballad of Sadie Orchard

Turtleback Mountain

Elephant Butte Dam

Truth or Consequences

187

152

Kingston

Hillsboro

Hatch Chile

27

25

Lake Valley

Nutt

26

Hatch

Cookes Range

Route

10 mi

THE SOAK IT IN DETOUR: HOT SPRINGS TO HOT CHILES AND THE BALLAD OF SADIE ORCHARD

TRUTH OR CONSEQUENCES TO HATCH

Warmth. New Mexico is justifiably famous for it. With an average of more than three hundred days of sunshine a year, the weather certainly fulfills that promise of warmth. But there are other forms of heat that apply, too. The natural hot springs that bubble under portions of the state have warmed locals and travelers alike for centuries. And then there's the lynchpin of native cuisine: the chile. Hot or mild, red or green, chopped or sauced, chile peppers are an adventure in warmth. This detour gives you an opportunity to soak in the warmth of the state and encounter along the way the very warmest of New Mexico attractions: New Mexicans.

DETOUR LENGTH

About ninety-four warm miles

WHAT'S IN IT FOR YOU

- Soak in the steamy geothermal water that flows under Truth or Consequences
- Travel the dirt streets of former mining towns
- Meet Sadie Orchard, one of the most colorful figures in New Mexico history
- Eat some of the finest green chiles in the world

Of all the place names in New Mexico, Truth or Consequences is the only one that threatens you outright. But T or C, as it's known locally, doesn't deserve to be seen as menacing. The only real consequence you might suffer here is the shame of overlooking its quirky history. So begin with a visit to the Geronimo Springs Museum to learn more about this part of New Mexico, including mining camps and ghost towns, as well as the story behind that unusual name. In fact, the museum has an entire wing, the Ralph Edwards Room, dedicated to the story of how the little town of Hot Springs elected to change its name to Truth or Consequences as publicity for the popular 1950s radio and TV program of the same name, hosted by Ralph Edwards. (Not everything in town changed names. The high school remains Hot Springs High School to this day, and the hospital never took the name Truth or Consequences Hospital, for obvious reasons.)

After the museum, walk across the street to the post office and admire the Depression-era Works Progress Administration mural inside. Painted in 1937 by modernist figurative artist Boris Deutsch, it depicts a traditional Native American dance scene. Deutsch, who immigrated to the United States from Russia at age twenty-four, painted murals like this one in government buildings around the country. The WPA left its architectural mark throughout town, building the Sierra County Courthouse (311 North Date) and the New Mexico Veteran's Home (992 South Broadway). In fact, as you walk around, glance down occasionally—some of the sidewalks here still bear their original WPA stamp!

There's something special under those sidewalks, too. Large parts of the town were built over geothermal reservoirs. Those springs provided curative warmth to the Apache Indians who once traveled this area, and a legend persists that the great Apache leader Geronimo himself bathed here. They continue to attract visitors year round today. In 2005, the National Park Service added the bathhouse and historic commercial district to the National Register of Historic Places, calling it a "unique urban health resort." You can enjoy a soak at any of the bathhouses around town, and hotels like the Sierra Grande and Blackstone even offer baths inside the hotel.

At Ralph Edwards Park, named for the game-show host, you might catch kids on the skateboard ramps and people fishing along the banks of the Rio Grande. Near the fishing pond at the east end of the park are large boulders, believed to be a former Apache Indian camping site. The park provides a good view of Turtleback Mountain, named for the rock formation on one peak that resembles a turtle trudging slowly northward. Turtleback—officially "Caballo Cone" to geologists—is part of the Caballo

Range and separates the Rio Grande Valley from the grueling Jornada del Muerto south of here, a barren ninety-mile stretch of Chihuahuan Desert that earned its name, the Journey of the Dead Man. The white "T" on the side of Turtleback Mountain stands for either "Truth or Consequences" or "Tigers," the high school team mascot, depending on whom you ask.

Next, stroll down Broadway Street and visit the quirky shops that line the road. They include a mix of established firms and new artist destinations, and they speak to the ever-changing character of this desert town.

Toward the eastern end of the street, at 310 Broadway, you'll find an unusual two-story brick building with a sign reading MAGNOLIA ELLIS. The building isn't open to the public, but a small placard near the road tells the story of "Magnificent" Magnolia Ellis, who moved here in 1938 and changed the history of the town. Ellis claimed the power to heal, not by touch, but by moving her hands just above and over a patient's body, which she believed would push out the bad energies that were causing sickness. Patients lined up in front of her clinic to see her, and many testified that she healed them of disease and suffering. Ellis used some of the money she earned to support community projects and to help provide for people in town who had suffered setbacks. She had a similar clinic in Kansas. Ellis died there in 1974.

Not just turtles and tigers make T or C a desert menagerie. Nearby Elephant Butte Lake and the dam that creates it were named for their location near a flat-topped hill, or butte, that resembles an elephant. Completed in 1916, only four years after New Mexico became a state, the dam is an important part of a larger network of dams and reservoirs that control the flow of the lower Rio Grande, preventing flooding and allowing for sustainable irrigation. And the sight of a massive body of water in the midst of the desert that surrounds it is startling.

DETOUR DÉJÀ VU

You might as well visit Camel Rock on the Rio Grande Detour (Detour 4) and add a camel to your list of rocks that resemble animals.

As you pass through town, stop to visit the Veterans Memorial Park and the Hamilton Military Museum. Complete with monuments that honor veterans of all U.S. conflicts, the park even has a half-scale replica of the Vietnam Veterans Memorial Wall in Washington, D.C. The museum features displays

on military history, focusing on the role New Mexico and its service members played in conflicts that shaped the world.

While Interstate 25 will get you to the Hillsboro exit quickly, it's worth a few extra minutes to make the trip down NM 187 instead. The road meanders in two lanes along the course of the Rio Grande outside Williamsburg, then deviates from the river to cross the low hills through scattered adobes, dry arroyos and the collection of residences that go by the name Las Palomas, Spanish for "doves." Patience is rewarded after a few miles by a first sighting of Caballo Lake, smaller sister to Elephant Butte Lake to the north, nestled at the feet of the Caballo Mountains on the west shore. The hard face of the Caballos is scarred by tracks that lead to long-abandoned mines clinging to high ledges overlooking the valley.

Though it's only about thirty miles to Hillsboro, it still feels remote. The town rests deep in a valley on the run up to the Black Range Mountains, nicely shaded by old trees and seemingly left behind by the world. Nonetheless, Hillsboro was once the county seat of Sierra County, before losing that distinction to Truth or Consequences (née Hot Springs) in 1937, and it's alive today with people and circumstance. In a way, that loss saved the historic character of this little town, leaving it preserved for later generations. Imagine Hillsboro more than one hundred years ago, when it and nearby Kingston were booming mining towns.

And further, imagine the arrival in 1886 of Sadie Orchard, whom historian Erna Ferguson described this way: "She was a tiny, high-bosomed woman with short feet in shorter shoes, tight spitcurls, and a wicked chuckle to punctuate her obscenities and profanities." Sadie worked as a prostitute in rough-and-tumble Kingston before marrying her husband and helping him run a stagecoach line that connected Hillsboro, Kingston and nearby Lake Valley. Sadie herself sometimes drove the coaches. The couple also opened the Ocean Grove Hotel in Hillsboro, which was next door to the present Black Range Museum. Sadie is said to have sported a British accent and claimed to be from London, even though she was likely born in Iowa. In her later years, Sadie's softer side shone through, as she cared for many of her fellow townspeople during the flu epidemic of 1918.

On a rise overlooking the village, brick ruins stand against the sun, rain and wind. This is the former Sierra County Courthouse, and it was inside those walls in May 1899 that arguments were heard in a trial that remains controversial to this day. It concerned the disappearance and presumed murder of Civil War veteran and prominent lawyer Albert Jennings Fountain and his eight-year-old son, Henry, who had gone from their home in Mesilla

This photo of Sadie Orchard shows her astride a horse, probably near her home in Hillsboro, circa 1880. *Erna Fergusson Collection (PICT 000-045-0043), Center for Southwest Research, University Libraries, University of New Mexico.*

(about eighty miles south) to Lincoln to secure indictments for cattle rustling against rancher Oliver M. Lee. Starting their return trip on February 1, 1896, father and son were last seen near what is today White Sands National Monument. They never arrived home. Suspicions fell on Lee and his ranch hand James Gilliland, and the three-week trial that took place in the Hillsboro courthouse—a venue specifically chosen for its distance from counties where Fountain and Lee had ardent supporters—was a major event in this little town. Ultimately, as there were no bodies to prove a murder had even taken place, the jury acquitted both Lee and Gilliland.

Leave Hillsboro and proceed south toward Lake Valley, one of New Mexico's finest ghost towns. The townsite reverted to the care of the Bureau of Land Management when the last resident left for health reasons in 1994. On-site caretakers maintain the property and greet visitors. Explore the museum (in the school building on the hill), talk with the caretakers, sign the guest book and then take the walking tour through what's left of

This historic photo of Lake Valley shows the settlement in its prime. A train can be seen passing in the distance. *Henry A. Schmidt Pictorial Collection (PICT 000-179-0875), Center for Southwest Research, University Libraries, University of New Mexico.*

the town, including the chapel, the doctor's office, the railroad tracks and several old homes. The oddly shaped peak behind town is officially called Monument Peak for its uncanny resemblance to a monument lizard scaling the top, but most people know it by a humbler name: Lizard Peak. The cemetery is up the small hill southwest of town. Traditionally, ghost towns don't age well; Lake Valley is a rare exception and a great opportunity to see one in its prime.

Keep a watchful eye when you arrive at the stretch of NM 27 between mile markers 7 and 8. Looking east, you'll see a small stone pyramidal monument that looks like it fell off the luggage rack of a passing spaceship. It honors the 1846 march of the Mormon Battalion from Council Bluffs, Iowa, through this part of New Mexico to San Diego, California. That year, after the United States claimed the Southwest from Mexico, the army joined forces with leaders in the Mormon Church to open a wagon road to the Pacific coast. The project had obvious military goals, but it was also designed to help the Mormons reach the West, where they could settle, free

from religious persecution. Lieutenant Colonel Philip St. George Cooke assumed command of the battalion when it reached Santa Fe. His quote, which has been inscribed on this lonely monument, shows his admiration for the company at the end of its two-thousand-mile march: "History may be searched in vain for an equal march of infantry." The spectacular mountains to the west are known as the Cookes Range. The highest summit, at 8,408 feet, is Cookes Peak, ensuring a continuing dramatic presence for the memory of Lieutenant Colonel Cooke in this part of the state.

NM 27 will carry you the remainder of the way to Nutt, a small blip on the map but one with an interesting history. The tiny town was founded around 1881 as a station on the Atchison, Topeka and Santa Fe Railroad and became a launch point for wagon trains and lone prospectors bound to try their luck in mining camps around Lake Valley, Hillsboro, Kingston and points beyond in the Black Range. A small wayside sign explains some of the history. The name, by the way, comes from an early railroad engineer.

Disguised as a mild-mannered farming community straddling the banks of the Rio Grande, the village of Hatch is in reality the Chile Capital of the World. Chile permeates the local culture and flavors the air year round, particularly in the fall when acres of the red and green peppers are harvested and brought in for processing. Much of that process involves modern, stainless-steel equipment, but it's still common to see bushels of peppers spread across the roofs of local homes, drying in the sun.

Celebrate the completion of this detour with a meal in one of the local restaurants. Be prepared: If you order Mexican food—here in the Chile Capital of the World or anywhere else in New Mexico—you're going to be asked, "Red or green?" So important is this query that in 1996 the New Mexico legislature adopted "red or green?" as the official state question. It's shorthand for, "Would you prefer red chile or green chile on your order?" We like green with chicken and red with beef, but if you're on the fence, ask for it on the side. Or if you refuse to take sides, simply answer, "Christmas," to get both.

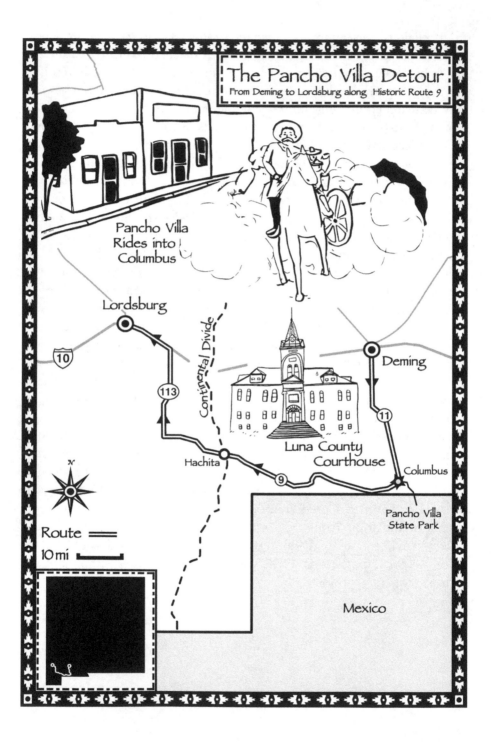

The Pancho Villa Detour
From Deming to Lordsburg along Historic Route 9

Pancho Villa Rides into Columbus

Lordsburg

Continental Divide

10

113

Deming

11

Luna County Courthouse

Hachita

9

Columbus

Pancho Villa State Park

Route ═══

10 mi

Mexico

THE PANCHO VILLA DETOUR: RAIDS AND RAILROADS

FROM DEMING TO LORDSBURG ALONG HISTORIC ROUTE 9

Let us introduce you to our friend the yucca. It is the quintessential New Mexico plant, tough-skinned, hardy, long-lasting and altogether distinctive. The white blossoms of the yucca plant were chosen as the official state flower by the state legislature back in 1927. Yuccas are practical but beautiful. They'll be with us all along this route, as we learn about courthouses and raids by foreign mercenaries and hotels of bygone grandeur. You'll see: yuccas make good companions.

DETOUR LENGTH

Around about 126 yucca-studded miles

WHAT'S IN IT FOR YOU

- Explore a giant, two-story museum housed in a former armory
- Walk along the street where one morning of terror in 1916 forever changed a small town
- Follow the vestiges of a long-gone freight and passenger railroad
- Imagine the former grandeur of one of the most elegant hotels in southwestern New Mexico

The resplendent white blossom of the yucca plant is the official state flower. *Courtesy of the New Mexico Tourism Department.*

On March 8, 1881, the rails of the Southern Pacific, coming west from California, met those of the Atchison, Topeka and Santa Fe coming east, to complete the second transcontinental railroad in North America. Railroad officials celebrated that meeting by driving a silver spike into the ground. (The spike was silver because this was the second transcontinental railroad; the first appropriately got the gold spike.) They also drove home a new name: Deming. Charles Crocker, an official of the Central Pacific Railroad (which controlled the Southern Pacific), chose to name the community in honor of his wife, Mary Anne Deming Crocker, whom he had met as a young man working at her father's sawmill in Mishawaka, Illinois.

Deming prospered, and when Luna County was created in 1901, Deming became the county seat. The Luna County Courthouse at the intersection of Silver and Ash is a sight to behold. Approach south on Silver Street for the best experience, as the red-brick building with clock tower emerges from behind a tree-lined promenade. The clocks on the sides of the tower may or may not show the correct time, but it's always a good time to appreciate architectural beauty. Constructed in 1910, the stately two-story building reflects an architectural style more common to the East Coast, the result of tastes and styles brought by the railroad.

The Deming Luna Mimbres Museum should be your next stop, but before you go inside, take a moment to appreciate the building itself and the war memorials in the courtyard. This hulking two-story brick wonder, featuring thirteen-inch-thick walls, is, not surprisingly, the former Deming Armory. It was built in 1916 by the El Paso architectural firm Trost & Trost. The firm completed a number of buildings that gave architectural shape to New Mexico during its early twentieth-century developmental years, including the New Mexico School for the Blind in Alamogordo, several structures on the campus of New Mexico State University in Las Cruces and a number of schools, women's clubs and hotels around the

state. The Deming Armory was one of the first armories completed in New Mexico. During wartime, it served as a training center and USO facility, and after being decommissioned in 1976, it was acquired by the Luna County Historical Society for use as a museum.

You'll need several hours to explore this museum. There's a large room filled with Mimbres pottery, an "Old Timer's Room" with photos and anecdotes from Deming's past, an extensive doll collection, a large ranch heritage display, a collection of rocks and geodes and one entire wing, known as the "Transportation Wing," holding restored fire engines and early automobiles. The military history room has information on the World War I army training camp in Deming known as Camp Cody, which, at its peak, housed close to twenty-eight thousand trainee soldiers and dozens of barracks and tents. Most of the camp is gone now, but a few hangers remain.

By the way, if it happens to rain while you're in Deming and you get the urge to start singing, there's a logical explanation. You'll find it at Nacio Herb Brown Park (corner of Eight and Spruce). Born in Deming, Brown was a prominent composer, beginning his work for MGM studios in 1929 with the musical *The Broadway Melody*. But his most popular and recognizable song, originally written for the movie *Hollywood Revue of 1929*, embedded itself in the nation's musical soul when Gene Kelly brought the tune to a puddle-splashing zenith in the movie of the same name: *Singin' in the Rain*. To honor their native son, Deming named this park in Brown's honor in 1960, four years before his death.

Before you leave Deming, we'll just note quickly for the record that one of the sponsors of the bill in the state legislature making the yucca the official state flower was a woman named Mabel Upton Portwood, who happened to be from Deming.

As you drive into Columbus, you'll feel the history here right away—it permeates the atmosphere. How could it not, given the events that played out here on March 9, 1916? That morning, the small border town and the local military outpost of Camp Columbus (soon renamed to Camp Furlong), were surprised by a sneak attack from across the Mexican border, led by Mexican revolutionary Francisco "Pancho" Villa and his "Villistas." Villa was upset with the United States for various reasons, political and otherwise, including U.S. recognition of his opponent in the Mexican presidential election. He took his revenge on the small community and its seven hundred residents. In the aftermath, eight soldiers, ten civilians and possibly as many as two hundred Villistas lay dead.

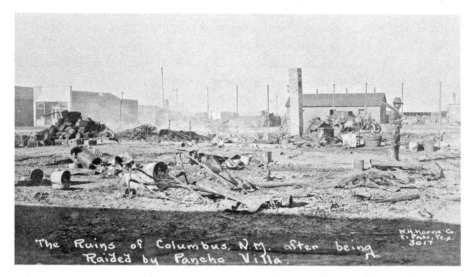

A guard protects the ruins of Columbus, New Mexico, after the devastating raid. *Flores Collection, RG81-052-001, New Mexico State University Library, Archives and Special Collections.*

To better understand the historic significance of this tragedy, stop first at the Columbus New Mexico Historical Society Museum, housed in the old El Paso and Southwestern Railroad depot. The museum preserves a collection of memorabilia about Columbus history, focusing on Camp Furlong, the railroad and the Villa raid, and includes a diorama of Columbus showing the small village in the aftermath of Villa's devastating incursion. Read the biographies and view the portraits of the citizens and soldiers killed that day; their stories shouldn't be forgotten.

At the museum, you can pick up a guide to the walking tour of town. Many of the buildings and lots around town include plaques that describe the history of that location and how the Villa raid played out, moment by terrible moment. You'll see the empty lot across from the depot, once the site of the Commercial Hotel, burned to the ground during the raid. And you'll learn the story of Charles Miller, who opened the Miller Drug Store on Broadway Street just a year earlier, killed that morning when he ran from the Hoover Hotel to his store in an attempt to secure guns for protection; James T. Dean, who ran toward the commotion mistakenly thinking it was a fire and hoping to help; and Bessie James, the only woman killed in the raid. While wandering this quiet town, you can imagine the fear, shock and desperation that must have accompanied that fateful morning.

In response to the raid, the U.S. Army organized what was called the "Punitive Expedition" and put Brigadier General John J. Pershing at the lead. Pershing, who had yet to acquire his nickname "Black Jack" Pershing, would later help lead the United States to victory in World War I. Under Pershing's command, ten thousand soldiers of the Seventh, Tenth, Eleventh and Thirteenth Cavalry and Sixth and Sixteenth Infantry regiments gathered in Columbus and in a camp south of Hachita (west of here) and, on March 15, marched across the border in pursuit of Villa and his men. In the year of skirmishes that followed, the expedition failed to capture Villa as was hoped, but it did take prisoners. Remember that beautiful courthouse back in Deming? Murder trials against twenty-four Mexican Villistas taken prisoner during the expedition were held in that building in 1916 and 1917. Six of them were convicted of the murder of Charles Miller and executed.

In what may seem a peculiar choice of name, the remains of Camp Furlong now compose Pancho Villa State Park. The headquarters building and recreation hall of this old military installation, where soldiers of the Thirteenth Cavalry were stationed to protect the New Mexico territory along the border, are preserved, and a number of RV and camping sites lie restfully across a landscaped desert park setting.

As you travel westward on NM 9, you'll be in the company of the old railroad grade and scattered remains of the El Paso and Southwestern (EP&SW) Railroad. You can clearly see portions of the grade north of the highway. Phelps, Dodge & Company laid the line in 1902 to carry copper from mines in Bisbee, Arizona, to the refinery in El Paso, Texas. Stockyards and pens along the route also allowed local ranchers to ship their cattle to market in El Paso. Later, passenger service was offered, with trains like the *Golden State Limited* and the *Californian* carrying passengers through the desert and forever changing the character of this corner of New Mexico. Small towns along its course, like Hachita up ahead, became railroad towns, catering to passengers and rail crews with hotels and restaurants.

DETOUR DÉJÀ VU

If trains are your thing, be sure to visit the town of Lamy on the Turquoise Skies Detour (Detour 9), where you'll see a scale model of the Lamy station built by the Santa Fe Model Railroad Club, and also the extensive Clovis Depot Model Train Museum in Clovis on the High Lonesome Detour (Detour 15).

So, yes, the town of Hachita has seen busier days, but it seems content with them being in the past. The name is Spanish for "Little Hatchet," borrowed from the Little Hatchet Mountains to the east. (The Big Hatchet can be seen dominating the horizon to the south.) Hachita began life as a small mining camp in the foothills of the Little Hatchet Mountains. When the EP&SW railroad arrived in the valley below (now called the Hachita Valley), many residents of what became known as "Old Hachita" moved about three miles north and formed "New Hachita" alongside the tracks. The two communities existed simultaneously for several decades, but as more and more residents left Old Hachita, New Hachita became simply Hachita. The sunbaked ruins of the buildings of Old Hachita still lie among the foothills of the Little Hatchet Mountains, home now to rattlesnakes and jackrabbits. Hachita thrived for a time—the railroad brought a new prosperity to replace what the mines had offered. The buildings along the highway (then called Railroad Avenue) might look a bit forlorn today, but there was once a thriving row of businesses here. The old Hachita Mercantile Company, once stocked with food, clothing and ranching supplies, survives today as the Hachita Community Center, open occasionally for community events.

At mile marker 36, look for the prominent kiosk behind the gate to the south. This is a map of the Continental Divide National Scenic Trail, which crosses the highway at this point—you can see blue trail markers in the surrounding landscape. Northbound hikers traversing the 3,100-mile trail from the Mexican border through the western United States to Canada will begin their trek at a spot known as Camp Crazy Cook about thirty miles south of Hachita. The unusual name commemorates the murder of cowboy Frank Evans, killed near the site on May 1, 1907, by an ax-wielding camp cook who, for reasons now forgotten, apparently lost it.

Lordsburg was named for Delbert Lord, an engineer on Charles Croker's Southern Pacific Railroad. You'll know you've found the Lordsburg Hidalgo County Museum when you see the giant windmill in the front yard. The museum preserves artifacts from the railroad and ranching heritage that have dominated the history of the city. Tour the mining room for an overview of this industry's place in the local economy and don't miss the Prisoner of War Room, which tells the story of an internment camp for Japanese Americans in Lordsburg during World War II.

We end this tour with a bit of bygone grandeur. Look for the building at the corner of Animas Street and East Motel Drive. Some buildings maintain a patina of greatness even after their glory days, and the old Hotel Hidalgo is such a place. It's no longer a hotel, but you can clearly see that it once

was. Our old friends Trost & Trost managed to build this sprawling structure across from the railroad depot for just $50,000, though of course this was back in 1928. With its elegant lobby that featured a huge fireplace, its ceiling beams, its grand stairway leading to the second floor and its forty-eight guest rooms, the Hotel Hidalgo became one of the more glamorous hotels on the Southern Pacific line. "On the floor is found a heavy velvet carpet," wrote a reporter with the *Lordsburg Liberal* in November 1928, "in which the feet practically sink, giving a most luxurious feeling to the occupant." Amelia Earhart stayed here, as did Hollywood movie cowboy Tom Mix. The roofed area at the eastern corner of the building was a service station, complete with gasoline pumps; the hotel also included a flower shop and restaurant.

It's a reminder, just as sure as courthouse memorials and the empty lots where purposeful buildings once stood, that everything changes sooner or later—sometimes much faster than we'd like.

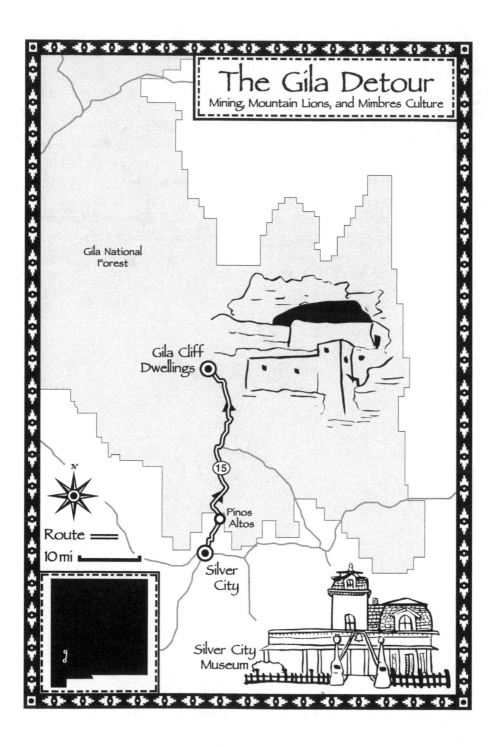

The Gila Detour
Mining, Mountain Lions, and Mimbres Culture

Gila National
Forest

Gila Cliff
Dwellings

15

Pinos
Altos

Silver
City

Route ═══
10 mi ▬▬▬

N

Silver City
Museum

THE GILA DETOUR: MINING, MOUNTAIN LIONS AND MIMBRES CULTURE

FROM SILVER CITY TO THE GILA CLIFF DWELLINGS

Among the impulses that have drawn men and women to New Mexico, one of the strongest has been the will to wrest a fortune from the ground. You see that drive played out in the remains of mining towns all across the state. The boom years have largely passed, as have many of these colorful places. But some still thrive, staking their claims on the future. That human will to thrive off the land runs deeper still, back to ancestral inhabitants who farmed and gathered and hunted in this area and found shelter in homes built into hollowed clefts in those cliffs. Discover all this and more on this detour and come away the richer for the experience.

DETOUR LENGTH

Forty-five exceptionally scenic miles

WHAT'S IN IT FOR YOU

- Explore Silver City and stroll along the ditch that was once its main street
- Tour the log cabin that was the first schoolhouse in Grant County and learn about Pinos Altos
- Hike to a memorial to one of the greatest mountain lion hunters in New Mexico history
- Roam through the rooms of a small village built into a cliff by members of the Mimbres culture

Silver City reveals its history in its name. This was a city built on silver mining. The precious mineral was uncovered in 1869 when brothers John and James Bullard began prospecting in the area and struck a rich silver vein. Bullard Street in Silver City recalls these early pioneers. Raids by Apache Indians hampered development—John Bullard himself was shot and killed by Apaches when he participated in a raid on one of their camps. Undeterred, miners kept coming. Deposits proved long-lasting, and a more permanent settlement developed. Today, Silver City is the county seat of Grant County and a vibrant community with a strong and active downtown filled with cafés, art galleries and small businesses.

If a flood wiped out the main street of your hometown, would you rebuild that street or just throw up your hands and move away? Silver City residents chose a third option when a flood swept away Main Street in 1895. Making a virtue of necessity, they turned the washed-out gully where the street had been into a park—known today as the Big Ditch. You can take a pleasant stroll along the ditch, visiting galleries and ice cream shops as you walk. Think of it as a river walk sans the river.

The city also offers two outstanding museums. The Silver City Museum is housed in the former 1881 home of H.B. Ailman, an early pioneer of Silver City. Walk through the rooms where the Ailman family once lived and admire exhibits on the mining and ranching history of Silver City and the surrounding area. The Western New Mexico University Museum has exhibits and photographs documenting the history and development of Western New Mexico University (WNMU), which was founded in 1893. (Confidential to the men reading this: be sure to check out the historic, one-hundred-year-old porcelain urinal in the basement men's room.) The WNMU Museum also has an extensive collection of pottery made by people of the Mimbres culture, whom we'll encounter later in this tour. Mimbres pottery is known for its characteristic black-on-white motifs, often featuring birds, lizards and abstract designs that look both ancient and modern at the same time.

A short distance north of Silver City lies the small village of Pinos Altos. Pinos Altos—Spanish for "tall pines"—is an apt name for this community nestled at the edge of the Gila National Forest. Pinos Altos also began as a mining camp, although this time the commodity was gold, uncovered in the waters of Bear Creek by three prospectors in 1860. One of them was Henry Birch, and the town that developed originally took the name Birchville. It was platted in 1867, making it older than Silver City; in fact, Pinos Altos served as the original county seat of Grant County. Among the notable early

residents of the town was Roy Bean, better known as the "Law West of the Pecos," who operated a business here before earning his nickname as a no-nonsense judge in Texas.

As was true in Silver City and throughout this area, Pinos Altos was the frequent site of Apache raids. However, a story is told here that early pioneers formed a truce with the Indians and, as a symbol of that peace, placed a giant cross high atop what is now Cross Mountain in 1874. Though it's not the original, a cross still exists there; you can see it crowning the mountain east of town.

Pinos Altos includes a number of historic properties. Many have signs explaining their historic relevance (though some are private residences today and shouldn't be entered). The Pinos Altos Historic Museum incorporates the first schoolhouse in Grant County, built in 1866. Inside is a wonderful assortment of artifacts related to mining history, old dishware and appliances, a pump organ, maps, Victrola phonographs, rocking chairs, arrowheads and lots of historic photos. The old one-room schoolhouse even has desks and a fireplace. You can get lost here and love it. The Pinos Altos Opera House is a testament to the high culture that has always existed in this mountain mining camp. It's not always open,

Photographer Russell Lee captured this image of a gold miner in Pinos Altos in 1940. *Library of Congress, Prints & Photographs Division, FSA/OWI Collection, LC-DIG-ds-00774.*

but you can sometimes get a look inside from the adjoining Buckhorn Saloon. (And, you know, since you're right here anyway, you might as well grab a bite to eat; the food is terrific.) The opera house features a small stage at the end of a long corridor, with box seats and audience seating in front and even chandelier lighting.

As you continue into the Gila National Forest, you'll be entering a land etched in history. These mountains were the homeland of the Chiricahua Apache for centuries before the arrival of Spanish-speaking and Anglo settlers in the nineteenth century. As these new settlers encroached on the land, the Apache withstood their advance with raids on the emerging settlements. The Apache were led by men whose names have echoed down through the years: Mangas Coloradas, Victorio, Geronimo. After 1849, as the U.S. Army intensified its campaigns against the Indians throughout the Southwest in what became known as the Apache Wars, the great leaders of the Apache tribes surrendered and moved to reservations or were killed.

The forest, the prominent river running through it and other points of interest later on in this detour, all share the name *Gila* (HEE-la), which place names expert Robert Julyan suggests is a Spanish corruption of an Apache word meaning "mountains." Farther to the north lies the vast Gila Wilderness, the first wilderness area in the country, set aside in 1924. The Gila National Forest itself was established in 1931.

Look closely as you head deeper into the forest for a parking area along the highway, where you can stop and make the short hike up the hill to the Ben Lilly Memorial. Lilly was the consummate mountain man, one of those figures who emerges from the din of history to become legend. Lilly would likely disagree with that assessment, having once stated, "My reputation is bigger than I am. It is like my shadow when I stand in front of the sun in late evening." Still, Lilly lived large on the edge of the final days of the frontier.

Born in Alabama in 1856, Lilly was raised in Mississippi. After stints as a blacksmith and farmer, he served as a personal hunting guide to President Theodore Roosevelt, who noted that Lilly seemed "indifferent to fatigue and hardship." Lilly later moved to Texas, then to Mexico and finally settled—as much as that was possible for a man of his nature—in the wilderness around Silver City in 1911. He had by that time honed his skill as a hunter, and ranchers often hired him to rid their land of predators such as mountain lions and bears; estimates say he killed up to one thousand mountain lions alone. He preferred a solitary lifestyle, avoided crowds, kept a full beard,

refused to perform any work on Sundays and went everywhere on foot, usually leading a pack of hound dogs.

Another interesting bit of Gila Wilderness history has been preserved at the Arrastra Site (just past mile marker 8 on the right up the hill). An arrastra is an older-style mill used to process ores by grinding them with stones. The arrastra here has been reconstructed to show how horses or mules walked in a circle around the pit, turning logs that in turn pulled what were known as "drag stones" across a soupy mixture of ore and mud. By adding mercury, any gold in the mixture could be separated. It was a messy and laborious process, but it was high tech for the time and suited to the needs of individual prospectors, probably even the one who built and lived in the rock house whose foundations are nearby.

The road that winds its way north from this point can be dizzying at times, so take it slow and enjoy the views. About those views: around and around you go as mile after mile of stunning ponderosa pines and juniper trees delight your eyes and—if it's warm enough to roll down the window—your other senses as well. A number of roadside pavilions along the way will introduce you to the ecology and geology of the area, including the sometimes hard truth that fire is a natural and necessary part of the cycles of nature.

The appearance of Gila Hot Springs may come as a bit of a surprise after all that alone time in the mountains, but here it is. Gila Hot Springs, like Silver City, tells you right up front what it's about: crisp and refreshingly hot geothermal waters courtesy of the deep inner earth. This small resort village continues a tradition today that began with its founding in 1898, when it was settled as a place to get away and enjoy the natural wonders of the area. You'll find a number of sites to soak just off the highway and along the Gila River.

Begin your visit to Gila Cliff Dwellings National Monument at the visitor center, where you can view a short movie about the people who lived here long ago and learn more about their lives. They're known today as the Mimbres, a subgroup of a larger culture in the Southwest known as the Mogollon, which stretched through parts of what is now southern New Mexico, eastern Texas, western Arizona and into Mexico. Archaeologists believe the people who built their structures inside the caves of Cliff Dweller Canyon did so sometime in the thirteenth century. There is other evidence of their presence here as well, including structures outside Cliff Dweller Canyon and sites along the river—but the most accessible, and spectacular, are the cliff dwellings themselves.

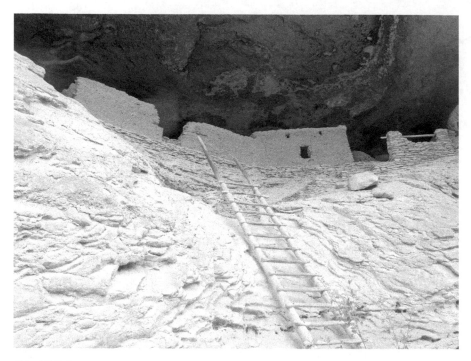

Gila Cliff Dwellings. *Photo by David Pike.*

From the visitor center, you'll drive a short distance to the Trail to the Past, which leads through Cliff Dweller Canyon and up into the cliff dwellings proper. The dwellings have been here for centuries already, and they'll be here for centuries to come—so there's no reason to hurry to get to them. Take your time along the path. Stroll the canyon floor. Admire the beauty around you. Take in the sounds of nature and let the breezes that roll through the canyon lift your spirits. As the trail ascends the canyon wall, it forms a series of switchbacks to help with what would otherwise be a steep climb. It then continues past and—if you're up for climbing a ladder—into the dwellings themselves. One structure contains a T-shaped door, a structural characteristic seen in other Ancestral Puebloan dwellings, such as those at Chaco Canyon in northwestern New Mexico.

Detour Déjà Vu

For more on Chaco, see the Chaco Detour (Detour 2). It visits Chaco Canyon and the grand, multistoried pueblos that comprise that historic site, as well as outlier sites at Salmon Ruins and Aztec.

While it's not known for certain why the people who lived here chose to build their home inside the natural holes in the canyon wall, it makes a lot of sense. The wall offered protections from the elements and would have helped keep stored food away from predatory game. There are seven caves total in the cliff wall. Between five of them there are more than forty rooms all told, some used as living quarters, others for storage and others for purposes that have been lost to time. Soot from the fires that burned here has darkened the roofs. For all its seeming complexity, this was likely a fairly small community; archaeologists suspect it was home to only ten or fifteen families. They lived here—thrived even—for several decades, growing corn, beans and squash along the river; hunting rabbits and deer; building fires to ward off dangers at night; crafting pottery; conducting sacred and communal ceremonies; and participating in trade networks that stretched into Mexico.

As you stand where these ancient people stood, you look out over the view that they must have shared. The same sun would have warmed the cliff face, and the song of similar birds would have bounced through the caves, mixing with the sound of people in their daily rounds. On cloudy days, the same rain would have fallen over the side of the cliff like a waterfall.

But every good story has an ending. The Mimbres people who lived here moved from the area around 1300, possibly in response to drought or other changes in the environment. Unfortunately, as later settlers moved into the area after the end of the Apache Wars, they damaged the structures, stole pots and removed artifacts. In 1907, President Theodore Roosevelt designated the site a national monument, protecting and preserving it for future generations, including detourers.

SOUTHEASTERN NEW MEXICO
— DETOURS —

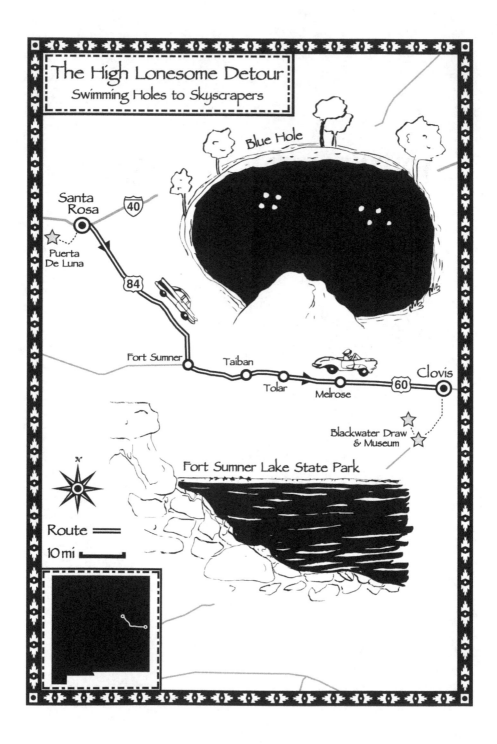

THE HIGH LONESOME DETOUR: SWIMMING HOLES TO SKYSCRAPERS

SANTA ROSA TO CLOVIS

The human history of New Mexico is so diverse and stretches so far into the past that you can move from the hunting grounds of Paleo-Indians to the stomping ground of Buddy Holly in a single detour. (Like this one.) And between those points of interest, there's a landscape so sparse and so spacious that an early explorer wrote that he felt as if he had been swallowed by the sea. We prefer to call it the High Lonesome.

DETOUR LENGTH

Approximately 105 enchantingly eclectic miles

WHAT'S IN IT FOR YOU

- Watch scuba divers descend into the crisp, clear waters of the Blue Hole
- Pay your respects at the grave site of one of history's most notorious outlaws
- Learn about the forced exile of thousands of Mescalero Apache and Navajo Indians
- Be inspired by the recording studio and original instruments used by music greats

Early settler Celso Baca is the man who gave Santa Rosa its name in 1898 when he became the postmaster of the small community formerly known as Eden. It was Baca who changed the name to Santa Rosa, honoring both Saint Rose of Lima and his wife, Rose, at the same time. Santa Rosa came into its own in 1902 with the arrival of the Chicago and Rock Island Railroad. Since then, it has continued to welcome visitors, first on the train, then later on the fabled Route 66 and today on Interstate 40.

Part of the allure are the numerous natural springs in this area. If you've missed any of the signs around town pointing out the Blue Hole, Park Lake and Santa Rosa Lake State Park or proclaiming Santa Rosa as the "City of Natural Lakes," you might be in the wrong Santa Rosa. Take, for example, historic Park Lake, where natural springs have been harnessed into a terraced and landscaped man-made lake for recreational use. The lake and surrounding park were built between 1934 and 1940 as a project of the Depression-era Works Progress Administration. Not far away is the well-known Blue Hole Dive and Conference Center. The "blue hole" is an eighty-two-foot-deep sinkhole filled with sparkling water supplied from an underground spring. The water is so crisp and clear that you'll feel you're looking through a mirror into another world. The Blue Hole has become a popular site for scuba diving, with divers descending into the waters year-round—temperature in the hole is a constant sixty-one degrees.

And if you happened somehow to miss the many signs for the natural lakes around Santa Rosa, there's no way you can miss the signs for Route 66, that historic and heralded auto route between Chicago, Illinois, and Santa Monica, California. Santa Rosa played a unique role in the history of the Mother Road; the route changed course here between its pre- and post-1937 alignments through New Mexico. The Route 66 Auto Museum will give you a closer look at the cars that would have driven the road. This is automotive heaven for vintage car enthusiasts. Among the wheels on display are a two-door 1957 Chevy, a 1949 Ford Woodie station wagon and a 1968 Fort Mustang Coupe. Classics all. Scattered among them in the showroom are displays of old candy machines, Route 66 road signage and other vintage memorabilia.

DETOUR DÉJÀ VU

You'll find more about Route 66 in the Kicks Detour (Detour 8) and the Rut Nut Detour (Detour 6).

If you're not feeling too waterlogged from your visits to Park Lake and the Blue Hole, Sumner Lake State Park south of Santa Rosa is a pleasant place to camp, fish, go boating or have a picnic. The centerpiece is the lake, 1,700 surface acres of it, created from Pecos River water impounded by an imposing earth-fill dam. Sumner Dam and its adjoining spillway were built in 1937 by the U.S. Bureau of Reclamation, which still oversees its operation.

Every state has a museum with an assortment of everything—old cars, photographs, re-creations of pioneer homes—gathered into a seemingly endless and wonderful maze of adjoining rooms. In New Mexico, that museum is the Billy the Kid Museum in Fort Sumner. As the name implies, the focus is the Kid himself, with popular artifacts ranging from one of his rifles to the last door Billy entered before being killed. (More on that shooting just ahead.) This historical menagerie also includes a display of vintage typewriters and cameras, bridles and saddles, old stoves, a replica blacksmith shop, vintage automobiles like a 1923 Model T Ford, a collection of guns and other weapons and even a horse-drawn hearse. And look for a beautiful bell on display toward the back part of the museum—it's the bell from the old Taiban church, which we'll be visiting later in the tour. You can also see a replica of the Kid's grave, which gives you a chance to view the stones up close, something you can't do at the actual grave itself.

Billy the Kid cut a wide swath through New Mexico, but his mortal remains are buried humbly in a graveyard near another great museum, the Old Fort Sumner Museum. The museum itself has displays on the Kid and on the history of Fort Sumner, with a number of old photographs and artifacts. Some of them recount the earlier settlement of Sunnyside, the forerunner of Fort Sumner, which might still exist were it not for a deadly tornado in 1908 that wiped it off the map.

Then, in the cemetery next to the museum, you'll find Billy the Kid's grave. The grave is encased in a steel cage, like an eternal jail cell. But that's less a statement on the Kid's life as a bandit than protection from more modern bandits who stole his tombstone in the past as a memento, or vandalized it. The Kid is buried beside two of his friends, Tom O'Folliard and Charlie Bowdre. Both were killed by members of Sheriff Pat Garrett's posse in December 1880, when Garrett came to Fort Sumner to arrest the Kid for his role in the Lincoln County War. Bowdre's cryptic last words were reportedly, "I wish."

The cement path in the cemetery leads also to two other notable graves. First is the stone marker for Lucien Bonaparte Maxwell, buried beside the Maxwell family plat. Maxwell was once the owner of the sprawling Maxwell

Grave of outlaw Billy the Kid, enclosed for protection against theft or vandalism. *Photo by David Pike.*

Land Grant in northeastern New Mexico, and he became an important player in the later years of Fort Sumner, which we'll learn about soon. Finally, as you walk the path out of the cemetery, you'll pass the grave of Joe Grant, who was shot by the Kid in Fort Sumner in January 1880, reportedly after Grant accosted him in a bar.

DETOUR DÉJÀ VU

The Billy the Kid Detour (Detour 16) includes a trip to Lincoln, New Mexico, where much of the story of Billy the Kid played out.

The cemetery that holds the Kid was once the graveyard for the nearby mid-nineteenth-century military installation known as Fort Sumner, which gave the town of Fort Sumner its name. Today, the Fort Sumner Historic Site and the Bosque Redondo Memorial preserve the site of the fort, as well as the Bosque Redondo Reservation. Intended by the army as a resettlement site for Native Americans in a bid to open their traditional homelands to Anglo

settlement, the reservation became one of the most ruinous chapters in the history of the country's relations with its first inhabitants.

It began in 1862, when soldiers with the First New Mexico Cavalry under the command of Colonel Christopher "Kit" Carson raided settlements of Mescalero Apache Indians in southern New Mexico, forcing those they captured to walk to this site along the Pecos River. This was to be their new homeland, a reservation known as the Bosque Redondo. The captured Mescalero and the soldiers proceeded to build the structure that would become Fort Sumner, which would oversee the reservation. Meanwhile, Carson returned to the field to do the same with the Navajo in northwestern New Mexico and the Four Corners region, raiding their settlements and forcing thousands of men, women and children to endure a grueling walk from their homelands to the fort. The Navajo know the ordeal as "The Long Walk."

The result of this terrible experiment was disastrous. Disease spread quickly through the confined quarters of the reservation. The alkaline waters of the river killed crops. Lack of food and water caused malnourishment. One evening in 1865, the Mescalero Apache left their fires burning for cover,

This historic photo shows the buildings at Fort Sumner under construction. *William A. Keleher Collection (PICT 000-742-0771), Center for Southwest Research, University Libraries, University of New Mexico.*

then quietly escaped the fort and returned to their mountain home. Three years later, army general William T. Sherman met with Navajo leaders Barboncito and Manuelito, among others, and negotiated a new treaty, then closed the reservation and allowed the Navajo to return to their true home.

After the reservation and fort closed, the properties were purchased by Lucien Maxwell, the man we met earlier in the cemetery. Maxwell moved here with his family and others from northeastern New Mexico and turned the officers' quarters into his home.

DETOUR DÉJÀ VU

The Rough and Ready Detour (Detour 7) fills in the story of Lucien Maxwell and his life in northeastern New Mexico before he moved to Fort Sumner.

In Fort Sumner, Lucien Maxwell's son, Pete, became friends with Billy the Kid. It was to the Maxwell home that Sheriff Pat Garrett tracked Billy the Kid on the evening of July 14, 1881, and shot him dead. The house is gone now, but a small stone on the path west of the reconstructed fort marks the spot where the Kid was killed.

As you travel east on U.S. 60 from Fort Sumner, you'll notice that small towns on the highway crop up every ten miles or so. That's no coincidence. These towns largely developed as railroad towns, spaced along the course of the Atchison, Topeka and Santa Fe Railway as it was laid here in 1906 so that crews could maintain the engine and to allow passengers and freight to be loaded or unloaded. The line was known as the Belen Cutoff because it veered from the north–south route at the town of Belen, south of Albuquerque, and continued east through New Mexico and into Texas across the open, flat land the railroad preferred for its trains.

The town of Tolar is one of these small railroad-legacy towns. It's hard to believe today, but Tolar once had a dry goods store, a hotel, a gristmill and several homes. All that's gone now, mostly because of what happened early in the afternoon of November 30, 1944.

As a westbound train of the Santa Fe Railway came through just after noon that fateful day, the local foreman signaled the crew that they had a "hotbox"—an overheating car. Train engineer Bill Clark slowed the train, and crew members disembarked to check the problem, but in the process, the heat caused an axle to burn off, which in turn derailed several cars. A fire broke out and raced through the train. That would be bad for any train,

but this train's cargo included 160 bombs to be delivered to B-29 bombers on the West Coast. The bombs exploded—and the result was devastating. The blast obliterated the train tracks in both directions and sent cargo and debris high into the air (including peanuts, which had been in one of the railcars). The axle of one train catapulted upward and crashed through the roof of the Tolar store, pinning Mrs. Watkins, who owned the store with her husband, into a corner. A metal fragment entered the skull of local resident Jess Brown, watching from the back of the store. He died while being driven to the hospital. Remarkably, his was the only death that day. Tolar never quite recovered from the events of that terrible autumn morning. Today, there's almost nothing left except a few houses and the memory of a deeply tragic event.

DETOUR DÉJÀ VU

If you visit the Carrizozo Heritage Museum on the Billy the Kid Detour (Detour 16), you'll see a piano from Tolar that was scarred in the explosion.

From Tolar east, you'll encounter the great high lonesome country that characterizes the eastern third of New Mexico. The views are wide, the horizon broad and the wind whispers across the land. You're passing through the Llano Estacado. Look for the historic marker by that name (between mile markers 357 and 358 on the north side of the highway) for a place to pause and take in the grandeur of this sight. Traditionally, the name Llano Estacado has been translated from Spanish as either "Stockaded Plains" (a possible reference to the imposing escarpments on its eastern edge, which look like a cattle stockade from a distance) or "Staked Plains" (the stakes believed to be either yucca plants or poles that early travelers used to tie their horses to). More recently, however, historians have suggested that the name should actually be Llano Estacando, or ponded plains. Small lakes, or playas, do form on the land during rainfalls. Regardless, it's a deeply moving stretch of country.

While still a small community, Melrose is the largest settlement between Fort Sumner and Clovis. It's a nice place, distinguished by the giant Melrose Grain Company grain elevator along the highway and humbly suggesting in signs along the highway that it is the "Small Town with the Big Heart." The town appears to hold no grudges against the railroad, which originally considered it as the eastern terminus of the Belen Cutoff but decided on

Clovis instead. If you stop at Baxter Memorial Park, which Melrose spruced up in 2005 for the centennial celebration of its founding, you'll see a stone memorial honoring earlier ranchers Walter Brown and Lonny Horn, whose combined surnames served as an early name for the settlement: Brownhorn. The railroad renamed it Melrose. The best way to peer into the past of this community is to drive down Main Street and view its vintage commercial buildings and the old train depot at the south end of the street.

A short side trip will bring you to Blackwater Draw, the type site for the Clovis culture, the name used to identify the oldest known humans in North America. They lived in this area some 13,500 years ago. Archaeologists consider a "type site" to be the location where the best record of a group of people can be found. Blackwater Draw is a multi-component site, meaning that humans have been coming here for thousands of years. So, in addition to the Clovis people, who hunted mammoth along the banks of the waters in the draw, members of the Folsom culture hunted here are well, around 10,500 years ago. And others followed. A self-guided tour leads you around the dry bed of what was once a prehistoric spring-fed lake, where mammoth, ancient bison and saber-toothed cats came to drink and where Paleo-Indians in turn hunted them for food.

As with the other towns we've encountered on this trip along U.S. 60, the city of Clovis took shape as a railroad town on the Belen Cutoff in 1906. It had one distinction, though: it was to be the division point on the line, the spot where the Belen Cutoff met the tracks coming from Texas. Nobody is quite sure why the town honors medieval French king Clovis I in its name, but one popular story says the daughter of a local railroad engineer named the town after studying Clovis in school.

If that's true, it was a lesson with great implications because the name is tied not only to the city, not only to the prehistoric Indian culture located near here, but also to another culture: music. Indeed, what's known today as the "Clovis Sound" is a distinctively clear and melodic type of rock-and-roll that emerged in the music of Buddy Holly, Roy Orbison and Jimmy and the Fireballs. All of them recorded some of their top hits at the Norman Petty Recording Studio in Clovis. You can see the studio—and even some of the original instruments—used to capture hits like Holly's "That'll Be the Day" in 1957 and "Peggy Sue" in 1958. A good companion site is the Norman and Vi Petty Rock and Roll Museum downtown. Displays in the museum chronicle the story of Norm and Vi Petty and include memorabilia from artists who recorded at the studio. There's even a re-creation of the studio itself with the original mixing

board. You can see one of the rubber balls that artist Bobby Vee threw into the audience during performances of his 1960 hit "Rubber Ball" and a Fender Stratocaster guitar signed by the Crickets.

The towering, cornmeal-colored building behind the museum is the historic Hotel Clovis. Its nine stories earned it the nickname "Skyscraper of the Plains" when it opened its doors on October 20, 1931. Chandeliers lit the lobby, a grand ballroom on the second floor held some of the best dances in Clovis and two Otis elevators carried guests up to their floors. Many of those guests were travelers on the railroad who came from the depot only a block away. Among the lavish accoutrements of the Hotel Clovis were seven Art Deco Indian-head busts atop the roof, each peering in a different direction across the city—you can still see them up there from the ground. Sadly, the loss of passenger service on the railroad coincided with the closing of the hotel in the 1970s. It sat abandoned for years, but community efforts to revitalize downtown over the past decade have reopened its doors as an apartment building.

Let's end this detour on a fun note. The former Clovis train station is now home to the Clovis Depot Model Train Museum. As giant trains hustle past on the tracks outside the museum, you can enjoy their model replicas inside. Scale model engines chug through feature-rich model landscapes, including one that incorporates buildings from Clovis itself—including the Hotel Clovis (with, yes, the Art Deco Indian head busts on the roof). And you get to control them through buttons on the display cases. You'll see a 1907 steam passenger train, an American Flyer Circus Train and several others. The museum also features working trains from Australia and Great Britain, as well as a display of a typical British tea service served to passengers on the rail. Our favorite display is in the room behind the gift counter. It features vintage model cars like an American Flyer boxcar built in 1927 and a Lionel electric locomotive made in 1925.

In addition to model railroads, the depot is also a museum for Clovis railroad history. You can walk through the rooms and admire switch stand lights, "date nails" used to keep track of the year a railroad tie was laid and a settee from the old Harvey House restaurant, which was in a building next to the depot. As you explore, expect a train or two to pass outside, as they have for decades now, forever changing this part of New Mexico.

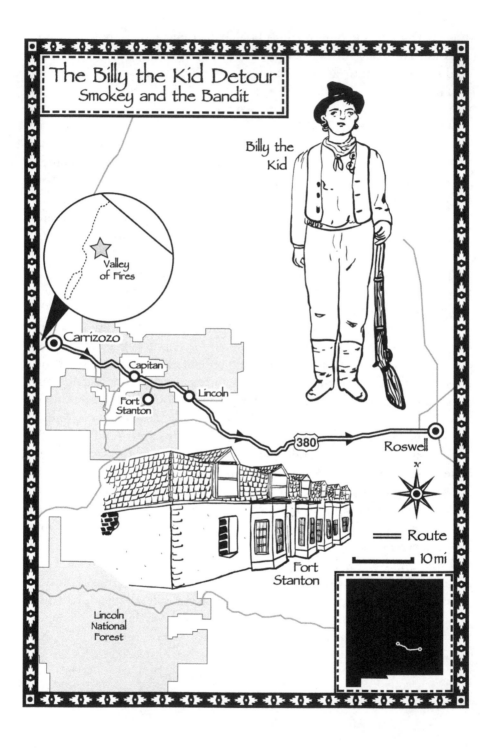

The Billy the Kid Detour
Smokey and the Bandit

Billy the
Kid

Valley
of Fires

Carrizozo

Capitan

Fort
Stanton

Lincoln

380

Roswell

Fort
Stanton

Lincoln
National
Forest

Route

10 mi

THE BILLY THE KID DETOUR: SMOKEY AND THE BANDIT

FROM CARRIZOZO TO ROSWELL

When detouring under the clear New Mexico sky, the empty road stretching to the horizon ahead of you, you're likely to feel a great sense of serenity. It seems a uniquely peaceful place. But that's only part of the story. Don't be fooled by the calm of the grass-covered Tularosa Basin or the mountain beauty of the Lincoln National Forest: history has often played out in dramatic ways in this part of the state. This detour introduces you to a wounded young bear that inspired a nation to protect its forests and a young man whose short, violent life continues to fascinate generations. You'll also encounter evidence of wars, reluctantly fought or tensely avoided, in the past and the recent present. All this and more as we trace the tracks of Smokey and the bandit through southeastern New Mexico.

DETOUR LENGTH

Between hill climbing and level-land cruising, roughly 133 miles

WHAT'S IN IT FOR YOU

- Admire art in galleries housed in century-old historic properties
- Visit the grave site of the real-life Smokey Bear
- Tour a historic fort that featured in the Apache, Civil and Lincoln County Wars
- Walk in the footsteps of Billy the Kid on the historic streets of Lincoln

The town of Carrizozo takes its name from the carrizo grass that was abundant in this part of the Tularosa Basin when enterprising brothers Charles B. and John A. Eddy built the El Paso and Northeastern Railroad through the basin in the late nineteenth century. Historians believe that the extra "zo" was added when settlers built a small town along the railroad at this location, probably to indicate just how much of that grass was in this area—a shorthand way of saying, "Look at all this grass!" Carrizozo became the county seat of Lincoln County in 1909 and prospered until the mid-1960s, when passenger service on the rail line through town ended and the population declined. Today, around one thousand residents call it home.

Like many New Mexico towns, Carrizozo is seeing a rebirth, brought about in part by artists and retirees. Historic Twelfth Street is the epicenter of this movement. The Tularosa Basin Gallery of Photography is probably the largest photo-only gallery in the state. If you love photography, you really must f-stop here! The building itself is historic, completed in 1917 and once serving as the Carrizozo Trading Company—the sign on the south side of the building still hocks "tents and wagon covers" and promises "highest prices for hides and pelts." Inside, you'll be surrounded by the images of a talented range of photographers, all members of the gallery, all from New Mexico. And per gallery requirements, all their photos were taken in New Mexico.

You won't be surprised to learn that the original name of the park at the southern end of Twelfth Street was Spider Park, since the structure at its center looks something like a spider crouched in a giant web, all of it built from lava rock culled from the nearby Valley of Fires Recreation Area. Today it's known as McDonald Park, after William C. McDonald, a prominent resident of the area and owner of the Carrizozo Ranch Company. He was also the first governor of New Mexico after statehood in 1912.

Roy's Ice Cream Parlor is housed in the building that once served as the town drugstore and hospital. (Patient rooms were upstairs; the pharmacy was downstairs.) Dr. Paden from nearby White Oaks ran the pharmacy, and memorabilia from that time lines the walls. The upstairs is no longer in use, but the downstairs still functions as a dining area and small museum. There's a working soda fountain behind the front counter, installed in the 1930s and providing treats ever since. We recommend the Valley of Fires, a sweet delight made with mounds of dark chocolate ice cream.

The Carrizozo Heritage Museum is housed in the building that was once the town's ice plant; the annex beside it was a power plant. Displays inside include a re-creation of an old schoolroom and a turn-of-the-century

millinery shop, an extensive exhibit on different forms of barbed wire (more than you probably realize) and a display on our friend Governor William McDonald. The museum's short video presentation is fun to watch, not only for the history of the museum it provides, but also because you get to sit in seats that were once in the historic Lyric Theater on Twelfth Street.

DETOUR DÉJÀ VU

Among the displays in the Carrizozo Heritage Museum is a piano with an interesting history: it withstood the blast from an explosion that rocked the southeastern New Mexico town of Tolar. Visit Tolar and read more about that terrible event in the High Lonesome Detour (Detour 15).

Your drive east from Carrizozo will take you out of the Tularosa Basin, toward the mountains and up into the beautiful Lincoln National Forest. The forest, designated initially in 1902 as the Lincoln Forest Reserve, became a national forest in 1918. It borrows its name from the village of Lincoln, which in turn takes its name from the larger county of Lincoln, created by the territorial legislature in 1869. All were named to honor President Abraham Lincoln.

The town of Capitan was founded around 1894 and originally known as Gray. In 1899, the Eddy brothers—the same enterprising duo connected with the history of Carrizozo—platted the town so that they could have access to nearby coalmines for their railroad, renaming it for the nearby Capitan Mountains. Today, this little village is known as the birthplace and final resting place of one of the best-known figures in American history. Indeed, he's so admired here that his face appears on the patch of the Capitan Police Department. Nobody seems to mind that this particular local hero growled and ate bugs. We're talking, of course, of Smokey Bear.

Smokey's triumph was born of tragedy. In 1950, a fire racing through Capitan Gap in the Capitan Mountains north of town quickly burned through the piñon and juniper on the slopes. When they finally brought the fire under control, firefighters came upon a badly burned bear cub clinging to a tree, his mother presumed killed or lost in the inferno. They nicknamed the cub "Hotfoot."

Only a few years earlier, in an attempt to protect the natural resources of the country during wartime, the government had created an ad campaign to focus public attention on preventing forest fires. The campaign featured an illustrated bear that warned campers and travelers visiting the nation's

forests to pay attention to their campfires, matches, cigarettes and other combustibles. Seizing an opportunity, New Mexico Game and Fish chief Ray Bell and state game warden Elliott Barker connected the ad campaign with the bear cub rescued in Capitan and convinced the ad council to make Hotfoot (now renamed "Smokey") the living representation of the Smokey Bear campaign image.

In 1950, the now-famous cub was given a permanent home in the National Zoo in Washington, D.C., where he drew huge crowds for the next twenty-five years. When Smokey passed away in 1976, his body was flown back to Capitan and buried in what is now Smokey Bear Historical Park. The park recounts Smokey's incredible story with displays, artifacts from his life and a short movie. A path leads through the outside gardens, landscaped with native trees and grasses, to the large boulder under which Smokey rests, shaded by a tall, thin ponderosa pine. A separate site, the Smokey Bear Museum and Gift Shop next door, expands on the story with one-of-a-kind artifacts, like the bottle his rescuers used to nurse Smokey when he was first found.

Young Smokey Bear stands atop an airplane while Ray Bell looks on. *Used with the permission of the Forest Service, U.S. Department of Agriculture.*

On up the road, you'll find the buildings of Fort Stanton Historical Site so well preserved that you might think you're driving into an active military installation. The fort looks as good as it does thanks to its sturdy construction, which features stone instead of the adobe and wood that doomed other New Mexico forts to fade back into the ground from which they arose.

The army established Fort Stanton at this location along the Rio Bonito on May 4, 1855, to help protect settlers from Apache raids. The fort was named for Captain Henry W. Stanton, who only a few months earlier had been killed in a skirmish with Apache Indians not far away. Typical of a frontier army fort, the installation included quarters for the commanding officers and barracks for the enlisted men, which in its first year included members of the First Dragoon and the Third and Eighth Infantry regiments. A small hospital, jail and rooms for the laundresses completed the arrangement, all surrounding a central parade ground.

After the fort was decommissioned in August 1896, it became a hospital for the treatment of soldiers with tuberculosis. Members of the U.S. Merchant Marines who contracted the dire disease were treated here, consistent with the prevailing belief at the time that clean air and a restful atmosphere were critical elements of the cure.

In 1941, Fort Stanton took on the additional mission of internment camp. Held here were crew members of the German luxury liner *Columbus*, caught en route to the West Indies when World War II broke out. The crew became "enemy aliens" overnight—albeit humble ones, who skillfully maintained the fort and even grew their own gardens. At the end of the war, all the prisoners returned to Germany. The hospital itself was last used in 1953, after which the facility became the property of the state. It's open to the public today as a state-run museum and historic site.

As the soldiers of Fort Stanton trained to protect citizens on the frontier, a battle of another sort was brewing in nearby Lincoln. Lincoln merchants Lawrence G. (L.G.) Murphy and James J. (J.J.) Dolan held contracts to supply beef to the soldiers at Fort Stanton and ran a store in Lincoln. But when Englishman John Tunstall moved to Lincoln in 1876, he tried to break their economic monopoly by opening his own store and raising cattle on his ranch, along with his partners, lawyer Alexander McSween and cattleman John Chisum. They also tried to secure beef contracts at the fort.

Among Tunstall's cowboys was William H. Bonney, better known to history as Billy the Kid. Although the Kid had been involved in acts of lawlessness around New Mexico for most of his young life, he was trying to settle down and change his ways when he went to work for the Englishman.

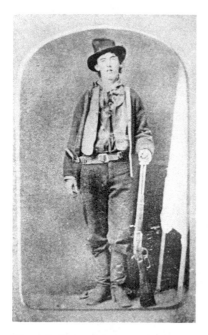

The only known photograph of Billy the Kid. *Courtesy of the Palace of the Governors Photo Archives (NMHM/DCA), Neg. No. 030769.*

Billy admired Tunstall, a well-mannered and literate gentleman. In fact, had the events on a single fateful day, February 18, 1878, turned out differently, it's possible the name of Billy the Kid wouldn't carry the historic weight it does today. On that day, Tunstall was riding into town to meet with a deputized posse aligned with Murphy and Dolan, who had gone to his ranch to inventory his stock as part of a legal matter. The Kid was with him, along with several other cowboys. Tunstall entered a canyon south of Lincoln, now known as Tunstall Canyon, where he met up with the posse. Gunfire erupted, and Tunstall was shot twice and killed.

What followed was a series of clashes on the dirt streets of Lincoln and throughout Lincoln County that were so violent they became known as the Lincoln County War. Billy the Kid and the other Tunstall ranch hands called themselves the "Regulators" and set out to avenge his death. A couple weeks after Tunstall's death, Billy shot and killed Lincoln County sheriff William Brady, who had deputized the posse that murdered Tunstall. Violence escalated across Lincoln County, culminating in a week-long, slow-burning showdown in mid-July. On July 15, the Regulators holed up in the house of Alexander McSween until the new sheriff, George Peppin, ordered it burned down. McSween was killed in the fracas. Finally, soldiers from Fort Stanton were sent in to quell the violence. Soon after, Sheriff Peppin was replaced with a new sheriff: the legendary Pat Garrett.

Lincoln today looks almost the same as it did during those seminal days back in 1878. You can see the Tunstall Store, complete with displays appropriate to the era, along with living quarters where Tunstall could sleep when not on his ranch. On the other side of the street is the former Murphy-Dolan store, later converted to the Lincoln County Courthouse, where the Kid was held after being captured by Sheriff Pat Garrett. He managed to escape, killing two law enforcement officers, Deputy Sheriff James W. Bell and Deputy Marshal Robert Olinger in the process. The spots where the two lawmen fell dead are marked on the courthouse lawn. The site where the

house of Alexander McSween once stood is also marked, and a number of other historic properties are open to the public. Finally, the state-run Anderson-Freeman Museum offers displays that contextualize the battle against the long history of Native American and Hispanic settlement in the region.

DETOUR DÉJÀ VU

Some of the players in the Lincoln County War lived and worked in a community known as Seven Rivers farther southeast in what was then a much, much larger Lincoln County. You can see the old Seven Rivers Cemetery, now relocated to Artesia on the Detour Detour (Detour 17).

In the spring and summer, you'll find fruit and vegetable stands along the highway running past the communities of Hondo, Tinnie and Picacho, and the bounty is as rich as anywhere in the state. Hondo, settled around 1866, takes its name from the Hondo River, which is formed from the confluence of the Rio Bonito, running past Fort Stanton and the Rio Ruidoso. Picacho borrows its name from a nearby mountain, while Tinnie, settled around 1876, is named for the daughter of an early settler.

As you continue east toward Roswell, the landscape flattens into the open and spacious terrain that characterizes eastern New Mexico. For a period of time during the Cold War, this peaceful landscape provided cover for a number of Atlas-F missiles. A historic marker titled Atlas Missile Silos (roadside turnout on the south side of the highway at mile marker 314) gives a short account of their history.

To protect Walker Air Force Base in Roswell, and to provide defense should the United States come under attack, the air force sank twelve concrete missile silos almost two hundred feet into the empty desert surrounding Roswell. They each housed a massive Atlas-F missile, along with a command of five soldiers to protect, service and, if necessary, launch the missile. The Roswell silos were deactivated in 1965; Walker Air Force Base itself closed in 1967. The abandoned silos fell into disuse and are not accessible to the public, although one was recently put up for sale for $295,000.

With that haunting thought to keep the legends of Smokey and the bandit company, continue on to Roswell, the end of this detour.

The name and character of Smokey Bear are the property of the United States, as provided by 16 U.S.C. 580p-1 and 18 U.S.C. 711, and are used with the permission of the Forest Service, U.S. Department of Agriculture.

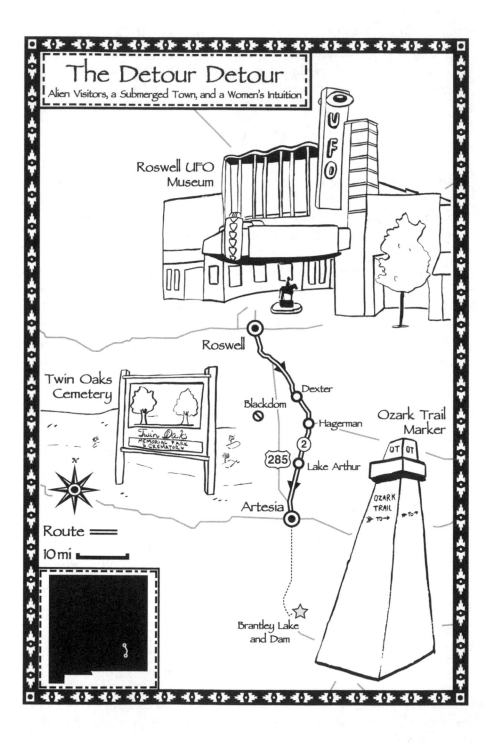

The Detour Detour
Alien Visitors, a Submerged Town, and a Women's Intuition

Roswell UFO Museum

Twin Oaks Cemetery

Twin Oaks MEMORIAL PARK & CREMATORY

N

Roswell

Dexter

Blackdom

Hagerman

2

285

Lake Arthur

Artesia

Ozark Trail Marker

QT QT

OZARK TRAIL
→ TO → → TO →

Route ═══

10 mi

Brantley Lake and Dam

THE DETOUR DETOUR: ALIEN VISITORS, A SUBMERGED TOWN AND A WOMAN'S INTUITION

FROM ROSWELL TO ARTESIA

This detour is an ode to the very idea of detours, to the pure pleasure of diverting from the main path. If we had to put a name to it, we'd say the joy of detouring is the joy of discovery; no matter how long or short they are, these side trips down side roads in New Mexico often contain elements of unalloyed delight. Delights on this detour range from the opportunity to hang out in a one-hundred-year-old hardware store to the chance to tour a relocated cemetery. In New Mexico, you don't have to detour far to be in another world.

DETOUR LENGTH

A little under forty-five delightful miles

WHAT'S IN IT FOR YOU

- Decide for yourself if a UFO visited New Mexico in 1947
- Admire one of the last remaining Ozark Trail markers in the country
- Pay your respects to the departed of a town that's now under water
- Learn how a woman's intuition changed the course of New Mexico history

Roswell, the jumping-off point for this detour, was founded around 1865 when two men, Van C. Smith and Aaron O. Wilburn, opened a general store at what was until then just a small watering hole along cattle trails through the Pecos Valley. Smith named the settlement that developed Roswell, for his father, Roswell Smith. After 1877, Roswell's development was guided by the larger-than-life figure of Civil War veteran Captain Joseph Calloway Lea, who arrived in the city in that year to try his hand at ranching. Lea did a lot for the burgeoning city, including helping plat the community, creating Chaves County and getting Roswell named its county seat, donating land for the courthouse and serving as its first mayor in 1903—all of which earned him the honorary title of "Father of Roswell." Sadly, Lea served only a few months in office; he died of pneumonia on February 4, 1904, at age sixty-three. His obituary in the *Roswell Daily Record* referred to him as "one of earth's noblemen."

Among Lea's many achievements was helping to establish New Mexico Military Institute in 1891. The military high school was originally known as Goss Military Institute, for Colonel Robert S. Goss, who worked with Lea to found the institution. The school changed its name to New Mexico Military Institute, or NMMI, in 1893. Starting with an initial class of twenty-eight students, the school grew in both student size and footprint—receiving a deed to a forty-acre tract of land from prominent local rancher and railroad baron James John (J.J.) Hagerman in 1895. Later, a junior college was added. Among the more prominent alumni of NMMI are news anchor Sam Donaldson and football legend Roger Staubach, but the institute is justifiably proud of all its graduates, having sent men to protect the country in conflicts since its founding. The McBride Museum on campus is open to the public and contains exhibits on the history of the institute.

Two other prominent local figures need mention here, both immortalized in bronze in the downtown area. The first is cattleman John Chisum, known as the Cattle King of the Pecos. Chisum established a ranch south of Roswell around 1865 that he called the Jingle Bob Ranch, reportedly for a distinctive ear cut Chisum used to mark his cattle. At one time, Chisum ran an estimated—and incredible—eighty thousand head of cattle on his sprawling enterprise. He even partnered with Charles Goodnight and Oliver Loving to establish the famous Goodnight-Loving cattle trail.

Second, you'll find a statue of Sheriff Pat Garrett charging forward on horseback in the parking lot across from the east entrance of the courthouse. Garrett is renowned as the law enforcement officer who helped bring an end to hostilities in Lincoln County known as the Lincoln County War and

who shot and killed outlaw Billy the Kid. Garrett's daughter Elizabeth, by the way, was an accomplished songwriter and soprano, and she wrote the official New Mexico State Song, "O Fair New Mexico," adopted by the state legislature in 1917.

DETOUR DÉJÀ VU

Both John Chisum and Pat Garrett were involved in the Lincoln County War in 1878. The Billy the Kid Detour (Detour 16) will take you through the history of events that led to those hostilities and their ultimate outcome.

But all this great history aside, we know why you're really in Roswell. You want some UFO action—you and hundreds of other people who visit Roswell every year. The city has become famous around the world as the one closest to the site where what might have been a UFO crashed in 1947. (That's "unidentified flying object" for those of you who aren't current on your paranormal acronyms.) The incident that created this acclaim happened on a summer evening in July 1947, when an unusual object crashed on a ranch north of Roswell. The Roswell Army Air Force responded to the debris field, prompting the *Roswell Daily Record* to run an attention-grabbing headline the next morning: "RAAF Captures Flying Saucer on Ranch in Roswell Region." The air force claimed the recovered object was simply a weather balloon and, fifty years later, in 1994, released an official report stating that the crashed balloon was part of "Project Mogul," a wartime effort to detect Soviet bomb tests. Despite these explanations, the "Roswell Incident" has captivated the public's imagination for many years. In fact, starting in the 1980s, the city of Roswell began to capitalize on the incident, enhancing its economy by drawing tourists and UFOlogists to the city.

Regardless of how you feel about this, you'll leave the International UFO Museum and Research Center impressed with the breadth of materials on display. Those materials include personal testimonials about the Roswell Incident, photos and drawings of unidentified flying objects, newspaper clippings and accounts of "flying saucers" from throughout history and around the world. There's even a life-size diorama of alien figures at a crash site. And no, it's not just you—they move every so often.

So, what, if anything, visited Roswell in 1947? We're glad you asked, because after extensive research, we're proud to announce that we have uncovered the truth behind this decades-old mystery. We have, indeed,

solved the riddle of the Roswell Incident once and for all. We can state now that what crashed in Roswell in 1947 was, unequivocally, a [REDACTED]. It came from [REDACTED], and its purpose was to [REDACTED]. At last, the real story comes to light!

But if aliens did swing by Roswell to show off their rockets, they were late to the party. Rockets were old news in Roswell by 1947, thanks to scientist and engineer Robert Goddard. Following early successes with creating rockets propelled by liquid fuel, Goddard came to Roswell in 1930 and continued his experiments on a plateau outside town. His work essentially pioneered the field of rocket science, creating the foundation for later wartime efforts and, indeed, the emerging space age. Goddard rates a statue in Roswell as well, outside the Roswell Museum and Arts Center. Inside, you'll find a re-creation of his Roswell laboratory and examples of his rockets.

Leaving Roswell and heading south on NM 2, you'll reach the pretty town of Dexter. Dexter was founded in the early 1900s when three enterprising men formed the Dexter Townsite Company to sell plots of land here. Those men are remembered today in prominent Dexter street names: M.H. Elford in Elford Avenue, Benjamin Tallmadge in Tallmadge Avenue and Albert Macy in Macy Avenue. All three streets run north–south on the west side of the railroad tracks.

Dexter might today have been known for an abundance of fruit orchards grown by the early settlers in the budding community had it not been for a freeze that hit this area back in 1906, only a year after the town was incorporated. The snow, which accumulated into five-foot-high drifts, dug icy claws into those fruit trees. When temperatures dropped, the liquid froze and expanded, forcing cracks in the bark. Old-timers tell stories of hearing popping sounds from the orchard as the limbs and trunks of trees broke open. After that, farmers turned their attention to alfalfa, which remains the cash crop for this small farming town, along with cotton and corn.

This and other fascinating bits of Dexter history are preserved in the Dexter Historical Museum (210 North Lincoln), which has photographs and artifacts from the town's past, organized by year, starting in 1904 and continuing to the present. Here you'll find old school yearbooks, photographs of early Dexter residents at work and play, old newspapers and displays with family history charts. The town exudes that sense of civic pride so common to smaller communities. Look for a girder support that was once part of a historic bridge over the Rio Felix—we'll be visiting there later.

If you want to find one of the oldest enterprises in a town, look for the local hardware store. In Dexter, that's the Dexter Hardware Store. The

store is a tad older than even Dexter itself; the land where it was built was purchased from the Dexter Townsite Company in 1904, the year before the town incorporated. When first built, the store included three buildings side by side along Second Street. Later, the leftmost building was torn down and a new one built in its place, after which a second addition was added behind that. For reasons now lost to even the old-timers, the building that once sat in the middle-most part of the lot was moved behind the new addition and bolted to it, its front attached to the back wall of the addition. As odd as it sounds, today you can pass through doors into the back part of the building and be entering what was once the front of the building. Stop in and ask if you can see it for yourself (but remember that employees can only show you if they're not busy with customers). You can join the gathering of locals, too, if you're there in the morning. This is one of those wonderful places you find in small towns off the major thoroughfares, where old-timers still gather every morning for coffee and storytelling, as they have for decades. And while you're there, see if there's anything on your shopping list that you could pick up. Economies of small towns like Dexter often depend on the vitality of their locally owned businesses.

Next to the hardware store, look for the small memorial under the elm tree in the park at the intersection of Birney and Second Streets. The stone monument remembers Floyd Lesley Bradley, the only casualty among the men of Dexter who served in combat in World War I. Bradley contracted the flu, possibly the Spanish flu, while en route to Europe and died on September 25, 1918. Though he was buried at sea, the memorial ensures he's never far away from his hometown of Dexter.

A stop by Lake Van will bring you to a tree-lined, spring-fed urban lake, with wooden piers that allow you to venture out a bit into the water without getting wet. You can fish here, too; the state stocks the lake with trout in the summer and catfish in the winter. If the name "Van" sounds familiar, that's because you've heard it before. It honors Van C. Smith, one of the founders of Roswell.

You can't visit the town of Blackdom anymore; though it once existed about fifteen miles southwest of Dexter, it's gone now. But its role in New Mexico history is too important not to mention. Blackdom was founded and settled entirely by African Americans at the outset of the twentieth century. The man who led the effort was Francis Marion Boyer, a college graduate living in Pelham, Georgia. Boyer aspired to create a community where blacks could own homes, educate themselves and their children, start businesses and raise families. So, in 1900, he walked all the way from Georgia to New

Mexico, purchased land at a site across what is now U.S. 285 southwest of here, sent for his wife and advertised for other blacks to join him in creating the community of Blackdom. They did well in the early years, reaching a peak of three hundred residents. Unfortunately, crop failures, poor water resources and lack of sufficient finances forced many Blackdom residents to move elsewhere. The townsite was abandoned by 1930.

Just before you enter the community of Hagerman, you'll cross the Felix River, and there you'll see the glorious and historic Rio Felix Bridge. Constructed in 1926 by the Boardman Company of Oklahoma City, the old bridge was built at an angle across the river, matching the original course of the highway and ensuring that floodwaters from the river wouldn't broadside the structure. The vertical and diagonal beams of the trussing are characteristic of a Pratt Truss design. Each of those three individual spans of trussing runs 144 feet long, making this the longest Pratt truss bridge in the state. The highway department constructed the new bridge in 1984.

By the way, if the name Hagerman also sounds familiar, it's because you've heard it before, too. The town, founded in 1894, was both laid out by and named for J.J. Hagerman, who donated the land on which the New Mexico Military Institute now stands. Earlier, Hagerman founded the Pecos Valley and Northeastern Railroad (affectionately called the "Pea Vine" from its acronym, PVNE), which ran from Amarillo, Texas, through the Pecos Valley to Pecos, Texas. Hagerman also purchased John Chisum's Jingle Bob Ranch a few years after Chisum's death in 1884, renaming it the South Spring Ranch.

In Lake Arthur, you're in for a few rare treats, the kind of discoveries only possible on a detour off the beaten path. At the intersection of Broadway and Main, you'll see the first: an old marker for the Ozark Trail. The Ozark Trail was one of the named automobile routes popular in the country before the advent of the federal highway system in 1926. Developed by promoters and local businesses, these routes encouraged early auto travel and tourism in the country and connected the economies of neighboring states. The Ozark Trail was mapped over existing roads from Arkansas to New Mexico and marked in select communities with these distinctive obelisks, which often had the names of cities on the route and number of miles to them. The marker in Lake Arthur is one of only seven remaining in their original placements in the country—and the only one left in New Mexico.

Lake Arthur is also home to the State History of Education Museum, housed in the old Lake Arthur schoolhouse at the end of Broadway Street. This is the only museum in the state dedicated to the history of education,

The Ozark Trail marker is a prominent feature in Lake Arthur. *Photo by David Pike.*

a fitting use given its own history. Built in 1906, this building was where the youth of Lake Arthur were educated for almost sixty years, until the more modern junior high and high schools surrounding it took over that duty; the building was decommissioned as a school in the 1960s. It opened as a museum in 1988 and holds displays of memorabilia such as yearbooks and

school photos that chronicle the history of education in New Mexico and specifically Lake Arthur.

Just before reaching Artesia, stop at the Twin Oaks Cemetery (59 Lake Arthur Highway). The cemetery is beautiful in its own right, but our destination is a short distance beyond the back part of the cemetery itself. Look for the small patch of land just west of the main cemetery; memorials and graves are visible in the near distance. (Cross the desert shrubbery and weeds here carefully and keep an eye out for snakes and broken glass.) It might seem odd to have two separate cemeteries adjoining each other, but the story of these two graveyards will reveal why this arrangement makes sense, while reminding us that the ties that bind us are stronger than time.

In 1988, engineers with the U.S. Bureau of Reclamation had a problem. The construction of Brantley Dam south of Artesia would impound the waters of the Pecos River into a massive lake—one that would flood an area north of the dam that contained the cemetery for the ghost town of Seven River. So the bureau exhumed the burials in the Seven Rivers Cemetery and reinterred those individuals in a separate hallowed space here, at the back of the existing cemetery of Twin Oaks. And they were determined to do it right, placing the graves in the same relative locations and orientations in their new location as they'd had in their original burials and using the original headstones, repairing them when necessary. Aware of the opportunity this project offered to learn from the past, archaeologists with the bureau also conducted a study of the individuals being reinterred.

Seven Rivers hadn't been a typical town. In its heyday in the 1870s, it was a major settlement in what was then a much-larger Lincoln County, bordering the Chisum empire, distinctions that secured it a place in a major drama of the time—the Lincoln County War, a battle between rival economic factions centered in the town of Lincoln, a battle that included a young Billy the Kid. A number of cowboys from Seven Rivers took part in the gunfights that broke out on the streets of Lincoln.

DETOUR DÉJÀ VU

For more on the Lincoln County War and to visit some of the locations where the war took place, see the Billy the Kid Detour (Detour 16).

Enter Artesia now and enter another world, one with its own sights, sounds and scents. In fact, that aroma flavoring the local air is the smell of

hydrocarbons, principally oil, natural gas and their byproducts. There's a good reason for that; beneath your feet are an estimated forty-three billion barrels of oil and eighteen trillion cubic feet of natural gas (yes, that's billion with a "b" and trillion with a "t"). You're standing on the western edge of the vast Permian Basin, which runs under much of the southeastern corner of New Mexico and extends to the Midland/Odessa area in Texas. It is the largest petroleum-producing basin in the United States, and it is big business in these parts.

The oil business took off here in the mid-1920s when the Illinois No. 3 oil well "came in," as the roughnecks say. Despite cycles of boom and bust largely related to commodity prices, the energy industry has remained a mainstay of the local economy. Recently, oil and gas activity has surged yet again, as new technologies have revitalized existing oil fields and led to the "discovery" of previously unrecoverable deposits of black gold.

Make a brief stop at the Artesia Visitor Center, where you can see exhibits on the history of the town, learn more about the oil business and pick up a guide to a walking tour of downtown. The visitor center is in the restored train depot—it's not the original one built for Hagerman's Pecos Valley and Northeastern Railroad but a later one built by the Santa Fe Railroad, which still runs through the city.

Be sure to visit the Artesia Public Library downtown. Books are great and all—thank you for buying this one, by the way—but what we really want you to see is the giant mural that dominates the interior of the main reading room. Called *The Future Belongs to Those Who Prepare for It*, this forty-six-foot-long, fifteen-foot-high, arced panorama was painted in 1952 by New Mexico artist Peter Hurd (himself a graduate of New Mexico Military Institute in Roswell). Though that title and the placement of the mural in the library might imply that it was painted for this specific location, it was actually done on commission for the Prudential Insurance Company for the lobby of its regional headquarters in Houston, Texas. That's where it stayed until 2011, when the headquarters building was slated for demolition. Painted as a fresco on the wall, the piece was locked in place and would likely be lost forever. But enterprising residents of Artesia rescued the piece, removing the entire wall and transporting it to Artesia, where it was lowered into their newly constructed library by crane through a removable section of the roof.

While you're in the vicinity, visit the sculptures that decorate the downtown area. One by artist Robert Summers depicts Sallie Chisum, niece of John Chisum. Sallie came to this area in the 1880s and settled along Eagle Draw, where she built a house and started her own ranch, becoming known as the

179

"Queen of the Jingle Bob." She also sank the first successful water well here in 1890, which led to the name of the town, Artesia.

In the statue, Sallie is reading a book to two schoolchildren. The book is *An Authentic Life of Billy the Kid*, written by someone who would have had a unique perspective on that life: Sheriff Pat Garrett. Look closely at the title page. It's a reproduction of the cover of that book as it would have appeared during Sallie's life. The two children were modeled after actual schoolchildren of the era. Check out the photograph that served as a model for the statue on a plaque next to the statue.

Just one block north, you'll find yourself immersed in a bit of Wild West drama being enacted by three separate, but related, statues. A trail boss, created by artist Vic Payne; a *vaquero* (the Spanish word for cowboy), created by artist Mike Hamby; and a cattle rustler, created by artist Robert Summers, all interact with one another from separate locations a block away. At the very moment you enter the scene, the vaquero has noticed the rustler stealing a cow from the herd and is alerting the trail boss.

A few blocks up Main Street (also U.S. 82) is another set of sculptures by Robert Summers and Vic Payne that depict work in and around an oil-drilling rig, as well as early Artesia pioneers, all part of Derrick Floor Park. Among those depicted here in bronze are Martin Yates and his wife, Mary, in a sculpture by artist Robert Summers. The event being recalled is the trip the couple took out into the stretches of flat land surrounding Artesia one day back in 1924. Martin, having sunk two unsuccessful wells to that point, asked his wife to select the next location. Martin and his partners, Van Welch (also depicted here in bronze) and Tom Flynn, sank a well at the spot she selected and successfully hit oil at 1,947 feet. As mentioned earlier in the detour, this was the Flynn-Welch-Yates Illinois No. 3, the first commercially successful well on state land, the one that launched the oil boom in southeastern New Mexico.

The best place to end this detour is at the Wellhead Restaurant, both because the food is delicious but also because of the décor, which turns the industrial and mechanical world of pump jacks and oil derricks into a refined and elegant atmosphere. One of the more interesting pieces of art is a re-creation of a photo of the Illinois No. 3 done in tile. As you enjoy your meal, think of cattle barons and cemeteries and giant murals, and take comfort in knowing that somewhere out there in the universe, the inhabitants of [REDACTED] were at last able to [REDACTED] on their own detour through the Land of Enchantment.

SELECTED BIBLIOGRAPHY

Arango, Polly. *Touring New Mexico*. Albuquerque: University of New Mexico Press, 2001.

Boyle, Dixie. *History of Highway 60 & the Belen Cutoff: A Brief History*. Denver, CO: Outskirts Press, 2010.

Caffey, David L. *Frank Springer and New Mexico: From the Colfax County War to the Emergence of Modern Santa Fe*. College Station: Texas A&M University Press, 2006.

Fergusson, Erna. *New Mexico: A Pageant of Three Peoples*. New York: Alfred A. Knopf, 1964.

Flynn, Kathryn A. *Treasures of New Mexico Trails*. Santa Fe, NM: Sunstone Press, 1995.

Hannett, Arthur Thomas. *Sagebrush Lawyer*. New York: Pageant Press, 1964.

Hunner, Jon. *Inventing Los Alamos: The Growth of an Atomic Community*. Norman: University of Oklahoma Press, 2004.

Jackson, Hal, and Marc Simmons. *Following the Royal Road: A Guide to the Historic Camino Real de Tierra Adentro*. Albuquerque: University of New Mexico Press, 2006.

Julyan, Robert. *The Place Names of New Mexico*. 2nd ed. Albuquerque: University of New Mexico Press, 1996.

Julyan, Robert, and Carl Smith. *The Mountains of New Mexico*. Albuquerque: University of New Mexico Press, 2006.

Julyan, Robert, William Stone and Tom Till. *New Mexico's Continental Divide Trail: The Official Guide*. Boulder, CO: Westcliffe Publishers, 2008.

Kelley, Shawn, and Kristen Reynolds. *Route 66 and Native Americans*. Santa Fe: New Mexico Department of Transportation, n.d.

Kelly, Cynthia C., ed. *Remembering the Manhattan Project: Perspectives on the Making of the Atomic Bomb and Its Legacy*. Singapore: World Scientific Publishing Company, 2005.

LeMay, John, and Roger K Burnett. *Legendary Locals of Roswell, New Mexico*. Charleston, SC: Arcadia Publishing, 2012.

McClanahan, Jerry. *The EZ66 Guide for Travelers*. Lake Arrowhead, CA: National Historic Route 66 Federation, 2013.

Melzer, Richard. *Buried Treasures: Famous and Unusual Gravesites in New Mexico History*. Santa Fe, NM: Sunstone Press, 2007.

Miller, Joseph. *New Mexico: A Guide to the Colorful State*. New York: Hastings House, 1953.

Perrigo, Lynn I. *Gateway to Glorieta: A History of Las Vegas, New Mexico*. Boulder, CO: Pruett Publishing, 1983.

Rittenhouse, Jack D. *A Guide Book to Highway 66*. Albuquerque: University of New Mexico Press, 1989.

Sandersier, Andy S. *The Lakes of New Mexico: A Guide to Recreation*. Albuquerque: University of New Mexico Press, 1996.

Simmons, Marc. *Following the Santa Fe Trail: A Guide for Modern Travelers*. Santa Fe, NM: Ancient City Press, 1986.

Udall, Stewart L., and Jerry Jacka. *Majestic Journey: Coronado's Inland Journey*. Santa Fe: Museum of New Mexico Press, 2003.

Varney, Philip. *New Mexico's Best Ghost Towns: A Practical Guide*. Albuquerque: University of New Mexico Press, 1987.

Whisenhunt, Donald W. *New Mexico Courthouses*. El Paso: Texas Western Press, 1979.

INDEX

ABOUT THE AUTHORS

David and Arthur Pike began exploring New Mexico in 1973 when their family moved to the state from rural Vermont. Their parents encouraged them to get to know their new home. So from their base on Marr Street in Truth or Consequences, they ventured out to nearby ghost towns, climbed the rugged peaks of the Caballo Mountains, swam in Elephant Butte Lake and wondered at the vast stretch of the Jornada del Muerto.

Over the years, in personal adventures together and apart, including extended road trips, they've expanded their knowledge of the geographic wonders and rich history of the state and become avid detour seekers.

David earned a bachelor's degree in business administration from New Mexico State University and a master's degree in creative nonfiction from Johns Hopkins University. He published an updated version of his comprehensive guide to the historic markers of the state, *Roadside New Mexico*, in 2015. The book won the state's Heritage Preservation Award in 2016. His essays on New Mexico places and people have appeared in *New Mexico Magazine*. He currently resides in Albuquerque.

Arthur earned a bachelor's degree in journalism from New Mexico State University, as well as a master's degree in technical and professional communication from NMSU. He lives with his family in Houston, Texas, where he manages a communication function for an energy company and writes short and long-form fiction.

ABOUT THE ILLUSTRATORS

Emily Lewis is an illustrator from Houston, Texas. She received her bachelor's and master's degrees in studio art and has exhibited her work in galleries and academic institutions nationally. Chris Pike is an illustrator from Las Cruces, New Mexico. He received his bachelor's degree in creative writing and has managed the production of several award-winning publications throughout the Texas hill country. Emily and Chris met while attending Texas State University and currently live in Portland, Oregon.

CPSIA information can be obtained
at www.ICGtesting.com
Printed in the USA
LVHW081048160520
655725LV00001B/19